# HIDDEN DEPTHS:
# WILTSHIRE'S GEOLOGY & LANDSCAPES

*Cover: Sarsen stones in West Woods lying on the Chalk of the Marlborough Downs (here with a superficial cover of Clay-with-Flints).*

*Back cover: Ammonite (Sigaloceras calloviense) from the Kellaways Beds at Latton; when illuminated from behind, it shows evidence of soft parts in the body chamber.*
*(Photograph by Neville Hollingworth, Natural Environment Research Council.)*

*Frontispiece: Pliosaurs swam around Wiltshire in the Jurassic seas. Fossil skeletons of this marine reptile have been found in the Kimmeridge Clay at Westbury (Drawing by Linda Geddes).*

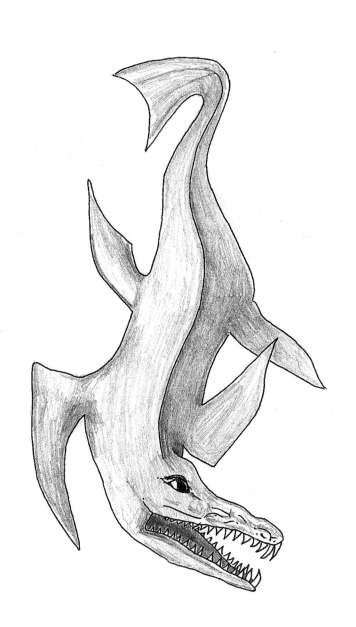

# HIDDEN DEPTHS

*Wiltshire's Geology & Landscapes*

## Isobel Geddes

**EX LIBRIS PRESS**

Published in 2000 by
EX LIBRIS PRESS
1 The Shambles
Bradford on Avon
Wiltshire
BA15 1JS

Design and typesetting by
Ex Libris Press

Printed in Britain by
Cromwell Press, Trowbridge, Wiltshire

ISBN 1 903341 05 1

# CONTENTS

Acknowledgements

## PART 1: GEOLOGICAL BACKGROUND

**1    Introducing the Geology**

Introduction                                                                    11

Geological principles                                                           14

Fossil preservation                                                             16

The dynamic Earth: repeated cycles of rock formation and
        destruction                                                            21

The history of Wiltshire's rocks                                               23

Wiltshire's geological structure - how this governs the surface
        rocks                                                                  29

**2    The Rock Sequence**

The Jurassic limestones of northwestern Wiltshire
        (the southern Cotswolds)                                               34

The late Jurassic clay vales of the Avon and Thames and their
        southeastern borders                                                   41

The mid-Cretaceous sands and clay beneath the Chalk                            47

The late Cretaceous Chalk of the downs                                         50

The Tertiary sands and clays of Savernake Forest and the northern
        New Forest; the sarsen stones of the downlands                         58

Quaternary superficial deposits and the effects of the Ice Age                 64

**3    Geological Resources**

Building stones                                                                71

Chalk's other uses                                                             83

Sand and gravel                                                                84

Clay                                                                           84

Iron ore                                                                       87

Soils                                                                          88

Water supplies                                                                 90

# PART 2: EXPLORING WILTSHIRE

| 4 | **The Avon Valley and the Southern Cotswolds** | 97 |
|---|---|---|
| | The upper reaches of the Avon | 98 |
| | The clay vale below Malmesbury | 100 |
| | The limestone valley west from Bradford-on Avon | 106 |
| | The By Brook valley around Box | 117 |

| 5 | **The Marlborough Downs, Swindon and the Thames Valley** | |
|---|---|---|
| | The western Marlborough Downs and their borders | 119 |
| | Wootton Bassett to Broad Town and Hackpen Hill | 127 |
| | Swindon Old Town | 132 |
| | Coate Water | 136 |
| | Northward to the Thames valley | 136 |

| 6 | **The Vale of Pewsey and its Western Approaches** | 143 |
|---|---|---|
| | The southwestern approach: Westbury and Bratton to Easterton and Urchfont | 144 |
| | The western approach: West Ashton to Seend, Devizes and Potterne | 155 |
| | The eastern (main) part of the vale | 161 |

| 7 | **Savernake Forest and the Vale of Ham** | 165 |
|---|---|---|
| | Savernake Forest | 165 |
| | The Vale of Ham | 171 |

| 8 | **The Downlands and Heaths of Southeastern Wiltshire** | 175 |
|---|---|---|

| 9 | **Southwest Wiltshire** | 183 |
|---|---|---|
| | The western lands below The Plain - from Warminster to Mere | 185 |
| | The Vale of Wardour's Chalk and Greensand | 191 |
| | Cranborne Chase and the Ebble valley | 198 |
| | Tisbury and Teffont Evias: the latest Jurassic limestones and clays | 199 |

| Glossary | 205 |
|---|---|
| Bibliography | 213 |
| Index | 215 |

# Acknowledgements

I am deeply indebted to Gilbert Green, who knows more about Wiltshire's geology than most. Formerly of the British Geological Survey, he has given invaluable help with the geological literature, location of rock exposures and criticism of the text.

My thanks are also due to Professor Jim Kennedy of Oxford University for his expert advice on the Cretaceous rocks, to Dr. David Nash of the University of Brighton, Dr. Neville Hollingworth of the Natural Environment Research Council and David Beatty of Blue Circle Industries for allowing the use of their photographs and to the managers of the various working quarries in the county for the guided tours of their sites.

The British Geological Survey has kindly given permission for the inclusion of simplified versions of parts of their 1:250,000, 1:50,000 AND 1:63,360 maps as specified on page 213 (British Geological Survey © NERC; all rights reserved), redrawn by Gilbert Green. The cross-sections of the geology are all based on information from the Geological Survey's published maps. The Geological Map of Wiltshire (Fig. 2) was originally published in *The Wiltshire Flora* in the chapter ' by Gilbert Green and has been reproduced in a modified form with the permission of the editor and the Wiltshire Natural History Forum, to who I am very grateful.

Janet Smythe of Keevil has provided a "layman's" perspective, as well as company and moral support during fieldwork. Bill Geddes, my husband, has rid the text of my most outlandish idiosyncrasies and made it altogether more comprehensible.

## About the Author

Isobel Geddes holds degrees in geology from Oxford and London Universities. Her career has included both teaching in secondary schools and adult education classes, and working as a geologist for Shell and for the Cambridge Arctic Shelf Programme, overseas and in Cambridge. She currently lives in central Wiltshire.

# Part 1

# GEOLOGICAL BACKGROUND

| ERA | PERIOD/EPOCH | | AGE AT BASE |
|---|---|---|---|
| CAINOZOIC | Quaternary | Holocene (Recent) | 10,000 yrs |
| | | Pleistocene | 2 million yrs |
| | Tertiary | Neogene | 23 million yrs |
| | | Palaeogene | 65 million yrs |
| MESOZOIC | Cretaceous | | 145 million yrs |
| | Jurassic | | 208 million yrs |
| | Triassic | | 245 million yrs |
| PALAEOZOIC | Permian | | 290 million yrs |
| | Carboniferous | | 362 million yrs |
| | Devonian | | 408 million yrs |
| | Silurian | | 439 million yrs |
| | Ordovician | | 510 million yrs |
| | Cambrian | | 570 million yrs |
| PRE-CAMBRIAN | | | 4560 million yrs |

*Fig. 1: The periods of geological time.*

# 1: Introducing the Geology

## Introduction

Travelling around Wiltshire, my personal enjoyment of the landscape is greatly enhanced by an insight into how it was formed. So if you, too, enjoy exploring the countryside and have wondered why the various features of the scenery - the rolling hills, the steep scarps, the broad river valleys and even the towns and villages - are where they are, this book will provide the answers. The landscape has not just been created by Man in historic, or even pre-historic time, but over the two hundred million years or so of geological time since the rocks of Wiltshire, the backbone of the scenery, were laid down. I will attempt to give, to anyone who is curious, an appreciation of the landscape of Wiltshire, and enrich the experience of discovering the county - whether on foot, cycling or by car - with a deeper understanding of why it is as you see it today. Landscape is the result of a combination of factors: geological structure, rock type, erosion processes and broad environmental changes, such as the fluctuations in sea-level which ocurred during the Ice Age.

The rocks beneath us tell a story of changing environments, of ancient seas, emerging lands and repeated glaciations. The geological history of those rocks exposed at the surface of this part of England began in the Jurassic Period, a mere two hundred million years ago - relatively recently, considering the amount of time since the Earth's creation some four and a half thousand million years ago (Fig. 1). The British Isles are made up of rocks representing most of this immense period of time. They have been laid down, layer upon layer, over the millennia, predominantly in the sea, with periodic interruptions due to movements of the Earth's crust caused by processes going on at deeper levels. The oldest rocks are exposed only in northwest Scotland, and generally - because Britain developed a southeastward tilt when the Alps were formed - rocks at the surface become younger towards the southeast of England, (although the older rocks are, of course, still present below, at depth). Glimpses of these ancient rocks can be had locally, where they have been brought up to the surface - usually by up-faulting and/or up-folding to produce what are known in geology as inliers - in the Malvern Hills, the Longmynd in Shropshire, and Charnwood Forest in Leicestershire, for example. These old, hard rocks always form distinctive uplands, quite different from the surrounding farmland. In Wiltshire, however, only the upper portion of the geological column is represented, by

| | | | |
|---|---|---|---|
| SUPERFICIAL DEPOSITS | | Landslip | Great Oolite limestone and rubble overlying Fuller's Earth clays. |
| | | River deposits | Modern, silty alluvium adjacent to rivers. Terrace gravel spreads farther away. Gravels, flinty in chalk areas, limestone elsewhere. |
| | | Clay-with-Flints and plateau flint gravels | Confined to chalk. Sandy and silty clays with variable flint content. |
| TERTIARY ROCKS | | Bracklesham Beds | Sands with variable interbedded clays. |
| | | Bagshot Beds | Sands |
| | | London Clay and Reading Beds | Clay, sandy clay and sand. |
| CRETACEOUS ROCK | | Chalk | Includes rubbly hillslope drift. |
| | | Upper Greensand | Silty sand and sandstone with chert important in south-west. |
| | | Gault Clay | Heavy non-calcareous clay, much obscured by downwash from Chalk and Upper Greensand. |
| | | Lower Greensand | Sands and silty sands, local ironstones. |
| JURASSIC ROCKS | | Wealden Purbeck & Portland Beds | Variable group of silty/sandy clays, limestones, sands and sandstones. Purbeck with more clay. Portland with more limestone. |
| | | Kimmeridge Clay | Heavy calcareous clay. |
| | | Corallian Beds | Very variable group of limestones, sands, sandstones, sandy/silty clay and, locally, ironstones. |
| | | Oxford Clay Kellaways Sand | As for Kimmeridge but northwards from Chippenham includes silty sands near the base (Kellaways Sand). |
| | | Great Oolite Group | Cornbrash (limestone). Forest Marble (middle and upper) calcareous clay with variable sandstones and limestones. Great Oolite and Forest Marble (lower) thick limestones. Fuller's Earth – calcareous clays (see under LANDSLIP). |
| | | Inferior Oolite & Upper Lias | Limestone similar to Great Oolite but thinner. Midford Sands – yellow silty sands; limestones and marls below. |

*Opposite, Fig. 2: Geological Map of Wiltshire (drawn by Gilbert Green from the British Geological Survey maps and reproduced with permission pf the Wiltshire Natural History Forum)*
*Above: Key to Fig. 2.*

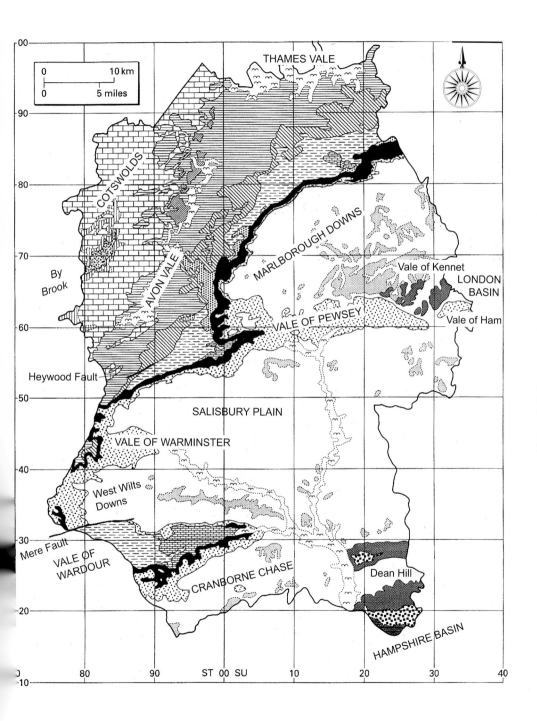

rocks of Jurassic, Cretaceous and Tertiary age (Fig. 2); that is, by representatives of the last two hundred rnillion years of the Earth's history.

It is interesting that it was within and on the western borders of Wiltshire that William Smith (1769-1839), one of the pioneers in the development of the science of geology, made many of his original observations of the rocks he encountered during the course of his work as a surveyor. Smith became experienced in canal construction which was booming at the time, as well as specialising in drainage and irrigation problems. He worked on many projects throughout England and found that he could apply his newly-acquired geological knowledge in selecting the best lines for his canals; for what he had discovered was of great relevance for the maintenance of canal water levels, for the choice of bridge foundations and for maintaining supplies of stone for construction. He was appointed to make a survey of the proposed Somerset Coal Canal which was to link up with the recently constructed Kennet and Avon Canal at Limpley Stoke a few miles east of Bath.

In the course of his work, he noticed that each rock layer had characteristic fossils and surmised that each successive stratum had been the bed of the sea and that the animals preserved therein had lived and died during the time of formation of the rock - a novel concept at the end of the end of the 18th century. He was the first, therefore, to recognise the real significance of fossils as a means of determining the age of the strata in which they occur. After his work on the canal was finished, and despite financial hardship, he produced, in 1799, a "Map of Five Miles Around the City of Bath", one of the oldest of geological maps. He then set about making the first geological map of England and Wales. This was completed in 1815 and was on the scale of five miles to the inch. Its fifteen sheets, when mounted, measured 266cm by 188cm, and were accompanied by a memoir, several geological cross-sections and two volumes describing the characteristic fossils of each formation with reference to the collection of some 500 specimens which he had lodged in the British Museum. In 1831 the Geological Society of London (of which he was not a member) recognised his contribution by awarding him a medal, and acknowledging him as the 'Father of English Geology'.

## Geological principles

In order to appreciate the time scale involved (Fig. 1), and the background to the changing conditions as the rocks of Wiltshire were laid down, consideration must first be given to some basic geological principles, which put into perspective current speculation about climatic change. This has always been happening, albeit very slowly, and all the continents have at some period or another been submerged beneath the sea, especially at their margins, for millions of years. Moreover they have, over time, all moved widely across the globe. But more of

this later. First, let us look at the make-up of the continents. These comprise a variety of rocks of different composition to the ocean floor which lies beyond the continental shelves. Continental rocks are less dense, being richer in lighter minerals like quartz and feldspar, and may be of igneous (i.e. originally molten) or sedimentary origin. I will not dwell here on igneous rocks, as there are none to be found in Wiltshire. Sedimentary rocks - including sandstone, limestone and clay - are the rocks of southern England. They were deposited layer upon layer (or bed upon bed) predominantly in the shallow seas at the margins of the continent. With increasing depth of burial, water was squeezed out and the grains became cemented to form rock. The degree of lithification (i.e. how strongly the individual grains are cemented together) depends on a number of factors. Generally, the older the rock, the harder it is - but not always. The sarsen stones, typically found on the Wiltshire downs, are very hard by virtue of their cement, although they are some of the youngest rocks in Britain.

Rocks exposed on the land surface are broken down by the action of rain, wind, frost and ice. During the course of this weathering and erosion, the individual minerals making up the rock are separated out and may be chemically altered. The most resistant products of this process are quartz (the main constituent of sand), the clay minerals and feldspar (a grey, white or pink mineral found as crystals in igneous rocks and as fragments in some sandstones). These are carried by rivers down to the sea from the land and deposited in estuaries, deltas or beaches as well as offshore, to eventually form new sandstones and clays. The higher the relief, the faster the erosion and the more rapid the sedimentation; so high mountains yield a much faster rate of sediment accumulation in the surrounding seas. But some of this material never actually reaches the sea and may build up on coastal river flood-plains or desert dune areas.

Other sedimentary rocks are of organic origin. Plant material may collect in swampy depressions where, given the right conditions, it may eventually form coal. Limestone is, however, the most common organic rock, and it occurs in super-abundance in Wiltshire. It is composed largely of the calcium carbonate remains of sea creatures and some types of algae. In shallow seas, well lit by sunlight and well aerated by waves, a large population of animals and plants thrived in the past, as indeed they do today. Their shells or skeletons, derived from the calcium carbonate in seawater, provide support and protect them from predators and/or wave action. Limestones are formed when empty shells and skeletal fragments are broken up by waves and carried by currents to quieter areas where they build up into shell banks or lime-muds and shell "sands". Coral reefs may be preserved in place if they become slowly buried by later sediments during a general subsidence of the sea floor. In warm shallow seas

and lagoons with a high concentration of dissolved calcium carbonate, there may also be direct precipitation of calcium carbonate from the water. This process sometimes occurs, with the aid of algae, around tiny nuclei of shell particles. As they roll around in the waves and tides, they become coated with successive layers of calcium carbonate to produce spherical particles (Fig. 3) which look like fish eggs - hence their name "ooliths" (= rock eggs). They can be seen forming today and can be found on beaches in tropical and sub-tropical seas (Fig. 4). The rock formed when they accumulate in large numbers is known as oolite. The Jurassic limestones of western Wiltshire are full of ooliths and broken shell fragments (Fig. 5).

It will be deduced from this description of sedimentary environments that gradations between the different rock types are possible - and, indeed, are commonplace - so that there are sandy limestones, shelly sandstones, calcareous clays (known as marls), or sandstones and muddy limestones. They can alternate with each other and show great variability both laterally and vertically, as can be seen on any sea floor or beach today.

## Fossil preservation

The seas in the past were as rich in living creatures and just as varied as they are today. Organic remains - or fossils - are not, of course, restricted to limestones. They can be also be found in sandstones, mudstones or clays, or wherever conditions were suitable for animals or plants to live and where conditions were such that their remains would be preserved on death. Marine rocks are where the majority of fossils are to be found; an absence of animal fossils is often a strong indication that rocks are non-marine. Remains of land plants are common in the deposits of river, estuary and delta. They are less common in the open sea, where they are commonly destroyed before they can be preserved. The reason for the majority of fossils being marine is two-fold. First, most sedimentary rocks are marine or deltaic in origin. Sediments formed on the land are far less likely to be preserved for long enough to become rocks. The freshwater environment also contains much more specialised and fewer different types of animal than the sea. The probability that land-living creatures will be preserved is very small indeed, because unless their remains are somehow carried into an environment of sediment accumulation, they will probably simply decay and be lost. Hence the marine environment, with its myriad life forms -many with shells - is the most prolific producer of fossils. Even here, only a tiny proportion of that life will actually be fossilised. The rest will decay to produce hydrocarbons which may eventually accumulate in the sediment as oil. Hard parts will be dissolved back into the sea-water and will be recycled as new shells are grown by successive generations.

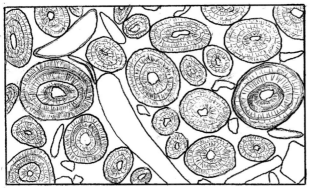

*Left, Fig. 3: Oolitic limestone in cross-section, magnified 25 times.*

*In warm, shallow seas, calcium carbonate is precipitated around sand grains which have become coated with a layer of microscopic algae. Further algal coating of the growing oolith, which is constantly being rolled around the sea floor by waves and currents, results in the build-up of a concentrically layered oolith. Their size is typically around 0.5-1.0 millimetres. Worn shell debris is also present and the spaces between the grains are filled with calcite crystals.*

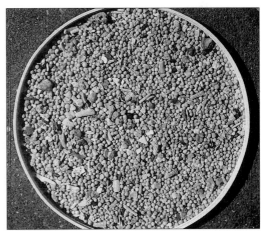

*Right, Fig. 4: Present day oolith and shell "sand" from a beach in Indonesia.*

*Left, Fig. 5: Jurassic limestone made of shell fragments and ooliths.*

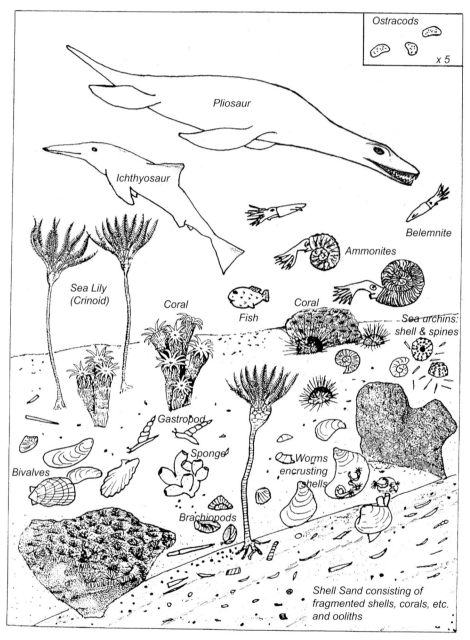

Fig. 6: Life in the Wiltshire's middle-late Jurassic seas (not to scale).

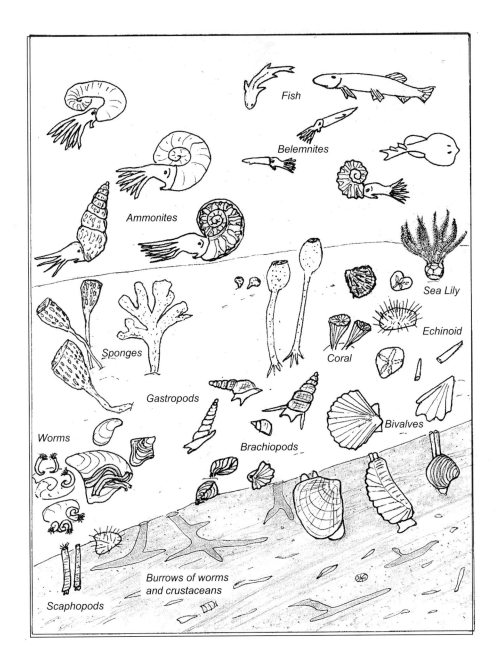

*Fig. 7: Life in the Wiltshire's Cretaceous seas (not to scale).*

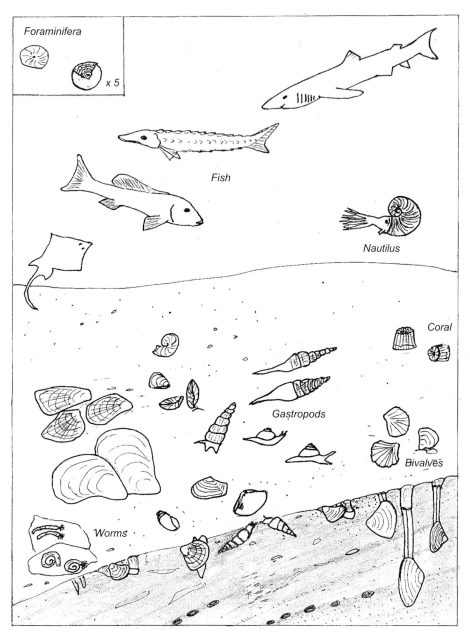

*Fig. 8: Life in the Wiltshire's early Tertiary seas (not to scale).*

Among the commonest fossil types found in Wiltshire are the molluscs: bivalve shellfish (including, for example, oysters), gastropods (snails) and cephalopods (ammonites and belemnites). The similar-looking brachiopods (surviving today as "lamp shells") are also abundant, as are echinoderms (sea-urchins and "sea lilies" or crinoids), corals, sponges, sea-mats (bryozoa) and planktonic micro-fossils. Some vertebrates have been found too, notably fish and marine reptiles, but usually just bits, like vertebrae and teeth, are all that is left. Complete fossils of vertebrates are rare because their bones separate as their bodies decay. Figures 6-8 give a general idea of the variety of marine life in the periods of time represented by the rocks of Wiltshire.

Fossils are absolutely vital to the geologist because the evolution of their forms through time makes it possible to place a rock containing them into the framework of the geological time-scale (described below). One limestone or sandstone can look pretty much like another, so without fossils to give a clue as to their age it would be impossible to make geological maps and come up with any logical history of the sedimentary rocks of the continents. They are one of the fundamental tools of geology, key indicators of both age and depositional environment.

The problem with fossil-collecting is that it can be time-consuming finding specimens sufficiently well-preserved to be identifiable. Micro-fossils of pollen and spores, and tiny planktonic sea creatures with skeletons, like foraminifera (which are generally calcareous) and radiolaria (which are siliceous), are only identifiable after being extracted from rock samples and viewed under a microscope. They can, however, be extremely useful in dating and correlating rocks, because their forms often change rapidly through time and because their small size has made them more likely to be preserved.

## The dynamic Earth: repeated cycles of rock formation and destruction

Basic to an understanding of geological changes throughout the history of the Earth is the concept of plate tectonics and how it relates to ocean-floor spreading, continental drift and mountain building cycles. It is no longer a theory, but now an established fact that the crust of the Earth is not rigidly fixed in position, but consists of a mosaic of separate rigid crustal plates which move over a period of time. Some "plates" include continents; many are just gigantic slabs of ocean floor. The present-day oceans are much simpler in structure and more recent in origin than the continents. They are almost entirely made of basalt lava, a denser rock than those which make up the continents. Being remote from the land, they have only a very thin cover of sediment, except at their margins where continental material may build up. It is thought that the various plates are

carried, as on a conveyor belt, by a process which is probably the result of convection currents in the mantle layer beneath the crust, the mantle being capable of flow under the high pressures and temperatures at that depth. These movements have been measured: the world's oceans are widening at a rate of a few centimetres per year as new basalt lava wells up into the mid-oceanic ridges, solidifies and becomes welded to the oceanic crust on either side. These are the places where rising currents in the mantle reach the rigid crust and split it apart to form a zone of rifting which separates the ocean floor into two "plates". These are then carried along horizontally, away from the ridges, until they converge with other plates. One plate will be carried down beneath the other by descending currents at this point. Where two oceanic crustal plates meet, deep ocean trenches form under the pressure as one plate pushes and sinks beneath the other. Wherever these plates meet and move against each other, volcanoes and earthquakes result from the friction, which causes melting, as is seen in the "Fiery Ring" of the Pacific Ocean today. Island arcs form where two oceanic plates collide. They typically have an ocean trench below their convex margin; if ocean floor is sinking beneath a continent, the volcanoes will develop along the continental margin. This is the situation today along the west coast of the Americas.

It is in these continental margin situations that accumulated land-derived sediments become caught up in the process. The deeper layers which are slowly turning into rocks become deformed and folded or, if they are too brittle, cracked and faulted. They pile up, together with the volcanic rocks which are erupting at the same time from the melting at the plate boundary. Mountain ranges thus rise up near the edge of the continent, like the Rockies and the Andes. If an ocean completely closes up, a tremendous pile of deformed rocks develops. This happened when India hit Asia and when Africa and Europe collided, to form the Himalayas and the Alps respectively. Because these continental rocks are made of relatively light material they are buoyed up on the surface of the Earth. The rigid continental plate can be considered to be "floating" on the upper part of the dense semi-plastic mantle material below. The bigger the pile of deformed rocks making up the mountain range, the higher they will rise up. This uplift results in rapid erosion and the build-up of masses of new sediment on the sea floors surrounding the continent, which will eventually form even more rock. As this process continues, the mountains go on rising until such time as changes in the Earth's interior result in a rearrangement of the mantle convection pattern. Diverging currents beneath continents cause rifts which may eventually start to split continents in two, with the development of a new ocean in between, as is happening in the Dead Sea - Red Sea rift today. Such continental drift separated Africa from South America, and North America from Europe. There have been

many such cycles of ocean formation and mountain building in the past, and the evidence is recorded in the rocks. For example, there are remnants of ancient oceans in Cornwall and the Southern Uplands of Scotland, separated in time by millions of years. The most recent cycle affecting Europe, and which culminated in the Alps, is the one which created the shelf seas in which the rocks of Wiltshire were laid down. This is recycling of rock material on a massive scale.

## The history of Wiltshire's rocks

Geological time is divided up into Eras, which are descriptive terms grouping the rock sequences into units based on fossil populations (Fig. 1). The earliest rocks, formed between 4,500 and 600 million years ago, contain relatively little evidence of life and do not occur in Wiltshire. Those formed in the subsequent Palaeozoic Era, when fossils first began to appear in abundance, are also not represented in the county. We are concerned here with the Mesozoic and Cainozoic eras (i.e. from approximately 245 million years ago to the present). Cainozoic, Mesozoic and Palaeozoic mean modern, intermediate and ancient life respectively. The Cainozoic Era is often divided into the Tertiary and Quaternary sub-eras (Mesozoic being Secondary, and Palaeozoic Primary). Each era is further divided into a number of geological periods distinguished by smaller differences in fossil assemblages. Hence Triassic, Jurassic and Cretaceous periods comprise the Mesozoic Era, while Palaeogene and Neogene make up Tertiary time. Quaternary time is divided into Pleistocene (the Ice Age) and Holocene (or Recent) which is from the end of the Ice Age (10,000 years ago) to the present day.

Each geological period was millions of years long and may include hundreds of metres of sedimentary rocks. The divisions represented by Wiltshire's rocks are indicated on Figure 9, together with their time spans. Their ages in millions of years have been estimated by the stage of decay of radioactive minerals contained in the rocks. Correlation of rocks is by means of diagnostic fossils which can be used to identify zones of time. For this system to work, a zone fossil must be fairly common within its own zone and rare or absent in older and younger zones; (i.e. it must be a short-lived species in terms of geological time). It should also be widespread geographically. Ammonites are very important for correlating and dating the Jurassic and Cretaceous rocks. They were free-swimming molluscs, related to squids and cuttlefish, which ranged over wide areas of sea at that time.

Between each rock unit at whatever level, as much, if not more time, may be represented by the boundary. This is known as an unconformity if there is a gap in the rock sequence. This may result from any combination of earth movements,

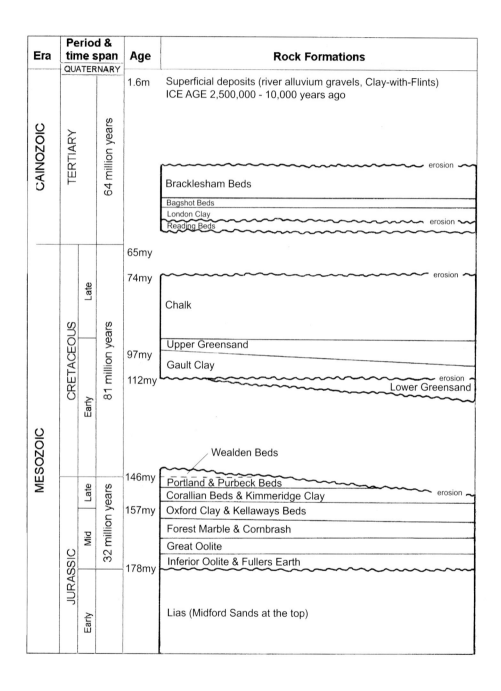

| Era | Period & time span | | Age | Rock Formations |
|---|---|---|---|---|
| CAINOZOIC | TERTIARY | QUATERNARY | 1.6m | Superficial deposits (river alluvium gravels, Clay-with-Flints) ICE AGE 2,500,000 - 10,000 years ago |
| | | 64 million years | | erosion |
| | | | | Bracklesham Beds |
| | | | | Bagshot Beds |
| | | | | London Clay |
| | | | | Reading Beds — erosion |
| MESOZOIC | CRETACEOUS | Late | 65my | |
| | | | 74my | erosion |
| | | | | Chalk |
| | | 81 million years | | Upper Greensand |
| | Early | | 97my | Gault Clay |
| | | | 112my | erosion |
| | | | | Lower Greensand |
| | JURASSIC | Late | | Wealden Beds |
| | | | 146my | Portland & Purbeck Beds |
| | | | | Corallian Beds & Kimmeridge Clay    erosion |
| | Mid | 32 million years | 157my | Oxford Clay & Kellaways Beds |
| | | | | Forest Marble & Cornbrash |
| | | | | Great Oolite |
| | | | | Inferior Oolite & Fullers Earth |
| | | | 178my | |
| | Early | | | Lias (Midford Sands at the top) |

*Fig. 9: Time scale for the rock sequences found in Wiltshire. Rock units are placed within their age range so are not to scale; my = million years*

erosion or non-deposition of sediments. The fact that there is a visible boundary between beds indicates that something changed in the depositional environment - that there was a break in sedimentation; this may have been a few hours, days, years or much longer, depending on the environment.

The Mesozoic Era began in Europe with the hot desert conditions of the Triassic Period. At that time the continent was probably located at lower latitudes. Britain lay at the southern edge of this "European" continent to the north of a now closed-up ocean - the remnants of which form the Mediterranean Sea. Relief was low and continental desert sediments with their typical red and green colour (the result of the iron content) built up on desert plains with playa lakes. Such rocks can be seen, for example, along the banks of the Severn estuary, under the south end of the old Severn road-bridge at Aust.

When these rocks were deposited it is clear that the sea was not far away, because fossiliferous layers appear at higher levels. The appearance of bivalves, and the bones of fish and marine reptiles marks the transition to the Jurassic Period, when there was a marine incursion which persisted and dominated England and Wales for the remainder of Mesozoic time. These were warm, shallow shelf seas, an environment comparable with the sub-tropical seas of today. They were on the southern margin of a continent with low relief. Generally, land-derived sediment was fine clay; sands are less common and the limestones are entirely of marine origin. There was repeated deposition of clay, silt and sometimes sand, then limestone. Warm temperatures are indicated by the fact that reef-corals and giant molluscs thrived, while in Yorkshire there are middle Jurassic plant beds, with abundant ferns whose modern-day relatives cannot tolerate frost. Sediments and fauna together indicate depths of less than 100 metres throughout Jurassic time, a period of 62 million years.

Volcanic activity during the Jurassic Period occurred in the North Sea and the Western Approaches, associated with the opening of the Atlantic Ocean. This was quite possibly the cause of the crustal instability. Fault movements perhaps caused the cyclicity in the sedimentation, with sudden movements deepening the sea periodically and producing an alternation of clays and limestones with variations in the depth and environment of the sea floor. They certainly caused occasional discordances and erosion surfaces between rock formations. In Wiltshire, the rocks laid down during the 33 million years represented here are tabulated in Figure 9. Distinctive groups of rocks have been identified which are named either after a characteristic lithology of after places where they are particularly well developed. The oldest rocks present are limestones, marlstones and clays of the Middle and Upper Lias groups, the latter topped by the Midford Sands, the top of the early Jurassic rock sequence. They are followed by the Inferior Oolite and Great Oolite groups. The Kellaways

Beds and the Oxford Clay are next, then the Corallian Beds, the Kimmeridge Clay, and finally the Portland and Purbeck Beds. The latter are semi-arid, coastal and estuarine deposits.

Late Jurassic uplift resulted in erosion of the uppermost beds listed above. These are missing in many parts of Wiltshire. Such episodes produced unconformities in the rock sequence. They represent a gap in time when anything could have happened between the deposition of the rocks below and above the unconformity. At the end of the Jurassic Period, much of England and Wales became land. There is a transition in southern England through the Purbeck Beds to the non-marine early Cretaceous Wealden Group sediments which have been dated by bivalves and ostracods. They are present at the surface in the Vale of Wardour, but not elsewhere in the county. Renewed subsidence brought a return of the marine environment some 30 million years later. Sediment and faunal distribution suggests that early on the western shore of this sea was not far from the margins of the present sediment outcrop. Overall, however, the later Cretaceous Period had significantly higher sea-levels, perhaps associated with the contemporaneous cessation of the progressive faulting which occurred as the North Atlantic Ocean opened up, with a rift developing across the Greenland/Scandinavian plateau.

It has been estimated that there were up to 300 metres between maximum and minimum sea-levels in Cretaceous time; but this was over a period of 80 million years. These variations may have been the result of sea-floor spreading and related earth movements, although climatic variations were also important. The exceptionally high sea-levels in Late Cretaceous time are thought to be due to the complete absence of polar ice caps. The Lower Greensand was deposited after the sea returned and planed off the top of the Jurassic and earlier Cretaceous rocks, producing the unconformity visible on the geological map (Fig. 1 - described in more detail in Chapter 2). Minor folding followed, causing erosion and another unconformity below the marine Gault Clay and the succeeding Upper Greensand. Conditions then became more stable for 10 million years, with a sea-level rise. This allowed the extensive deposition of the Chalk in shallow seas with minimal land-derived sediment (just a little clay) -in contrast to all the sands and clays laid down below, when the Earth movements initiated erosion on land and deposition of clastic sediments in the sea.

In late Cretaceous time the Atlantic was still opening from the south and there was as yet no connection to the Arctic Ocean. Greenland was still attached to the Norwegian continental shelf. India and Africa were still separated from Eurasia by a continuous sea. Western Europe was about ten degrees nearer the Equator than today. The climate was probably still dominated by the south-westerly wind belt, but with no mixing of polar waters the climate was

considerably warmer. Most of the world's present mountain ranges had not yet been formed (although they were actively growing around the Pacific Ocean) and the stumps of the ancient massifs such as in northwest Britain would have been higher. Sea-water was not locked up in ice, so sea-levels were high and large areas of the continents were beneath the sea. At the end of the Cretaceous period, a pulse of compression from the slow collision of Africa and Europe resulted in uplift and erosion of some of the Chalk, with the formation of some gentle folds.

The end of the Mesozoic Era was a catastrophic time, with the extinction of major groups of fossils - the dinosaurs and the ammonites, for example. But this happened over a very long period; it was not as sudden as we are sometimes led to believe. The meteorite impact, for which there is evidence in the Caribbean, undoubtedly had some effect, as did prolonged volcanic activity, both probably causing reduced sunlight due to dust ejected into the atmosphere. There was, worldwide, outpouring of lava at this time on a massive scale as, for example, during the opening of the Atlantic and as India separated from Antarctica and moved northwards towards Africa. The Cretaceous-Tertiary boundary did not, however, mark the demise of all Mesozoic species, but the beginning of a new burst of evolution in response to changing conditions on a global scale. The ammonites had in fact been on the decline for 30 million years. Many Tertiary bivalves have evolved from Cretaceous forms and the dinosaurs are the ancestors of birds. However, a rapid turnover of many tiny planktonic creatures did occur, more so in oceanic than shelf forms. A combination of major environmental changes, like changing sea-level, prolonged volcanic activity and a catastrophic meteorite impact, would have affected land, shelf and ocean communities. A reduction in the number of species would have left many habitat niches vacant and ready for a new burst of evolution when conditions became more favourable in the succeeding Cainozoic Era.

Tertiary time was a period of regression of the sea from northwest Europe, which was characterised by marginal coastal sedimentation - a mixture of marine and non-marine. There was a 20 million year time gap before any sediment was deposited on the Chalk. The removal of the Chalk's upper fossil zones, more pronounced in the north, suggests a prolonged period of erosion and tilting too. A marine erosion surface has been identified in the earliest Tertiary beds, with the marine iron mineral glauconite, plus rolled and battered, well-rounded flints. All that remains of this period in Wiltshire is a thin sequence of sediments. The basal Reading Beds are estuarine or lagoonal sands and clays. They are followed by the marine London Clay then the Bagshot Beds, which are probably coastal deltaic sands.

Fossils from this time are very similar to present-day forms (Fig. 8) and

temperature-sensitive groups such as corals, molluscs and foraminifera can be identified. Indications are of a world-wide sharp fall in temperature at the end of the Mesozoic Era, followed by a rise during early Tertiary time. Plants suggest warm temperate and even sub-tropical conditions at the time of deposition of the beds listed above.

Around 60 million years ago Hebridean volcanic activity was underway, giving rise also to the basalts of Antrim. All this was related to the continuing opening of the Atlantic Ocean. Volcanic ash even appeared in the Palaeogene rocks of Essex and Kent. The source of the sandy sediments may well have been provided by this tectonic activity. Anyway, the base of the marine London Clay marks a rise in sea level which was widespread.

The ending of Tertiary deposition was due to the uplifting of much of northern Europe, restricting the sea to small areas beyond Wiltshire. Britain lay far from the main zone of Alpine deformation, and only ripples of this upheaval, which culminated 25 million years ago, are recorded in the open folding seen in the anticlines and synclines of Wiltshire. The most obvious result in Britain was the development of the London and Hampshire basins, which preserved the Tertiary rocks lying above the Chalk. Sea-floor spreading in the Atlantic caused profound changes in British geography. There was a strong down-tilting to the east and relative uplift in the west, probably related to the intrusion of granites. These have a low density and would cause the continental crust to to be buoyed up in the mantle layer below. The southeasterly drainage pattern developed on the tilted Tertiary surface. There are major erosion surfaces on the Chalk plateau which date from early Tertiary time, when sea-levels were higher.

Later Tertiary faunas indicate a progressive cooling which culminated in the Quaternary Ice Ages. A fall of ten degrees centigrade has been indicated in north-west Europe since the start of the Tertiary period. It is thought that the Antarctic ice sheet, which has such a great influence on world climates, was in place by late Tertiary time, followed by the Greenland ice cap. The skeletons of deep-ocean foraminifera contain certain oxygen isotopes which are thought to be an index of oceanic temperatures. They show a cyclical fluctuation through Tertiary and Quaternary time which coincides with variations in solar radiation. It is this factor which is now thought to be the driving force behind climatic change, although there will be modifications caused by things like the distribution of land and sea, or the extent of high mountains. It may be significant that the Ice Age followed Tertiary and Quaternary mountain-building on four continents. The emergence of so much high land at once must have had a cooling effect on global climates. Likewise, the last Ice Age may have been triggered by ocean current changes caused by the joining of North and South America, which separated the Pacific and Atlantic oceans at the equator.

The "Ice Age" actually contained around eight cold periods over the last 2.4 million years - six of them probably producing extensive ice in Britain. These were separated by warm periods - some warmer than the present day - which were associated with rises in sea level as the ice retreated. In the last two interglacial periods, sea levels were higher than they are now, resulting in the raised beaches and river terraces that can be observed in many places. The sea-level in the last glaciation was 120-150 metres lower than today and much of the North Sea and English Channel would have been land. Unique floral and faunal assemblages allow correlation and give an indication of temperatures and vegetation. Dating of the last 40,000 years can be done using carbon isotopes. A known proportion of carbon is radioactive. It is naturally present everywhere, and is taken up by living things. If their remains are preserved, the carbon breaks down to the more stable form at a measurable rate. Thus the proportion of the two types of carbon gives a measure of the time since the carbon was trapped in the fossil remains. The first true glacial climate occurred in late Tertiary time, around 2.5 million years ago. The last had its greatest extent 20,000 years ago. The present "interglacial" (i.e. the current warm period), started 10,000 years ago. At that time, sea-levels were rising and the open tundra became colonised by trees: first birch, then pine, followed by hazel, elm, oak and alder as the climate ameliorated and soils developed. This process has been documented by studies of pollen grains. It is interesting that there was a sharp decline in tree pollens and an increase in the pollen of weeds 5,000 years ago, which marks the time of active tree-clearance by Neolithic Man. Since then, the vegetation of England and Wales has been dominated by human activities.

## Wiltshire's geological structure - how this governs the surface rocks

The present-day pattern of rock outcrops shown on the geological map (Fig. 2) reflects the structure of the rocks. Originally laid down more or less horizontally, they now generally have a gentle overall dip to the southeast, as shown in Figure 10. This tilting of the accumulated pile of sediments, which were simultaneously in the process of turning to rock, occurred during the Tertiary collision of Africa and Europe that created the Alps. During and after these crustal movements, which were by no means sudden, weathering and erosion by running water and, at times, ice, planed off the surface of the newly emerging land to reveal deeper levels of rock strata. This is demonstrated in the section across Wiltshire (Fig. 10), which crosses all the main groups of rocks. Beneath all these is a basement of older rocks formed during the preceeding cycle of sedimentation which was ended by, or rather culminated in, the mountain-building episode at

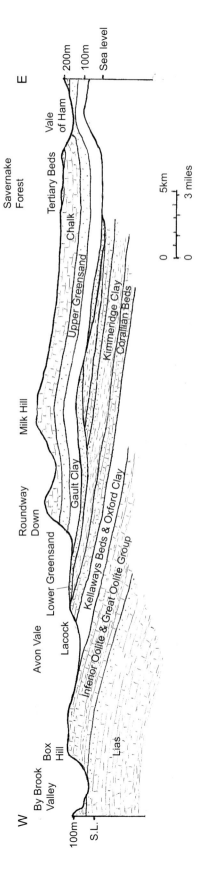

Fig. 10: Section across Wiltshire showing the geology, from the By Brook valley near Box to the Vale of Ham on the Berkshire border.

the end of the Palaeozoic Era. This affected a broad belt from southern Ireland, through south Wales, southern England and on to Brittany, the Massif Central of France and the Harz Mountains of Germany (from which the name of the episode -Hercynian- comes). Major lines of weakness dating from this time have been recognised in the deeper crust along the vales of Pewsey and Wardour (below the Mesozoic cover), and it is thought that they governed later structures, subsequent movement tending to occur along the earlier fractures.

Because of the general southeastward tilt, the oldest rocks crop out in a northeast-southwest band in the northwest of the county. The youngest rocks (of Tertiary age) appear in the southeast. The gently dipping layers have, in certain areas, had a series of smaller-scale, more local, east-west trending folds superimposed on them: arches (anticlines), connected by shallow troughs (synclines). The upfolds typically have steep northward-dipping limbs and gentle southward-dipping limbs. Three parallel anticlines are to be found along the vales of Pewsey, Warminster and Wardour (Fig. 2), with a fourth further south through Cranborne Chase, traceable from Berwick St John through Bowerchalke to Dean Hill (Fig. 132). Two of these upfolds can be traced as axes of uplift further afield. The northern one runs from the Mendip Hills, through the Vale of Pewsey and eastwards into the Hog's Back in Surrey. Similarly, the Vale of Wardour anticline can be traced westwards into Devon.

It was always assumed until fairly recently that the folds of Wiltshire were the result of compression during the formation of the Alps, as Africa pushed north against Europe. However, seismic reflection studies of the crust in this area have now revealed much older rift valley systems with deep-seated east-west boundary faults, which affected Mesozoic and Tertiary sedimentation and controlled the position and allignment of the folds and faults visible at the surface. One of these faults is hidden beneath the Vale of Pewsey and only shows itself in the Jurassic rocks northeast of Westbury, where it is known as the Heywood Fault (Fig. 2). The other is the Mere Fault on the edge of the Vale of Wardour, where the fault has broken through the Mesozoic cover over a distance of seven miles. This faulting was mostly of a tensional nature, probably associated with the opening of the North Atlantic. It continued through Mesozoic time, causing accumulating Jurassic and Cretaceous sediments to drape over the fault scarps. Boreholes have shown that Jurassic sediments are considerably thicker to the south of these lines. This suggests that movement must have occurred along the fault scarp  throughout deposition, allowing more sediment to accumulate on their southern sides; movement at that time was down to the south (opposite to the most recent direction), and was a response to tension and stretching of the crust by slippage down the fault plane (known as 'normal' faulting). The total amount of downward movement during Mesozoic time was 170 - 450 metres

on the Mere Fault and 220 - 380 metres beneath the Vale of Pewsey. Maximum southerly downthrow was probably attained during Cretaceous time.

The compression in the Tertiary Period, originating in the Alpine region, eventually pushed the rocks northward, producing the folds with steeper northern limbs along the earlier lines of weakness. This compression reversed the direction of movement on the older faults. The Mere Fault now raises late Jurassic limestones and clays by a hundred metres or more to the level of the late Cretaceous Upper Greensand and Chalk. This compressional fault movement is known as reverse faulting.

In addition, the tensional stresses brought about by these crustal movements caused the rocks to be fractured by an extensive system of minor faults and joints (regularly arranged sets of cracks). There are two general directions, either northeast-southwest or northwest-southeast. The faults are usually less than six miles long; there was some movement between the rock on either side, though no more than a few metres usually. The slight offset of the axes of the Dean Hill anticline and the Bowerchalke anticline is possibly due to an underlying northwest-southeast fault along the line of the Avon valley south of Salisbury (Fig. 132).

Vertical movement alters the rock outcrop pattern, sometimes cutting out beds, sometimes repeating them. With folding, younger rocks are preserved in the down-folds or basins, while older rocks are exposed by erosion in the crests of the upfolds (Figs. 133 & 140). This explains the preservation of Tertiary deposits only on the borders of Wiltshire on the edges of the two major Tertiary basins of Britain: the London Basin and the Hampshire Basin. At Savernake in the east, the Vale of Kennet syncline runs into the London Basin, while southeast of Salisbury, the Alderbury syncline is partially separated by an upfold (the Dean Hill anticline) from the main Hampshire Basin (Fig. 133).

Beneath the Tertiary sediments lies the Chalk, making up about two thirds of the county and forming undulating downlands rising to heights of almost 300 metres. The Chalk has been deeply cut into by river valleys to reveal successively older, deeper levels of rock westward. The rivers tend to carve their valleys along lines of geological weakness, where rocks are softer and more easily eroded. The weakness may be due either to original rock type, such as clay, or to rocks fracturing during earth movements. Hence the crests of upfolds tend to be stretched and loosened as a result of tension, and are commonly eroded away as the land surface is planed off with time, rather than simply forming higher ground as might be expected. The Vale of Wardour and the Vale of Pewsey anticlines form two obvious inroads into the Chalk outcrop. The Vale of Warminster is on another upfold, less pronounced though similar. These parallel folds have had a major impact on the Chalk's outcrop pattern. The edges of the Chalk often form steep scarps overlooking the older rocks of the vales below,

because chalk is porous and does not suffer erosion from surface water running over it.

At the foot of the Chalk escarpments, the older (early Cretaceous) sands and clays appear. The sandstones of the Upper Greensand also form appreciable ridges and scarps, especially south of Warminster, owing to extensive development of chert beds in the upper part.

Beneath the edge of the Cretaceous rocks, to the west, is the belt of Jurassic clays and limestones. There is a thick clay layer cutting right across Wiltshire, made up of the Oxford Clay and the underlying Kellaways Beds, which here are full of clay. The Bristol River Avon, flowing down from the Cotswolds west of Malmesbury, has picked out this clay to form a wide valley bordered in the southeast by the low escarpments of the overlying Corallian sand and limestone beds. In the north of Wiltshire, to the north of Swindon, the clay vale is occupied by the Thames and its tributaries. There is a low watershed between the Thames and the Avon. The western boundary of these valleys is formed by the rise of the Middle Jurassic limestones at the southern end of the Cotswold Hills, which extend into the northwest of the county. They also suffered minor tilts and flexures, although they rarely dip at more than three degrees. These middle Jurassic limestones produce a prominent west-facing scarp in Gloucestershire along the Severn valley. The dip slope to the east-south-east creates an undulating plateau as the land falls gently eastwards towards the clay vale.

# 2: The Rock Sequence

## The Jurassic limestones of northwestern Wiltshire (the Southern Cotswolds)

Just east of Bath, spanning Wiltshire's western boundary are early Jurassic (or Lias) rocks, the oldest rocks of the county. Above them are the three middle Jurassic limestones, separated by clays, which form the southern end of the Cotswold Hills (Figs. 2 & 9). Their sequence is as follows:

Cornbrash (up to 15 m. limestone)
Forest Marble (20-40 m. clays & limestones)
Great Oolite (up to 35 m. limestone)
Fullers Earth (35 m. clay with limestone)
Inferior Oolite (5-15 m. limestone)
——unconformity——
Upper Lias (up to 30 m. mostly sandstone)
Middle Lias (upper part limestone, marl & clay)

There was a period of folding and erosion between the Upper Lias Group and the Inferior Oolite, i.e. there is an unconformity between them. In Wiltshire, only the upper part of the latter formation is present. The four formations above the Inferior Oolite: the Fullers Earth, the Great Oolite, the Forest Marble and the Cornbrash, are often collectively referred to as the Great Oolite Group, named after the dominating thick limestone.

The limestones, laid down in warm shallow shelf seas, are more or less horizontal producing an undulating plateau landscape stretching from Malmesbury, beyond Bradford-on-Avon and Bath, to Frome (in Somerset). Deep valleys dissect it, cut by tributaries of the River Avon such as the By Brook. The top of the plateau is made of Great Oolite and Forest Marble, the Cornbrash generally appearing eastwards on the dip slope until it disappears under the Kellaways and Oxford Clays. The latter run from the Thames valley at Ashton Keynes in the north of the county, southwestwards through Chippenham, Melksham and Trowbridge.

### THE MIDDLE LIAS GROUP

The top of this generally upward-coarsening sequence, consisting of silty mudstones, siltstones, fine sandstones and sporadic ferruginous shelly

limestones, is found in Wiltshire only at the bottom of the Avon valley at Limpley Stoke. Here there are nine metres of sandy, shelly, oolitic, iron-rich limestones and marlstones with clays. Ironstone nodules are common, the oxides weathering to a brown colour, with a concentric laminar structure. Fossils are abundant -ammonites, belemnites, bivalves and brachiopods. The sequence was laid down in shallow water.

## THE UPPER LIAS GROUP (MAINLY THE MIDFORD SANDS)

The first metre of the Upper Lias deposits is limestone, with some bands of marl and clay. Above are the Midford Sands; they appear at the bottom of the valleys of the River Avon (east of its confluence with the River Frome), and its tributaries the Midford Brook and the By Brook (where the outcrop extends a mile or two north of Box). Named after a village south of Bath, they form the top of the Early Jurassic Upper Lias Group in this area. However, as landslips and river alluvium cover the outcrop there is nothing to be seen of these sands, except half-a-mile north-east of Midford just west of the Wiltshire border, around Tucking Mill (G.R. 766 616), where William Smith lived for a time (see Chapter 1). The sands are about 30 metres thick in this area, but they are a localised deposit and only nine miles to the southeast their equivalent has been identified in a borehole at Westbury, where they consist of 15 metres of muddy sands and dark sandy clay.

## THE INFERIOR OOLITE

The Inferior Oolite limestone is only 5-15 metres thick in this area (in contrast to 100 metres around Cheltenham to the north, where it is much more prominent and the Cotswolds are 300 metres, rather than 200 metres in height). It gives rise to a step in the side of the By Brook valley around Box (G.R. 820 695; see Chapter 4), overshadowed by the more massive Great Oolite above, forming the top of the valley sides. As mentioned above, the lower parts of the Inferior Oolite are missing in Wiltshire, upper levels resting directly on the Upper Lias sands, a period of crustal movements and widespread erosion having intervened before the return of shallow seas. Exposures are rare because the formation is commonly covered by the overlying Fullers Earth clays which have slumped down the hillsides.

The formation, in Wiltshire, is mainly a rubbly, shelly oolitic limestone with some purer oolite bands. It is mostly made up of broken-up chunks of limestone and shell debris, derived from brachiopods, bivalves, corals, sea urchins and, rarely, ammonites, often rolled around and worn-looking. These may also be encrusted with epifauna, like the calcium cabonate tubes which are the homes of marine worms, an indication of time spent lying about on the sea floor. Bored

surfaces, covered with oysters and iron oxide, indicate long periods when there was no sediment build-up. This is evidence of the fine balance between erosion and deposition, where the balance has only just tipped in favour of deposition. The matrix of the rubble is fine-grained.

## THE FULLERS EARTH

The Fullers Earth, a clay about 35 metres thick, is so named because of its use in the fulling process of the woollen industry, whereby cloth was cleansed of oil and thickened. The true Fullers Earth is from the two-metre thick Fullers Earth Bed and has many additional uses nowadays, for example in the refining of fats, oils and sugar, where it is used as a filtering material, absorbing impurities. It is also used as a bonding agent for foundry sands. Certain clay minerals present in the Fullers Earth Bed are responsible for the special adsorbtive properties. Their tiny crystals have a very large surface area, which can be further increased by treatment with acid, enhancing their adsorbtive powers. Fullers Earth was at one time mined only in England: in Surrey, Bedfordshire and Kent, as well as Bath (where the mine closed in the 1980s), and was considered of great value.

The sequence consists of 10 metres of clay containing an oyster bed, followed by a rubbly white limestone with a rich brachiopod fauna, known as the Fullers Earth Rock and about 3 metres thick; then there are a further 23 metres of monotonous clay, with thin bands of marly limestone, containing the Fullers Earth Bed near the top. This is now known to be reworked volcanic ash. The poor-grade clays lower down might be partially volcanic. They are frequently the cause of land-slips where water seeps through the overlying limestones until it reaches the clays, which then become soft, wet and slippery. Undermining by the water causes blocks of limestone to tumble down the hillsides. This largely obscures the outcrop and that of the Inferior Oolite below. These beds are only occasionally exposed (e.g. at the entrance into an old stone mine tunnel at Murhill (Fig. 11; see Chapter 4).

## THE GREAT OOLITE

The Great Oolite is a limestone sequence, about 30 metres thick, containing the important building stones used extensively in the area, notably at Bath. It is the lack of large fossils (broken shells are common) and the even granular texture in the thickly bedded oolites which gives them their valuable "freestone" properties (see Chapter 3). There are four subdivisions, each topped by a hardened, bored, often oyster-encrusted surface, representing a time gap with a break in sedimentation when bottom-dwelling sea creatures made their mark on the already partially cemented rock. The two freestone levels are separated by rubbly, more thinly bedded and variable limestones.

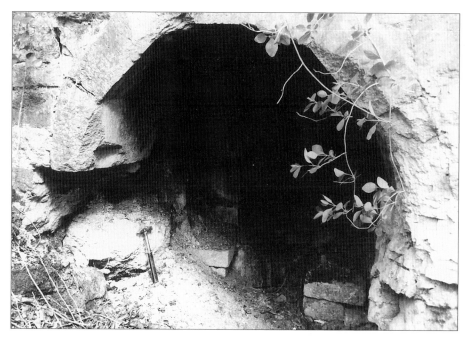

*Fig. 11: A rare exposure of clays and limestones of the Fullers Earth, in the bottom of an abandoned stone quarry at Murhill.*

At the base of the formation is the lowermost building stone (the Combe Down Oolite), a cross-bedded and shelly oolite. It has beds over two metres thick, some full of burrows. The top surface has been planed off and bored by molluscs and other marine animals; oyster encrustations are common. Above are more variable types of limestone (collectively known as the Twinhoe Beds). They may be massive, marly, shelly limestones with large orange ooliths, or else rubbly, iron-impregnated, fossiliferous limestones with a fine matrix and patches of recrystallised calcite crystals. A third variety is shell-detritus limestone which has no ooliths. Above, six metres of thick, pure, uniform oolitic freestone follow (the Bath Oolite). The bored top surface is sharply overlain by shelly, marly and oolitic limestones which have patches of coral reef, with associated deposits of detrital limestone (the Upper Rags). Cavities have weathered out containing fine ochreous material and there is much recrystallised calcite (Fig. 12). There are lots of more intact fossils -snails, bivalves, sponges, sea lilies, sea mats (bryozoans), brachiopods- representing the other reef-dwellers.

Colours range from white to cream or grey, often weathering to a yellow-brown; this colouration is due to the oxidation of tiny crystals of iron sulphide (also present in Fig. 12), which are scattered throughout the rock. Cross-bedding,

at an angle to the main beds, is common throughout, an indication of currents which built up banks of shell debris and ooliths on the shallow sea floor.

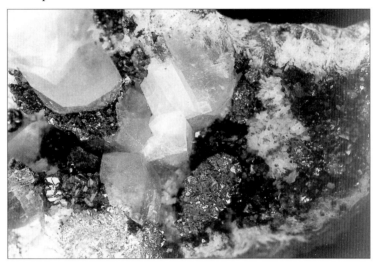

*Fig. 12: Crystals of calcite (white) and pyrite ('fool's gold', iron sulphide) in a cavity in Jurassic limestone.*
*Photograph by Neville Hollingworth, Natural Environment Research Council.*

South of Farleigh Hungerford in Somerset, just a few miles west of Trowbridge, the Great Oolite limestones disappear over a distance of a mile or two, being replaced laterally by clays southwards (the Frome Clay). This must mark the edge of the shelf (perhaps a fault scarp). It is probably no coincidence that this point where the limestones peter out is on the same structural line as the Vale of Pewsey fault, a major structure with a southward downthrow, active throughout Mesozoic time (see Chapter 1). A fault scarp beneath the sea would result in a sudden change in water depth; shelly and oolitic limestones accumulate in shallow waters.

### THE FOREST MARBLE

The base of the Forest Marble is defined by the appearance of clay beds. The basal clay is of variable thickness and may be absent altogether. Around Bradford-on-Avon, the Bradford Clay is famous because this influx of clay over the Great Oolite limestones entombed and preserved a bed of pear-shaped sea lilies (a particular type of crinoid called *Apiocrinus*) in their position of growth on the top of the (Great Oolite) limestone below. The clay is no longer visible at Bradford-on-Avon, where it is 3 metres thick. At Brown's Folly, a few miles to the west, it is only centimetres thick, but it is actually visible and the brown clay

contains dismembered bits of sea lily and brachiopods. The fauna of brachiopods, bivalves and the sea lily is distinctive and is also found in limestones where the clay is not present, so it can be used to correlate and define the base of the Forest Marble Formation.

The rest of the formation, 20-40 metres thick, consists of variable clays, clayey limestones and shelly, sandy and oolitic limestones with current bedding. The limestones became famous in the Forest of Wychwood in Oxfordshire, where they were quarried for building; when polished they look like marble, hence their name. They represent shell banks built up by currents on a muddy sea floor. The shells are largely bivalves (Fig. 13); they may be broken or whole and there may also be ooliths present. Locally, sands replace the limestones near the top. They can be most completely viewed a mile or two north of Sherston at Knockdown Quarry (G.R. 844 876). It is still worked, but destined to become a landfill site. They were used for farm buldings and for walling because they split easily along the shell bands. Thinly bedded Forest Marble limestones have provided frost-resistant roofing 'slates' (e.g. from Gastard, near Corsham). These are relatively thick and of poor quality compared with bands lower in the sequence in the Gloucestershire Cotswolds.

The variable range of rock types represent a shallow, near-shore environment.

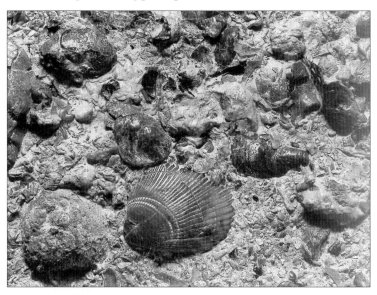

*Fig. 13: A bedding surface of shelly limestone from Corston, typical of the Forest Marble.*
*Photograph by Neville Hollingworth, Natural Environment Research Council.*

## THE CORNBRASH

The Cornbrash at the top of the middle Jurassic sequence is so named because of the 'brashy' or stony soil it produces. This contains small fragments of yellowish weathered limestone, and is suitable for growing cereals (as the stones provide shelter for the germinating seedlings). It is a roughly-bedded yellow-weathering, rubbly fossiliferous limestone, only 3-6 metres thick in places. There are irregular partings of rubbly marl, sands and clays interbedded with the limestones. The limestones contain fine shell debris and there are usually no ooliths. The fossils are a mixture of brachiopods and sea urchins (Fig. 14), bivalves and ammonites. At the top are 30 centimetres of reddish marl with shell fragments and yellowish sandy limestone. Near Malmesbury the limestones are over 15 metres thick and have been much worked for building stone, although this is of poor quality, most suitable for walling. It can best be seen at Lower Stanton St. Quintin (G.R. 921 806), where flattish dip-slope topography is well developed. Its outcrop usually forms a plateau of higher ground as it lies between softer clays. The limestones are often water-bearing and underlain by clays, giving rise to spring-line villages.

*Fig. 14: Fossil brachiopods and sea urchins found in ploughed fields over the Cornbrash in northwest Wiltshire.*
*Photograph by Neville Hollingworth, Natural Environment Research Council.*

## The late Jurassic clay vales of the Avon and Thames and their south-eastern borders

There is an abrupt change above the Cornbrash, from limestone to clays, as we pass up from the sequence of alternating clays and limestones into the much thicker clays forming the broad vale of northwestern Wiltshire, below the gentle dip slope of the Cotswolds. The Kellaways Beds and the Oxford Clay have been grouped together on some geological maps, as it is not always possible to distinguish between them in the field. There is a total absence of exposure except where excavation is in progress for the purpose of house-building and road construction. It is their faunas, changing upwards with time, which define them. They are overlain by the Corallian limestones, sands and clays which form the southeastern edge of the vales. The Corallian Beds are overlain by the Kimmeridge Clay, in turn succeeded in a few places by Portland, Purbeck and Wealden beds. In north Wiltshire, there is a complication, in that above the highest limestone of the Corallian Beds, are some 20 metres of clay with the same (Oxfordian) aged fossils as the Corallian Beds (named the Ampthill Clay). On the present geological map this clay is included in the overlying Kimmeridge Clay (strictly of a younger, Kimmeridgian, age) because, unless fossils are found, it is impossible to make a distinction when mapping them (especially where outcrops are lacking). The sequence is summarised below:

Cretaceous formations
—unconformity—
Wealden Beds (up to 9m. sand & clay)
Purbeck Beds (up to 25 m. limestone, sand & clay)
Portland Beds (33 m. limestone & sandstone)
Kimmeridge Clay (up to 305 m. clay)
Corallian Beds (60 m. limestone, sand & clay)
Oxford Clay (100-183 m. clay)
Kellaways Beds (20-30 m. clay & sandstone)
- - - - - - - - - - - - -
Cornbrash

### THE KELLAWAYS AND OXFORD CLAYS

The clays of Wiltshire's Avon and Thames valleys, which separate the Cotswold region from the Chalk downlands, actually form a low-lying continuous vale stretching northeastwards past Oxford to Lincolnshire. The Kellaways Beds, at the base of the sequence overlying the Cornbrash limestones, are 20-30 metres thick and are named after the village in the Avon valley, northeast of Chippenham. As a result, this village has the honour of having its name (in

Latin) used for the international Jurassic time division, the Callovian Stage, recognised by a particular assemblage of ammonite fossils (Fig. 15). The overlying and much thicker (100-183 m) Oxford Clay gives its name to the subsequent Oxfordian Stage.

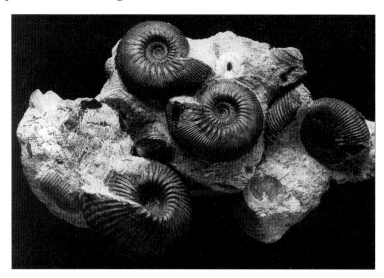

*Fig. 15: Ammonites (Keplerites trichophorus and Cadoceras sublaeve) from the Kellaways Beds.*
*Photograph by Neville Hollingworth, Natural Environment Research Council.*

The Kellaways and Oxford clays are dark grey, bluish or greenish in colour, weathering to brown. They have produced an undulating landscape with heavy brown soils. Some gypsum (calcium sulphate) crystals have been found in the clay, together with calcareous concretions or nodules which formed around decaying animals, producing chemical changes in the surrounding mud. Around and north of Kellaways (G.R. 950 755), beds of hard calcareous sandstone up to 4 metres in thickness appear at the top of the Kellaways Clay, known as the Kellaways Rock (together comprising the Kellaways Beds). The Kellaways Rock has been used for local buildings.

Ammonites, belemnites and bivave shells occur throughout, as well as reptile and fish remains and wood fragments. The environment would have been that of a deeper shelf sea, away from strong currents, where clay deposits could slowly build up.

After it leaves the Cotswolds, the River Thames follows the northern part of the outcrop in Wiltshire, continuing to Oxford, while the River Avon has cut a broad valley further south, containing the towns of Chippenham, Melksham

and Trowbridge. Southwest of Trowbridge the clay passes into Somerset.

The combination of high carbon and low sulphur content, in the lower part of the formation, make it a good brick-clay. The brickworks have now all closed, however, superceded by the huge Bedfordshire workings.

## THE CORALLIAN BEDS

This formation, up to 60 metres thick, is named after the corals it contains. Lithologies are variable, consisting of shelly, oolitic and coral limestones separated by shelly sands, marls and clays. There is commonly a lateral passage from sands to clays to limestones. They represent the varied environments of a shallow shelf in warm seas, following on from the previously deeper water, quieter clay environments. Corals can be found lying around in the fields of Steeple Ashton, where there were patch reefs; other fossils include large gastropods (snails), bivalves, sea urchins and ammonites. The outcrop stretches northeastwards from below Salisbury Plain's Chalk escarpment at Westbury, to form the east side of the Avon valley. Beyond Calne and past Swindon to Highworth, it borders the Thames valley. It forms a broad tilted shelf with a well-developed escarpment facing the clay vales of the Thames and Avon. The gentle dip slope to the south or southeast sinks below the Kimmeridge Clay or the unconformity at the base of the Cretaceous rocks dominated by the higher Chalk escarpments.

The lower beds, known as the Lower Calcareous Grit, contain around 20 metres of soft sands, locally cemented into hard "doggers" of calcareous sandstone, marls and clays. The beds are lenticular, and so vary laterally. They are noted for their fossils, particularly ammonites, and highest levels contain hard, shelly limestones, a blue-grey colour when unweathered. Near Melksham the Lower Calcareous Grit provided builders' sand (east of Sandridge Park G.R. 939 647). At Seend Cleeve (G.R. 934 609) this same formation was worked for stone. There may be a marly clay above; it is 9 metres thick at Highworth. Next, there are coral and oolitic limestones, known as the Coral Rag. It is these that are responsible for the low but fairly steep scarp which can easily be observed from West Ashton (east of Trowbridge), to Bowden Hill and Derry Hill, then Calne, Lyneham and Wootton Bassett. At the base is an oolite over 3 metres thick. The shelly, oolitic Calne Freestone has been locally quarried for building stone, and other limestones of the Coral Rag have been used for building in Wootton Bassett, Purton and Highworth as well as the smaller villages on the outcrop. The limestones are succeeded in places by around six metres of clays, then calcareous sands of the Upper Calcareous Grit. Around Highworth and Wootton Bassett, 1-2 metres of the upper sands are impregnated with iron oxide and form a plateau. Their lateral equivalent at the top of the sequence northwest of Westbury

is a rusty-looking orange and dark red oolitic ironstone three or four metres thick, containing an abundance of oyster-type bivalves, which was, until 1925, extracted from pits around the station for its iron (Fig. 106; see Chapter 4).

## THE KIMMERIDGE CLAY

A change in conditions, probably a deepening of the sea, resulted in a return to clay deposition and the accumulation of up to 305 metres of dark, sometimes shelly, clays which now form flattish areas of land below the long Cretaceous escarpments of Salisbury Plain and the Marlborough Downs. These clay areas are often used as pasture because of their water-logged soils. The impermeable nature of the Kimmeridge Clay allows it to gather the tributaries of the River Nadder and the Semington Brook, where springs appear from the base of the overlying Portland limestones or Cretaceous Greensands. It crops out in three areas, separated by areas where erosion obliterated these clays before Cretaceous time. They are found beneath the Portland Beds around Swindon, south of Devizes at the entrance to the Vale of Pewsey, and at the west end of the Vale of Wardour. At the foot of the Marlborough Downs and below Salisbury Plain at Westbury, the top of the Kimmeridge Clay has been removed by early Cretaceous erosion. South of Westbury it has not survived and older Jurassic rocks (Corallian Beds and Oxford Clay) are overlain directly by Cretaceous Lower Greensand or, commonly, Gault Clay.

*Fig. 16: Pliosaur skull in the Kimmeridge Clay pit at Westbury cement works.*
*Photograph by David Beatty, Blue Circle Industries.*

Fossils are common, including remains of reptiles and fish as well as the more usual ammonites, belemnites, bivalves and brachiopods. Exposure, however, is rare. A very large clay pit belonging to the Blue Circle cement works at Westbury, next to the chimney, has yielded two 'sea dragons' (pliosaurs) in recent years (Fig. 16), now housed in Bristol Museum.

## THE PORTLAND AND PURBECK BEDS

These beds, up to 58 metres thick, at the top of the Jurassic sequence have three small outcrops in Wiltshire (Fig. 2). Elsewhere, they have been removed by pre-Cretaceous erosion. The smallest is at Swindon, where a small pre-Cretaceous downfold preserves both the Portland and Purbeck beds, lying conformably on top of the Kimmeridge Clay on the hill of Old Swindon, which rises above the clay on which New Swindon and the railway are located; there are two even smaller patches just to the southeast, partially covered by Cretaceous Lower Greensand (Fig. 78). The second outcrop, immediately south of Potterne, is in the centre of the Vale of Pewsey anticline, where only the sands at the base of the Portland Beds are preserved between the Kimmeridge Clay and one or other of the Cretaceous erosion surfaces (there are two of these, one below the Lower Greensand, the next below the Gault Clay). The A360 road crosses the core of the anticline at Heron Bridge (G. R. 995 567). The third exposure, and by far the thickest and most important, is in southern Wiltshire, in the Vale of Wardour anticline.

The Portland Beds consist of sandstones and limestones, about 33 metres thick in the Vale of Wardour. The limestones are well-known as building stones. The Portland Stone (from the Isle of Portland in Dorset) was used for St. Paul's Cathedral, while the Chilmark Stone from the Vale of Wardour was used for Salisbury Cathedral, where it is still being used in restoration work. There was a gradual appearance of sands, sandstones and marly beds above the Kimmeridge Clay, perhaps the result of a shallowing of the sea, or a shift in sediment transport patterns, causing the accumulation of 4 metres of brown or greenish sands and clays. Later, sediment supply ceased, and about 23 metres of limestones built up on top, shelly and sandy at first, then very fine, with black coral-bearing chert bands. The Upper Building Stones at the top of the sequence are 6 metres of pale, fine-grained limestones. At Swindon, about 3 metres of limestones, some fine and white, others pinkish and shelly, are overlain by 2-4 metres of orange sand and sandstone. Fossils include corals, bivalves, brachiopods, gastropods (snails), worm tubes and huge ammonites (Fig. 96), together with occasional reptile and fish remains.

The Purbeck Beds represent a change to coastal deposits, well exposed in the Isle of Purbeck (Dorset), marking the retreat of the sea. In Wiltshire, these

youngest Jurassic beds are only found above the Portland limestones at Swindon and in the Vale of Wardour. There are up to 25 metres of sands and freshwater marls, clays and shales which are lagoonal deposits, alternating with marine limestones. The limestones are sometimes packed with shells (noteably oysters); others are oolitic. There are fresh-water travertine limestones too. The original presence in some beds of rock-salt crystals (subsequently replaced), and gypsum indicates that the climate was semi-arid. The rocks are richly fossiliferous. As well as fresh-water and marine bivalves (which prove the alternation of marine and fresh-water deposits), gastropods, sea urchins, worms, insects, fish and reptile remains (including dinosaurs, crocodiles and turtles) have been found. Importantly, the beds also contain crustaceans, particularly ostracods -small (1-20 mm) bean-shaped crustaceans (Fig. 6) which live in all types of aquatic habitat, and which are especially useful for dating and correlating fresh and brackish water deposits that lack the usual fossils. The ostracods demonstrate that all three divisions recognised in Dorset are present here, but the rocks are reduced in thickness (i.e. the same period of time is represented). Carbonaceous shales contain the silicified remains of cycads and conifers (at Chilmark, an upright tree stump 1.8 metres tall has been found).

### THE WEALDEN BEDS

The Purbeck Beds pass gradually up into interbedded sands and white and grey mottled clays up to 9 metres thick, representing a river delta that built out over the region. They contain distinctive wood fragments, the only fossils. The reason for separating them off is that their age is earliest Cretaceous, belonging to the stage known as Wealden. In other words, the coastal, lagoonal and non-marine deposits in the Vale of Wardour continue without a break from the Jurassic to the Cretaceous Period. In reality there is very little to be seen as they are no longer exposed; they reach the surface in the Nadder valley around Dinton, lying above the Purbeck limestones and marls, and beneath the Lower Greensand. The top of the sequence has been removed by pre-Lower Greensand erosion.

## The mid-Cretaceous sands and clay beneath the Chalk

There are three Cretaceous rock formations lying under the Chalk, from top to bottom:

The Chalk (up to 336m.)

- - - - - - - - - - - - - - - - -

The Upper Greensand (15-70 m. sandstone)

The Gault Clay (10-27 m. clay)

———— unconformity ————

The Lower Greensand (0-15 m. sand)

———— unconformity ————

Jurassic formations

### THE LOWER GREENSAND

These deposits mark the return of the sea after a 30 million year gap. During this interval, north-south compression resulted in gentle east-west trending folds and some faulting in the Jurassic rocks, which were subsequently truncated by erosion to produce the unconformity which can be seen on the geological map and section (Figs. 2 & 10). The sea advanced from the south over southern England. The map shows the Cretaceous rocks resting on Jurassic rocks ranging from Portland sands to Kimmeridge Clay. Looking at the outcrop pattern in more detail, north of the Vale of Wardour the Lower Greensand lies first on the Kimmeridge Clay, then on the Corallian Beds. Likewise, south of Swindon it covers both Portland & Purbeck beds as well as the Kimmeridge Clay. The Lower Greensand outcrop is patchy, due partly, perhaps, to uneven deposition on an irregular surface but mainly to subsequent erosion, before the deposition of the Gault Clay on top; the latter often lies directly on the eroded Jurassic deposits. Although less than 15 metres remain, the Lower Greensand was, eventually, deposited over most of the area. These sands originally contained a green mineral called glauconite (an iron-potassium silicate), still present in the Upper Greensand (see below) -hence their name. However, on exposure to air the mineral decomposes to form iron oxides which stain the sandstones a rusty yellow-brown. This has happened in the Lower Greensand. Their grains are coarse, angular and poorly cemented; silts and clays are sometimes present, as well as the occasional pebble bed. They probably represent a nearshore environment. The outcrops are scattered, the widest being west and northwest of Devizes (Fig. 104), where the formation consists of particularly iron-rich sands, some clayey. A small outlier capping the top of the hill at Seend contains sands so rich in iron oxides that they were worked for a number of years (see Chapter 3). These ironstones are also known as "boxstones", owing to the pattern of

preciptation of the hard iron oxide deposits which formed along both bedding and joints to produce structures with a somewhat irregular rectangular form (Fig. 17), a weathering phenomenon common to many ironstones. Just east of Calne the sands are quite different, being a paler yellow or grey colour, with a much lower iron content. They are strongly cross-bedded, medium-fine sands up to 12 metres thick (Fig. 83). South of Swindon there are less than 2 metres of highly ferruginous sand with cobbles of Portland limestone eroded from the underlying beds. Locally there is a plentiful fauna of brachiopods, ammonites and other molluscs (e.g. at Seend and Calne); otherwise fossils are not common.

*Fig. 17: Lower Greensand ironstone at Seend. Note the "boxstone" weathering.*

The Cretaceous depositional environment of warm shelf seas, with its associated fauna, is portrayed in a general way in Figure 7. The sands can be examined at a few localities described in Chapters 5 and 6.

### THE GAULT CLAY

Further crustal movements, including a slight general tilting towards the east which caused uplift in the west, resulted in renewed erosion, not only of the Lower Greensand, but also of successively older strata westwards before the sea again encroached. There was thus another gap in sedimentation, followed by the deposition of silts marking the base of the Gault Clay. The basal unconformity has completely removed the Lower Greensand in many places, where the Gault Clay lies directly on Jurassic rocks as old as the Oxford Clay (Fig. 2). There is a continuous narrow outcrop at the base of the Chalk downs, although actual exposures are very rare, especially now that the old brick pits

have closed and become overgrown. The bulk of this formation, up to 27 metres thick, consists of calcareous and often silty or sandy bluish-grey clays. They contain iron-rich yellow concretions around lignite fragments and nodules up to 15cm. across, cemented by iron carbonate and calcium phosphate. Fossils are rare in Wiltshire, the ammonite *Hoplites* and the bivalve *Inoceramus* being typical. The old brick pit at Devizes was a notable fossil locality, but little can now be seen (see Chapter 6). Water depths are thought to have been around 125-200 metres during deposition.

### THE UPPER GREENSAND

The Upper Greensand is about 15-70 metres thick and is more aptly named, being at least greenish in colour at some levels when fresh. In fact Wiltshire is the type locality, where the Greensand was first given its name, now used throughout the country for the mid-Cretaceous sands below the Chalk. The dark green iron-potassium silicate mineral called glauconite is very common and it is this which gives the rocks their greenish colour. As it only forms in shallow marine conditions, glauconite is a useful indicator of sedimentary environment. The basal five metres are fine, grey siliceous beds, followed by forty metres of sandstones producing a steep, often wooded, slope above the

*Fig. 18: The Upper Greensand on the main road from Potterne to Devizes. Note the calcite-cemented "doggers" jutting out from the softer sandstone.*

Gault Clay. In the Vale of Wardour, the Upper Greensand actually forms scarps and prominent ridges reaching exceptional heights of up to 237 metres (as at Beacon Hill; Fig. 149). North of Warminster the Upper Greensand becomes thinner.

The rocks are pale grey-green sands, which are calcareous and speckled with dark green glauconite and often shiny mica flakes also. Large calcite-cemented concretions over half a metre across and known as "doggers", are common, occurring in regular layers (Fig. 18). There are continuous calcareous sandstone and limestone layers too: one such example is the Potterne Rock found south of Devizes, which has been quarried as a building stone. Layers of silica-cemented sandstone and compact greyish chert (similar to flint and likewise made of silica) occur in the higher beds in the southwest of the county. It is these hard bands, together with the porosity of the sands, which protect the Upper Greensand from erosion where it crops out in the valley sides, thus keeping the slopes steep. Phosphatic nodules occur in bands at the top, in the gradation to the base of the Chalk, where sandy glauconitic beds contain a Chalk-age bivalve fauna.

Molluscs are the dominant fossils, particularly bivalves, which are often strongly ornamented, being offshore sandy bottom-dwellers such as scallops and oysters. Brachiopods can also can be found, as can sea urchins and plesiosaur bones. There are lots of sponges (the source of silica in the cherts and sandstones) and the dwelling tubes of marine worms. Ammonites are not common. Chapters 6 and 9 describe the main localities where the rocks can be examined.

## The late Cretaceous Chalk of the downs

The Chalk underlies almost two thirds of Wiltshire. Its landscapes are characterised by steep escarpments, behind which are open undulating downlands. Branching dry valley systems dissect the countryside, remnants of a time during and after the Ice Age when the porous rock was rendered impermeable by permafrost. At this time too, for up to 20 metre below the surface, the Chalk was broken up by the daily alternation of freezing and thawing, giving it a very rubbly appearance at the surface. This frost-shattered chalk is much more friable than unweathered, deeper samples (which are harder to find).

A rising sea level in later Cretaceous time allowed the build-up of this uniform limestone over large areas of northern and eastern Europe. There was little land in northwestern Europe, so deposition of land-derived sediment was minimal, being limited to a little clay. This allowed the accumulation of pure limestone on the continental shelves. In Britain, the Chalk appears in a wide band stretching from southern Yorkshire to Devon, and thence eastwards into Kent. It is up to 336 metres thick in Wiltshire. This particular type of fine white limestone is, in England, unique to the Cretaceous Period. It is distinguished by

its softness, whiteness and purity, as well as its deposition over large areas through long periods of time. Unlike most other limestones, the calcium carbonate, which generally makes up over 98% of the rock, was deposited in a form (calcite) which is stable at surface temperatures and pressures, so that the original particles are still intact and largely uncemented by regrowth of crystals. In contrast, the Jurassic limestones are made up mainly of fossil shells and ooliths which have a tendency to recrystallise over time because they were originally made of a less stable type of calcium carbonate (aragonite). This latter process cements the grains together and makes the limestone harder. The whiteness is a result of its unusual purity and the very small particle size, which increases the rock's reflectivity. Compared with many other limestones, chalk contains a very small amount of silica (below 1% usually), has even less iron oxide (less than 0.1%) and a low clay content, seldom more than 4%. It is finely disseminated iron sulphide (pyrite) which gives Jurassic limestones a bluish-grey colour when freshly exposed, and which changes to a rusty yellow colour as the rock weathers and the pyrite is oxided to limonite. Pyrite nodules can be found in places. They are interesting, rusty-looking globular aggregates of radiating, blade-like iron sulphide crystals, a few centimetres across (Fig. 19). Pyrite also occurs as minute crystals, scattered through the chalk and giving it a yellowish tinge.

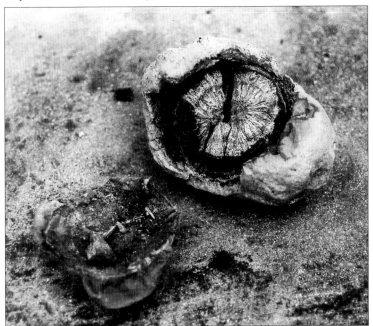

*Fig. 19: Pyrite nodule from the Chalk, containing radiating iron sulphide crystals ("fool's gold"). Photograph by Peter Geddes.*

The Chalk is mainly composed of skeletal fragments of golden-brown planktonic algae, of a type which still exist today. These algae secreted simple plate-like crystals of calcite, one thousandth of a millimetre across, inside their cells to produce spheres of overlapping rings of plates called coccoliths (measuring one hundredth of a millimetre in diameter), as shown in Figure 20. Each living cell was a globular spherical structure supported by 7-20 coccolith rings embedded in a pliable membrane. The algae were the main food of shrimp-like creatures called copepods. It is now thought that, in order for the plates to sink and accumulate on the sea-floor, they first had to be eaten and passed through the copepods. The resulting faecal pellets built up into an ooze on the sea floor and have been preserved as the Chalk! A variety of larger fossils are also present, ranging from foraminifera and ostracods (both animals of the plankton), to sea-mats, sea urchins and bivalve shells. The bedding is often hard to distinguish, although it may be picked out by more clayey marl bands and flint nodules, which occur either in layers or scattered through the rock. Certain marl bands are several centimetres thick and may extend laterally for hundreds of kilometres. Some contain minerals that indicate a volcanic ash origin. Other discontinuous marls simply represent an influx of clay into the environment, during storms, for example.

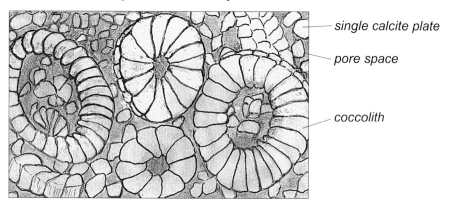

single calcite plate

pore space

coccolith

*Fig. 20: Chalk magnified 5,000 times by an electron microscope. Algae produced the tiny calcite plates which were originally arranged in circular groups called coccoliths. In the living algae seven to twenty coccoliths were embedded in a flexible membrane overlapping one another to form a globular coccosphere, which is around one hundredth of a millimetre across. There is a large amount of pore space, but as connections between the cavities are small, permeability is low unless the rock is fractured.*

Chalk fossils are varied, as in any limestone. There are remains of free-swimmers such as ammonites, belemnites and fish (scales and teeth), as well as bottom-dwelling sponges, corals, brachiopods, gastropods, bivalves and sea urchins (Fig. 7). Burrows, made by certain crustaceans, bivalves and sea urchins, are responsible for the streaks and mottles commonly visible. Several other lines of evidence indicate that the sea floor was a soft ooze, of the type found beneath the waters far from both land and sediment supply today. Many fossils show special adaptations for soft bottoms: some bivalves may have strong folds or spines on their shells to prevent their sinking into the lime mud, for example. Brachiopods show special adaptations for anchorage to soft bottoms too. On the basis of contained fossils (notably sponges), depths have been estimated to have been 100-200 metres in southern England. Sedimentation rates have also been calculated to have been about 20-40 metres per million years. However, this deposition was not continuous; there were periods of sediment removal and non-deposition. From time to time there was increased current activity which concentrated shell fragments in hollows. Breaks in sedimentation are marked by the hard, nodular bands which are scattered through the Chalk. Here, the finer, soft material has been removed by the winnowing action of currents to leave behind the better-cemented patches and nodules. This increased current activity suggests that a shallowing of the water occurred, either as a result of crustal movements in the Earth, or of sea-level changes. The lithification of the nodules occurred relatively early, at depths within the reach of burrowers, which can be shown to have avoided the hard nodules. Bacteria may have been the cause of this early cementation. Removal of all intervening soft sediment (by currents) resulted in the coalescence of nodules to form a continuous "hard-ground" on the sea floor. There is every gradation from nodular chalks to hard-grounds. The latter may have oysters attached and are often covered in fossilised encrusting animals (collectively called epizoa) and holes from boring sponges; these are not found on isolated nodules, suggesting that originally they must have formed below the surface. The fauna of hard-grounds is different from that in the normal chalk, with the common appearance of corals and gastropods and bivalve species adapted to hard bottoms. The best developed examples are in the Chalk Rock and the Melbourn Rock (see below).

The shoreline is thought to have been to the southwest, the Chalk becoming thinner in the south of Devon, where the basal beds are coarse calcareous sandstones. In the west of Scotland and the northeast of Ireland too, there are sandstones containing the same fossils that are found in the Chalk. These indicate a late Cretaceous age and represent a near-shore Upper Greensand-type environment of sand deposition.

The upper levels of the Chalk are characterised by the presence of flints.

These are mainly in layers parallel to the bedding, although there is a range of occurrence from continuous sheets to scattered nodules. They are commonly associated with burrows, often forming burrow casts which produce their characteristic shape. Despite their alignment with bedding planes, the evidence indicates that their formation was not contemporaneous with sedimentation. Firstly, they do not occur in the chalk nodule beds and hard-grounds (described above), as one might expect (as these represent periods when accumulations of chalk were subjected to currents that winnowed out fine, soft material, leaving only the harder lumps on the sea floor). Secondly, flints are never found with encrustations of sea-mats or algae or any other evidence of bottom-dwelling plants and animals having attached themselves. They were therefore not present at the time of sediment deposition. The silica is undoubtedly derived from the siliceous skeletons of animals or plants, such as sponges and plankton, which were subsequently dissolved by the water in the pores of the sediment. At some time after deposition, the chemistry of this water within the chalk must have locally changed, for example where there was decaying organic material within a shell or burrow-infill. These changes lowered the solubility of the silica in the pore-water, causing the silica to be precipitated as an amorphous gel, which then crystallised. Burrowed horizons produced bands of flints, but flints also formed casts of sponges and sea urchins. The silica first filled pores and spaces inside shells or burrows, and then, by a chemical process, gradually replaced the calcium carbonate of the shell or burrow-fill, to form a cast of the original. Once the silica had been precipitated, there would have been a lower concentration of silica in the water around the site. The result of this chemical imbalance was an inflow of more silica into the area by diffusion. This could cause the original flint to slowly grow larger: some flints are well over half a metre across. Flint formation continued for some time after the deposition of the Chalk, during the process of lithification: flint sometimes fills joints. It was certainly completed before the Late Cretaceous erosion of the upper levels of the Chalk, because the basal Tertiary beds are full of flints which, being so hard, are extremely durable. Flints are 98% crystalline silica, and 1% interstitial water trapped between the crystals. When broken open they can be seen to have a dark brown glassy appearance (glass is also made mainly of silica), which actually, on microscopic examination, shows a very fine crystalline structure. The outer surface of the flint is white or pale grey in colour due to the fact that the water could escape from between the crystals here, leaving microscopic air spaces with different light-reflecting properties (Fig. 21).

Three broad divisions can be recognised within the Chalk: the Lower Chalk, Middle Chalk and Upper Chalk, distinguished not only by lithological characteristics but also by fossil content. Different stages in the evolution of the

fauna in Late Cretaceous time can be seen at each successive level as new species appear and old ones vanish from the rocks. The Melbourn Rock and the Chalk Rock, the prominent bands containing better-cemented hard-grounds and nodular chalk, separate these divisions.

*Fig. 21: A flint in the Upper Chalk. Note the pale outer layer, where water has escaped from between the crystals resulting in different light-reflectance.*

### THE LOWER CHALK

The Lower Chalk, 30-80m. thick, is distinguishable by its lack of flints and its higher clay content (Fig. 22), which makes it greyer in colour in the lower part especially. It has basal beds, transitional from the Upper Greensand below, containing glauconite, sand and clay. A bed of brownish glauconitic sand containing scattered calcareous concretions (small stony well-cemented nodules), marks the base. Phosphatic concretions also occur in the basal beds in glauconitic sandy marls (clayey chalk). These are followed by marly grey chalk, which becomes purer upwards. The clay content results in a softer rock forming moderately sloping ground at the foot of the escarpments of harder pure chalk above. Fossils are relatively abundant here: sea urchins, brachiopods, sponges, bivalves, ammonites and belemnites (at the top).

### THE MIDDLE CHALK

The Middle Chalk, 25-46m. thick, has the bed known as the Melbourn Rock at its base -a nodular, hard layer a metre or two thick (Fig. 23), representative of a period of non-deposition. These nodules have a yellow-brown tinge. It is an

*Above, Fig. 22: Typical Lower Chalk below Kitchen Barrow in the Vale of Pewsey.*

*Left, Fig. 23: Nodular Melbourn Rock at the base of the Middle Chalk on Pewsey Hill.*

incipient hard-ground; all the fine, soft material has been winnowed away and the remaining well-cemented material stands out. Above are nodular chalks with marls, passing into softer, white to greyish chalk. There are no flints in the lower part, and not very many higher up. North of the Vale of Pewsey the upper part is lumpy and nodular. Common fossils include brachiopods, sea urchins and bivalve molluscs.

### THE UPPER CHALK

The Upper Chalk is up to 210 metres thick and has the Chalk Rock marking its base. This is another condensed nodular chalk, including several superimposed hard-grounds which have been phosphatised and also contain specks of the dark green iron mineral glauconite. It is thinnest in the west of the county (only one metre around Warminster), nearer the edge of the chalk sea, where shallower depths would have resulted in more erosion. In the east, near Marlborough, it is four or five metres thick. Above the nodular beds, the Upper Chalk is typically soft and white, thickly bedded, and with many more flints. Some of these flints occur as scattered nodules, others are found in regular layers (Fig. 24). Sandy

*Fig. 24: Flint horizons in the Upper Chalk at Middle Woodford.*

limestones and sands, reflecting proximity to the shoreline, appear in the southwest of Wiltshire. Southern Dorset and Devon are the westernmost occurrences of the Chalk and are thought to represent nearshore deposits. Common fossils are sea urchins, sea lilies (crinoids), belemnites and bivalves.

The higher levels of the Chalk have been removed by erosion as a result of gentle tilting to the south prior to Tertiary deposits being laid down. The fossil content of the uppermost beds proves that the Tertiary-age Reading Beds lie on successively lower levels of the Chalk northwards.

## The Tertiary sands and clays of Savernake Forest and the northern New Forest; the sarsen stones of the downlands

The Tertiary rocks of England are preserved in only two synclines (or down-folds), known as the London and Hampshire basins. The eastern borders of Wiltshire happen to include the extremities of these basins, one cropping out in Savernake Forest, the other lying southeast of Salisbury, (immediately east of Alderbury and Redlynch), on the northern fringes of the New Forest. Tertiary age rocks, if the soft sands and clays present here can be called rock, were laid down on Chalk which had previously been tilted and eroded during the intervening gap of 30 million years (Fig. 9). They lie on progressively lower levels of Chalk northwards, indicating that the tilting was to the south. In the Savernake area, Tertiary rocks lie on Middle Chalk, so about 200 metres must have been removed there.

The Tertiary rocks are marked by a change in soil type to acid or neutral; (most of Wiltshire has alkaline, calcareous soils). There is consequently a marked change in the vegetation which has a more heathy aspect, with acid-loving plants such as heather appearing.

Major environmental changes took place during the thirty million year time-gap, accompanied by evolutionary changes. Dinosaurs were no more, or rather those remaining had become birds, and mammals were now dominant. The sub-tropical seas were gone, obliterated by crustal movements, and northward continental drift had carried Britain nearer to its present latitude (although faunas suggest that the climate was still warm). It was situated on the western margins of a depositional basin which extended through Belgium to France. The detailed geography of that time is not clear, but the sediments indicate alternation of coastal swamp/delta and marine conditions, the sea being situated to the east.

Here, at the edge of the area of deposition, there are in total only ten or fifteen metres present, except on the Hampshire border, where the thickness is closer to 75 metres. With the closure of the old brick and sand pits, the rocks are rarely seen. Their general lack of consolidation means that they do not produce marked landscape features and any exposures are quickly overgrown by vegetation, the

best indicator of their presence.  Four sub-divisions are found in Wiltshire:

—— top eroded ——
The Bracklesham Beds (<60 m. clay & sand)
The Bagshot Beds (4-5 m. sand & clay)
The London Clay (<5m. clay)
The Reading Beds (4-5 m. clay & sand)
——— unconformity ———
The Chalk (Cretaceous)

### THE READING BEDS

These oldest Tertiary continental beds are considered to be river, estuarine and lagoonal or marsh deposits, consisting of reddish and variegated clays associated with pale sands.  The basal beds contain green-stained flints.  In Wiltshire, there are only 4-5 metres present.  Their thinness here may be the result of pre-London Clay erosion.  They are typically unfossiliferous.

### THE LONDON CLAY

Uniform widespread marine clays appear between the Reading and Bagshot beds in the Hampshire Basin and towards the east of the Savernake Forest outcrop, although in Wiltshire they are less than 5 metres thick.  They are bluish when fresh, but weather to a brown colour and contain some silt and fine sand, pyrite nodules, grey calcareous concretions and beds of flint pebbles.  Fossils are marine: bivalves, nautilus, worms and foraminifers as well as the seeds of land plants.  The beds at the base contain black flint pebbles, shallow-water molluscs and plants plus the marine mineral glauconite.  The flora indicates a warm, wet, sub-tropical type of climate.  Around 500 species have been described from the Thames estuary, including palms, magnolias, mangroves, dogwood, cinnamon and laurels.

The clay was commonly worked for bricks in both areas of outcrop.

### THE BAGSHOT BEDS

The Bagshot Beds are comprised of fine, ferruginous cross-bedded sands, clays and sandy clays, red, brown, white and yellow in colour.  There are impersistent flint pebble bands.  They probably had a coastal deltaic origin.  They coarsen to the west in the Hampshire Basin exposures. The composition of the rocks suggests they were derived from that direction.  There are only 4-5 metres preserved in the Wiltshire outcrops.  Fossils are infrequent and consist of sub-tropical plant remains only.

## THE BRACKLESHAM BEDS

These deposits appear above the Bagshot Beds in the northern New Forest, in Wiltshire's southeastern corner, supporting heath and woodland. They consist of 60 metres of alternating clays and sands with a rich marine warm-water fauna including corals, sea-urchins and crabs; but fossils are scarce in Wiltshire. In addition they contain drift-wood, dark grains of glauconite and scattered flint pebbles, especially at the base. The tree cover makes it difficult to discern, but the Bracklesham Beds actually stand out as a harder scarp above the soft Bagshot Sands below. The latter, being extremely porous, tend to keep the overlying clays drier than is usual and as some sand layers in the Bracklesham Beds are well cemented with iron oxide, they can form a landscape feature.

## THE SARSEN STONES

Sometimes known as "grey wethers" (wethers are sheep), these isolated blocks of stone are found lying around on the Chalk downs, particularly on the Marlborough Downs, between Avebury and Marlborough (Fig. 25). They have also been found resting on Jurassic rocks near Swindon and elsewhere. There are relatively few sarsens scattered over the Chalk of Salisbury Plain, although they can be found in walls and the corners of old cottages; so undoubtedly there were many more which were subsequently broken up and removed for building purposes.

The name 'sarsen' is thought to come from either the Anglo Saxon *sar stan* meaning 'troublesome stone', or from *saracen*, meaning 'alien' or 'stranger'. The individual stones can be up to 6 metres long, as seen in the Avebury stone circles (Fig. 26).

Most sarsens are white to greyish or yellowish sandstone, being made of often iron-stained quartz sand with angular grains of various sizes, including flint grains and white feldspar. The latter is typical of sands deposited close to their source, before this mineral has had time to decompose. Iron-staining can cause reddish or brownish colouration. Sandstones deposited on land are typically impregnated with iron oxides. The stones sometimes contain lenses and thin beds of flint pebbles showing various stages of rounding, usually angular to sub-angular (Fig. 27). The pebbles may alternatively be scattered through the rock, an indication of very rapid deposition, such as might occur in a flash flood. These latter are sometimes termed "pudding stones" if the pebbles are particularly abundant, which is not often. Any bedding is generally impersistent, and the shape of the stones appears to be determined by the extent of the uneven cementation, rather than by bedding.

Loamy sarsens, made of silicified clayey silt, are less common. They are finer grained, tougher and darker grey than the others. They tend to form

*Fig. 25: Sarsen stones at Lockeridge Dene in the Marlborough Downs.*

*Fig. 26: Sarsen stones in one of the late Neolithic stone circles at Avebury.*

rounded blocks under 60 centimetres in diameter.

The stones are probably the remnants of locally hardened zones in sands of Tertiary age, maybe from the Reading Beds or the upper Bagshot Beds. Comparison with localities in central Australia and southern Africa (Fig. 28), where similar recently-formed sandstones have been studied, and also with still-buried Tertiary sands in the Paris Basin in France, gives clues as to their origin. Groundwater can become saturated with silica as it moves through sands. Local changes in the chemistry within the sand deposits may then cause cementation of the loose grains with additional silica, resulting in the development of hard silicified areas beneath the land surface. Changes in acidity can trigger this precipitation from the ground water, probably in zones where there is mixing of waters from different sources; silica solubility increases with both increasing acidity and alkalinity. The growth of bacteria and certain plants can also contribute to the process of silicification. Lenses of silica-cemented sand (silcrete) have been observed to develop just above the water table, suggesting a relationship with local groundwater flow and drainage patterns. The silicified areas dip towards the valley, following the top of the water table which is focused on springs in the valley floor. Studies suggest that silicification may be relatively rapid, perhaps taking only 30,000 years for three metre-thick lenses to form. The cementation was not of uniform depth or lateral extent, as it depended on local conditions, hence the surfaces are frequently knobbly and pitted. Cavernous hollows were formed by later removal of softer areas. The Tertiary-aged cover, largely of soft, uncemented sands and clays, which was probably at one time continuous over Wiltshire, has subsequently been eroded away, leaving behind just these scattered, locally silicified, patches. The "sarsen trains" -a linear distribution, well seen at Overton Down (G.R. 130 709), probably developed along former drainage lines as ground water moved towards the valleys. It is most likely that the actual sandstones are river deposits, with angular sand grains and poorly developed bedding. Their strikingly irregular shape appears to be due to a combination of jointing and uneven cementation. They contain many fossil plant roots, indicative of deposition on land. Looking like rusty brown tubes, these roots are up to 3 centimetres in diameter (Fig. 29), the root itself having frequently decayed away at some point after silicification of the rock, leaving behind tube-like holes. Some are filled with sandy, iron-rich material, which became cemented and is still preserved; others are occupied by the original roots and rootlets, which were themselves also silicified. Indeed their metabolism may well have encouraged silicification. The roots of some plants are known to deposit silica within their cells. The fossil roots are in position of growth and have not been distorted by pressure, a further indication of early silicification which was, however, not yet so advanced as to prevent root penetration. They

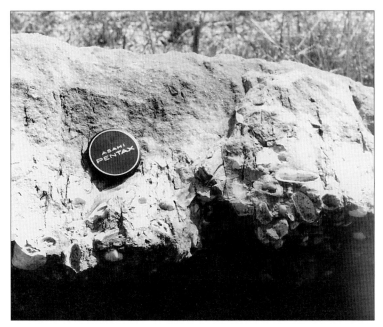

*Above, Fig. 27: Pebbly sarsen stone on Hackpen Hill, Marlborough Downs.*

*Below, Fig. 28: Silcrete body in northwestern Botswana.*
*Photograph by David Nash, School of the Environment, University of Brighton.*

*Fig. 29: Fossil root hole in a sarsen stone at Avebury.*

probably belonged to plants of the monocotyledonous type, such as palms, which grew at that time in the soil above.

Sarsens have been used, since prehistoric times, for monuments such as Avebury and Stonehenge as well as for paving and building stone (see Chapter 3). As a result, their natural occurrence has been greatly reduced over the years, although it has recently been estimated that there are still several tens of thousands left, even after centuries of exploitation. English Nature and the National Trust have bought several areas containing large groups of stones, with the aim of protecting those remaining. They can be seen in many localities, for example at Fyfield Down Nature Reserve (around G.R. 130 710), Lockeridge (G.R. 144 674) and Piggledean (G.R. 141 690).

## Quaternary superficial deposits and the effects of the Ice Age

It is easy to assume that the landscape of the present day is the result of processes still continuing; indeed this is in part true, but the consequences of the Ice Age are still to be seen all around the countryside.

### THE EFFECTS OF THE ICE AGE

There was a series of successive glaciations during the period known as the "Ice Age", which actually lasted for almost two and a half million years. The first glaciation was in late Tertiary time, ice possibly reaching the North Sea. This was followed by a second ice advance which deposited erratic boulders, originally from the Midlands, in the Thames valley. A third glaciation carried Welsh erratic rocks, dumping them in the Thames basin again when the ice melted. A fourth ice advance extended as far as the Scilly Isles, Cornwall, North Devon and the Thames. This takes us to the interglacial period 250,000 years ago when the first Human bones and artifacts were left in the Thames valley.

20,000 years ago ice covered Wales and England as far south as the Severn estuary and The Wash. The last ice sheet retreated 10,000 years ago, only just before Mesolithic times (Middle Stone Age), when pine pillars were erected at Stonehenge. These have been dated at 9,000 - 10,000 years; the fact that the pillars were of hardy pine suggests that it was too cold for broad-leaved trees. Vegetation and animal remains indicate that some interglacial periods were substantially warmer than today, and that sea levels were up to 20 metres higher. The problem lies in distinguishing the effects of older glaciations, because the evidence has been destroyed during subsequent ones. There is a school of thought that the 'bluestones' of Stonehenge and Heytesbury could have been brought by the earliest (Late Tertiary) ice sheet; they have a variety of Welsh sources, not just Pembrokeshire, as is commonly believed. A few have been striated (i.e. scratched) by ice movement (although this could have happened in Wales).

In Wiltshire, there is no evidence of glaciation: no Jurassic rocks have been found dumped by the ice in unlikely places; neither are there any boulders of the older Triassic, Carboniferous or Devonian rocks. There may have been a continuous Cretaceous cover during the Ice Ages, and indeed the current depths of erosion, with removal of so much Chalk as to reveal the older rocks seen today, are probably attributable to Ice Age conditions. Large volumes of melt-water must have had a massive effect on the landscape, carving out valleys, even in permeable rocks like the Chalk, as a combination of permafrost and water saturation would have allowed surface waters to flow over them. The result is the large number of dry valleys or combes. Permafrost would have caused the break-up of surface rocks to deep-levels as the freeze-thaw action of water in cracks forced them open even further.

## LAND-SLIPS

Land-slips have had a significant effect on valley sides, resulting in a broadening of the valley, especially where clays underlie permeable limestones or sandstones. Where rivers cut valleys into such rocks, undercutting of the softer, easily eroded clay renders the slope unstable and blocks of solid rock higher up the valley side fall down, producing jumbles of rock debris on the lower slopes. It is springs emerging from the hillside above the clay bands that are largely responsible for the landslides rather than the rivers themselves. The impermeable clays prevent further downward movement of water from the permeable rocks above, causing water to seep out of the valley sides at this point, eroding the clay as it does so. Examples of this are common on the sides of the Avon valley and its tributaries below Bradford-on-Avon; the valleys cut deeply into the Jurassic limestones and clays. In the southern Vale of Wardour, likewise, where the Upper Greensand

scarp is underlain by softer sands and Gault Clay -all dissected by tributaries of the Nadder- there have been landslides on a large scale. Repeated internal slippages can produce stepped arcuate notches in the valley sides. Under periglacial conditions this process would have been accelerated. Most of the land-slips probably date from this time.

### PLATEAU AND VALLEY GRAVELS

At the end of the Ice Age, and when the glaciers retreated during warmer periods within it, melt-water streams would have had strong currents which carried vast amounts of glacier-borne gravel, sand, silt and clay. Relics of extensive gravel sheets are found in Wiltshire at levels up to 100 metres higher than the present-day valley deposits. They are known as "plateau gravels" and consist largely of flint pebbles. They are sometimes visible filling the solution holes known as "pipes" which can be seen beneath the ground surface in quarries, where there is a section through the top of the Chalk (Figs. 30 & 134).

*Fig. 30: Solution "pipe" filled with Plateau Gravels in the Chalk's surface (centre with bushes growing on them). Rainwater percolating down joints dissolved out hollows in the top of the Chalk at the English China Clays pit near Wilton.*

"Valley gravels" are younger, being found on valley sides as sheets or terraces, often about 20 metres above the present floor, and well above the present-day alluvium. Such gravels are found now in the valleys of the Thames, both Avons, the Kennet and the Wylye. They represent a time when sea-levels were higher, and when valleys would have been less deep. At the end of the Palaeolithic (Old Stone Age) period, the land was probably only a few metres above present levels. At that time, the rivers were gradually redistributing surface material as they developed their valleys, sorting it into different grain sizes by dumping the larger pebbles first, when currents were no longer strong enough to move them along. However, it then became colder again, and sea levels fell as water once more was locked up in growing ice caps. The rivers then cut their valleys deeper, leaving earlier gravels as terraces on the valley sides. Subsequent rises in sea-level, associated with further melting of the ice, caused infilling of these valleys with new river deposits. Many Palaeolithic flint implements have been found in valley gravels in the Avon valley near Salisbury, and in those of the Thames in north Wiltshire. Flood deposits and wind-blown sediments consisting of sand and clay, contain the remains of mammoth, woolly rhinoceras, cave lion, bison, hyaena, musk ox, reindeer and lemming near Salisbury. The Thames gravels have similarly yielded reindeer, bison, mammoth and crocodile bones and teeth, as well as flint hand-axes, ranging in age from 50,000 to 250,000 years. The remains of about a dozen woolly mammoths, together with nine late Ice Age flint axes, have recently been found in Thames river gravels in the Cotswold Water Park at Latton (Figs. 31 & 32). There is speculation that their proximity is no coincidence.

These gravels are being extracted at present from the Thames valley around Ashton Keynes (G.R. 070 940; see Chapter 5), and were formerly worked in the Avon valley south of Great Somerford (G.R. 966 820).

## RIVER ALLUVIUM

At the present time, the larger streams and rivers of Wiltshire are depositing alluvium, comprising silt and clay derived mainly from the soil, on the low gradients of their broad floodplains. The lack of coarse material is because the rivers originate in the relatively low-lying limestones of the Cotswold Hills (the Bristol Avon and the Thames) or in the Chalk and Upper Greensand (the Kennet, the Salisbury Avon and its tributaries, the Nadder and the Wylye), and do not have great erosive power. Some deposition of alluvium occurs during floods, but most of it is continually built up on the inside of the bends of the meandering rivers. The river flows more rapidly on the outside of a bend, constantly cutting into that bank and slowly moving the bend further downstream. On the opposite bank, flow is slack and it is here that sediment builds up. Thus the whole

*Above left, Fig. 31: Palaeolithic flint hand axe 250,000 years old, from the basal valley gravels of the Thames at Latton.*
*Photograph by Neville Hollingworth, Natural Environment Research Council.*

*Above right, Fig. 32: Mammoth's thigh bone 250,000 years old, from the lowest layer of the Thames gravels at Latton.*
*Photograph courtesy of Neville Hollingworth, Natural Environment Research Council.*

*Below, Fig. 33: Terracettes on King's Play Hill, formed by soil-creep downslope.*

meander system moves forward, leaving behind a layer of alluvium. It is constantly eroding earlier deposits as it moves down its valley, widening the valley where meander bends actually cut ino the valley sides.

As the meanders moved slowly downstream, they buried some of the Ice Age valley gravels under more recent alluvium.

### HEAD

Soil-creep downhill occurs all the time, forming a build-up of downwash deposits at the break in slope, simply by gravity; but soil-creep is more active when there is surface water present, and even more so in periglacial conditions. During the Ice Age, permafrost would have sealed the pores and cracks in pervious rocks, making them impermeable; and severe frost would have caused shattering of rock outcrops to depths of several metres below the ground. During summer thaws there would have been movement down-slope of a slurry of water-logged soil and unsorted weathered rock debris. This material, full of angular rock debris, is known as "head". Its composition varies according to the rocks upslope. Huge amounts of head have spread down the valleys of Wiltshire over the millenia, grading into river deposits. Below the chalk escarpments, calcareous, clayey loam has built up; while below the Greensand hills the head is sandy, although it has often become mixed with material moving down from the Chalk escarpments above (Fig. 107). It is invariably concealed by vegetation.

The terracettes, characteristic features of the steep downland slopes, have been formed by this downward soil-creep (Fig. 33).

### CLAY-WITH-FLINTS

The "Clay-with-Flints" forms a patchy cover on higher parts of the Chalk downs. It undoubtedly covered much more of the Chalk's surface, but has since been dissected by valleys, often now dry. It becomes more extensive eastwards and is thought to represent the remnants of Tertiary sediments which originally covered the area, together with the insoluble components (clay) left *in situ* after prolonged chemical solution of the chalk which has been going on since it was first exposed to percolating water - either rainwater or meltwater from the ice sheets. The low temperatures at this time favoured the dissolution process, especially with melting snows and/or permafrost producing long periods of water saturation. Rain is weakly acidic, containing carbon dioxide dissolved from the air as it falls; the carbonic acid dissolves calcium carbonate. Clay-with-Flints can sometimes be seen amongst the roots of fallen trees on the downs (Fig. 86). It is a reddish-coloured clay containing rounded flint pebbles, presumably derived originally from the Chalk, but later rounded in river beds and beaches before being recycled in Tertiary gravels. The lowermost parts,

lying on the irregular surface of the Chalk (and therefore derived from its solution), have the highest proportion of dark red-brown sticky clay, containing grains of iron oxide, sand, silicified fossils and unworn flints with their white patina still intact and commonly spotted with black manganese oxide. Higher levels are more variable in colour, with the addition of Tertiary material. They are reddish or brown sandy loams and clays, containing worn flints (with the white surface layer partially abraded away), quartz and sandstone pebbles. Thickness varies, but can be up to ten metres. Bedding is absent, but flow structures may be visible as a result of settling in solution pipes and hollows in the chalk. As decalcification has been almost complete, the deposits have had a marked effect on soils, rendering them neutral or even acid and allowing the growth of bracken in the woodlands (e.g. in West Woods and Savernake Forest), and sometimes broom and heather too on what would otherwise be chalky alkaline soils.

The sarsen stones described above could be included here, as at least some of the removal of the softer contemporary enclosing sediments took place in Quaternary time, although this process probably started, like the Ice Age, late in the Tertiary period. During the wet periglacial conditions there was possibly a certain amount of downhill movement of sarsen stones into valleys, lubricated by the slippery chalk-mud ooze, familiar to present-day walkers during wet spells.

The break-up of the Chalk's early Tertiary cover was aided by the development beneath it of large depressions formed as the underlying chalk was dissolved by water percolation, especially along joints. Three large masses of silica-cemented sandstone, similar in size to the Stonehenge sarsen stones (one 6.4m x 3.5m x 1.2m), have been found during excavations to build the M40 road in Oxfordshire, in red Clay-with-Flints filling a complex cavity in the Chalk. It is perhaps significant that here the sandstones are still friable, though silicified, because they have not been exposed to the atmosphere for a sufficient length of time - a commonly observed feature of building stones. The trilithons at Stonehenge have been dressed by hand - the lintels have obviously been shaped to fit with a joint onto the upright stones and there are engravings of axe heads too; this would have been much easier if they were still relatively soft, although various methods of dressing sarsens have, of course, been developed over the years (see Chapter 3). It is possible that they were found by the early Bronze Age people, like the Oxfordshire stones, buried in Clay-with-Flints and thus preserved in a solution hollow in the Chalk. They would then have hardened in the last 4,000 years, since they were erected and exposed to atmospheric weathering. The "Station Stone" and the "Heel Stone" at Stonehenge are irregular, unworked standing stones, like those at Avebury. The latter are made entirely of naturally-shaped, weathered sarsens, presumably of local origin.

# 3: Geological Resources

The rocks of Wiltshire have been extensively utilised over the centuries: the harder limestones and sandstones as building stones, and at one time as roadstone; the clays mainly for bricks, but also, locally, for lining ponds and even the Kennet and Avon canal (Fig. 34). The Chalk is used for lime (for cement and for agriculture); and the sands and gravels for building aggregates.

## Building stones

The character of a region is largely determined by a combination of landscape and the local stone used to build the towns and villages. Even where there is a lack of stone (for example in the Chalk downlands), the alternative building materials traditionally used are distinctive. The development of more efficient transport networks, first the canals, followed by the railways, then the roads has, perhaps sadly, meant that the local character of towns and villages is being lost, as building materials are brought in from further afield.

Jurassic limestones provide the best stone for building. The freestones, ragstones and tilestones have been widely used in the Cotswold region for both buildings and dry-stone walls. The "Cotswold stone belt" crosses northwestern Wiltshire, between Malmesbury and Farleigh Hungerford (Fig. 57). The older parts of the towns and villages of northwest Wiltshire all have buildings made of these Jurassic limestones (Figs. 35 & 36). Even in the clay vales to the east, it was extensively used (e.g. at Laycock), as transport distances were not all that great. The use of building stone has declined in the last hundred years, due mainly to the expense and the easy availability of cheaper (and more durable) alternatives these days, especially now that transport is not the major consideration that it was. The famous Bath Stone is an oolitic limestone virtually free of large fossils and also thickly bedded, so it can be cut freely in any direction, without splitting, hence its name, "freestone". The massive beds utilised for building are part of the Great Oolite Formation. As long ago as Roman times, some two thousand years ago, this stone was quarried. On Box Hill it was used for a local villa and the same stone may have been used for the construction of the Roman baths of Aquae Sulis and the temple of Sulis Minerva (now Bath). The stone was originally cut from surface quarries but, as the best quality beds are usually only a few metres thick, it soon became necessary to follow them into the hillsides. Vast underground workings developed. Along the route of

*Above, Fig. 34: The Kennet and Avon canal was a remarkable feat of engineering and of great importance to the region in the first half of the 19th century, carrying stone, bricks and agricultural produce. The opening of the Great Western Railway resulted in its decline.*

*Below, Fig. 35: Houses made of local limestone at Bradford-on-Avon.*

Fig. 36: South Wraxall church was built from the Jurassic limestones of the plateau on which it stands; note the stone roof-tiles.

Fig. 37: The aqueduct at Avoncliff, carrying the Kennet & Avon canal over the River Avon was built between 1796 and 1798. It is constantly in need of repair as the limestone from which it was made is not strong enough to withstand the constant leakage of water.

Fig. 38: Stone to repair the Avoncliff aqueduct (in 1999) from the Stoke Hill underground quarry at Upper Limpley Stoke, less than two miles away.

the Kennet and Avon canal, steep tramways linked the quarries high on the Avon valley sides with the canal at Avoncliffe, Limpley Stoke, Murhill and Conkwell. Murhill quarry opened in 1803 to supply stone for the Kennet and Avon canal. It was not an ideal choice, as the limestone could not withstand the constant leakage of water from the canal -as witnessed by the crumbling face of the Avoncliff aqueduct, under repair today (Figs. 37 & 38). The quality does vary greatly, differences in durability being related to the fossil content, thickness of beds and level in the formation. The strength of Bath Stone comes from the calcite cement between the grains, rather than from the ooliths. The cement prevents water being absorbed into the rock by the porous ooliths. This cement is largely derived from shell fragments mixed in with the ooliths, which recrystallised after burial. Thus, it is no coincidence that the best weatherstone in the area is the shell-rich Box Ground, a local variety of Bath Stone from the lowest part of the Great Oolite Formation. The same level was extensively worked in the hills around Bath and is still quarried there on Combe Down. The newly re-opened mine at Corsham (Hartham Park) is also at this level; it was probably these lower beds of the formation which gave Bath Stone its reputation. The higher levels of freestone such as those still worked underground at Westwood (Westwood Ground), Limpley Stoke (Stoke Ground) and Corsham (Monk's Park) are softer, purer oolites, up to 13 metres thick in the latter area. They still have some shell debris and plenty of cement between the ooliths, however; enough to make good building stones. The stone worked in the Bradford-on-Avon area is from an even higher, locally occurring, level near the top of the Great Oolite. It is the most distinctive, being characterised by strongly developed cross-bedding with layers of broken shells which are picked out by weathering.

Any irregularities or cracks ruin the stone for top-quality building, thereby reducing its value. The stone is soft and easy to work when first quarried. It is traditionally kept underground until May because the freshly quarried stone can be damaged by frost (owing to its high water content). It is then seasoned on the surface through the summer, when it loses water. The huge demand for stone in the 19th century resulted in unseasoned stone being used, with disastrous consequences. The stones must also be kept the right way up when building, with the bedding planes horizontal. Otherwise, fine layers will tend to flake off from the surface because weathering picks out any weaknesses in the bedding.

The Anglo-Saxons used Box Ground for the 7th century St Laurence chapel in Bradford-on-Avon, and Winchester Cathedral (1222) is made of Bath Stone. Box Ground stone was used in the Middle Ages for Malmesbury Abbey, Laycock Abbey, Monkton Farleigh Priory, Great Chalfield Manor and Longleat House. However, the "Golden Age" of Bath Stone was in the building of Bath in the

18th and 19th centuries. With the development of transport systems such as the Kennet and Avon canal and the Great Western Railway, its use spread further afield. It was even used in London by John Nash in the 19th Century (although it decayed so badly in the pollution that Portland Stone had to be used to replace it; the latter is particularly resistant to air pollution). The Westwood underground quarries were opened originally as a source of stone to build the railway. It was the building of the Box railway tunnel in the last century which revealed more valuable high quality stone running in the direction of Corsham, resulting in vast underground workings in this area. By 1900 there was a network of tunnels and tramways for the removal of stone totalling around 60 miles in length. Old underground workings have been put to a variety of uses e.g. M.O.D. storage, especially during the last war, as wine cellars and for mushroom growing (since 1870).

In other parts of the Great Oolite the bedding is more irregular. Poorer quality limestones from the Great Oolite, Forest Marble and Cornbrash, which are more fossiliferous and less thickly bedded, are known as "ragstone" and have been extensively used for cottages, farm buildings and as a walling stone. The fields around Bradford-on-Avon, Atworth, Gastard and Malmesbury were dug for thinly bedded, fissile, shelly limestones of the Forest Marble, which provided stone roof "tiles", typical of the older Cotswold buildings (Fig. 36), as well as cobbles and larger paving slabs.

The younger Corallian limestones above the Oxford Clay crop out further to the southeast. They are less regularly bedded, but make durable building stones (e.g. the white Calne Freestone). It has oolitic grains, fine-grained ovoid pellets ("false ooliths" of debatable origin) and small shell fragments. It was quarried around Lyneham and Calne. Freestones are exceptional in this formation, though, and there is a wide variety of textures and colours (shades of cream, grey and brown) which give character to towns along its outcrop like Highworth and Wootton Bassett. Dressings are often of local brick or freestone. North of Calne, coral became more common, forming fine-grained crystalline, fossiliferous limestones lacking bedding and used as rubble-stone in walls. Around the reefs detrital deposits built up, forming pale, shelly limestone which can produce good quality building stone.

The Portland Stone at the top of the Jurassic sequence is a pale grey limestone which is often sandy. It is excellent quality stone, well suited to city buildings, as it is better able to withstand pollution than Bath Stone, although it does become blackened. The building stone comes from the middle and upper levels of the formation, from whence they have been quarried extensively since the Middle Ages. The Purbeck Beds above contain white, fine-grained limestones, also used for building. Some of the latter are thinly bedded and split easily, and have

been used for tile-stone. Limestones of this age have been utilised only in the Vale of Wardour and at Swindon. Elsewhere, they were removed by erosion in early Cretaceous times.

In the Vale of Wardour there are two main limestone horizons which have been quarried for building. The lower, up to 12 metres thick, crops out around Tisbury and is distinguished by being particularly sandy and by its glauconite content. Chicksgrove quarry (G.R. 963 296) is still worked for building stone and has around 20 metres of limestones, including the level at Tisbury near the base. The uppermost building stone horizon has been extracted for hundreds of years from open and underground quarries in the sides of the "Chilmark Ravine", a small valley southeast of Chilmark. It is over 5 metres thick and has less sand, no glauconite and is further distinguished by the presence of ooliths. It provided the famous Chilmark Stone used for Salisbury and Rochester Cathedrals. In 1938 the tunnels were used as ammunition stores, as were the Bath Stone mines further north. The restoration of Salisbury Cathedral has resulted in the re-opening of the old underground workings (Fig. 39). Rocks of the same age from the Isle of Portland were used by Wren for St. Paul's Cathedral and other London churches; it had the advantage of being tranportable by sea. Wardour Portland Stone has, of course, been widely used for local buildings e.g. on the Fonthill estate (Fig. 40), which obtained its stone from its own quarries; its pale grey colour gives a distinctive character to the villages. The waste stone was fired for quicklime, so kilns were commonly associated with quarries e.g. near the old Teffont Evias quarry, where the kilns have recently been restored (G.R. 989 313; Fig. 41).

The hill of Old Swindon contains several old quarries, from which this part of the town was built. The building stones are around 5 metres thick, with limestones in the lower beds and sandstones at the top, though some of the latter are too soft for building. A small syncline preserves Portland and Purbeck beds (which form the hill). Town Gardens (G. R. 151 833) have been created in the space left by the removal of the stone. Sections of the rock can be studied around the boundary of the park. The Victorian "New Swindon" was built of brick from clay pits to the north.

The Lower Greensand has only locally been used as a building stone, where natural cementation by iron oxide has rendered it sufficiently durable. The area around Sandy Lane had quarries which provided the dark orange-brown sandstone for the cottages in the village (Fig. 42). The roofs are thatched.

The Upper Greensand has harder layers at a few levels, where there has been cementation by calcite or silica, though building stones are not common. The Potterne Stone is a calcareous sandstone used locally in the Vale of Pewsey. Greenish grey glauconitic ragstones have been used for building in Mere

*Above, Fig. 39: Underground Chilmark Stone quarry in the Chilmark Ravine, Vale of Wardour.*

*Below, Fig. 40: Palladian gatehouse on the Fonthill Estate built with local Wardour Portland Stone.*

*Right, Fig. 41: Restored old lime kiln at Teffont Evias; waste limestone from the quarries was made into quicklime.*

*Below, Fig. 42: Sandy Lane's cottages are built from local Lower Greensand, a dark orange-brown sandstone.*

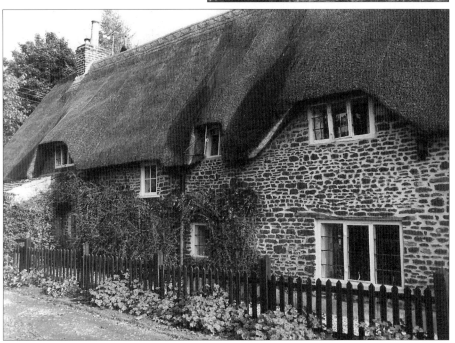

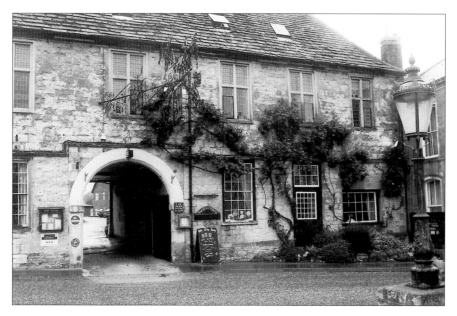

*Above, Fig. 43: Mere has many buildings of greenish grey Upper Greensand.*

*Below, Fig. 44: Upper Greensand was commonly used for the foundations of brick and timber-framed houses as it forms a good damp course; this example is in Market Lavington.*

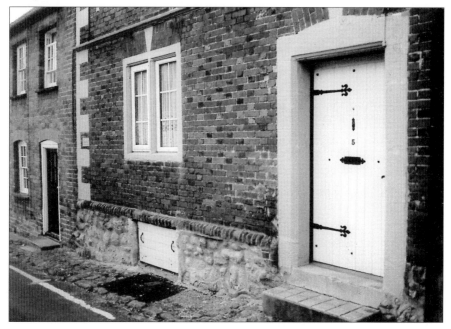

(Fig. 43) and near Barford St Martin, where Hurdcott Stone is still quarried. It is used particularly for restoration work. This may have been the source of the stone used at Old Sarum for the Norman Cathedral and castle, as well as for other Norman churches in south Wiltshire. The stone was found to make a good damp course, transmitting less moisture from the ground than brick; so it was used for house foundations and is often seen in the lower parts of brick and timber buildings (e.g. at Potterne and Market Lavington -see Fig. 44).

On the southeastern border of the county, the Tertiary Bracklesham Beds are quarried today for sand at Pound Bottom (G.R. 220 178). The sands contain iron oxide-cemented layers of red pebbly sandstone which have been used in the church and some older buildings in Downton nearby.

Sarsen stones of Tertiary age, found today scattered over the Marlborough Downs, have been used for building locally since Pre-historic times, when they were used for the standing stone circles of Avebury and Stonehenge (Fig. 45). They were used also for shaping and polishing flint cutting tools, being so hard and abrasive. One such Neolithic polishing stone can be seen on Totterdown (G.R. 128 715) and another is one of the standing stones of the West Kennet Avenue (G.R. 106 705). Grooves for sharpening the edges of the tools can be seen, with rounded hollows for polishing the faces of the flints. They were probably more widespread in their distribution, but over the years they have been cut up and incorporated into buildings, walls etc. Romano-British foundations contain them; they have been used as tramway setts and they form some of Swindon's curbstones. They have an unfortunate habit of "sweating" in damp weather, by condensing atmospheric water vapour onto their surface when there are rapid temperature changes. This restricted their use somewhat. Mediaeval builders split them by lighting a fire to heat them, then pouring on cold water. By Victorian times accurate cutting techniques had been developed. The remains of broken splitting wedges are still embedded in stones which couldn't be broken on Fyfield Down (G.R. 135 706) and Totterdown (G.R. 143 718). The building of the Kennet and Avon canal allowed them to be carried further afield, although it also allowed the cheaper import of bricks. Because they were slowly disappearing, English Nature and the National Trust have bought areas of the Marlborough Downs to preserve the remaining sarsens: for example, at Piggledean, Lockeridge Dene and Fyfield Down.

The Chalk is not a building stone; it is normally too soft. However, there are hard nodular bands such as the Melbourn Rock and the Chalk Rock, and these have been used in the past in buildings for want of anything better; the stone is known as "clunch". It can be found occasionally in the outer walls of some old cottages (Fig. 46), in perimeter walls (Fig. 47) and on the inside of the churches at Aldbourne and Wanborough too. In Chalk regions, chalk has traditionally

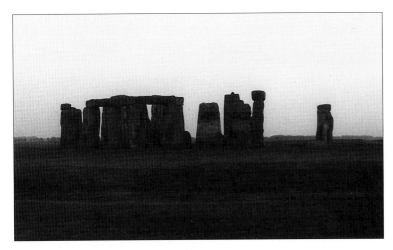

*Fig. 45: The large trilithons of Stonehenge on Salisbury Plain were made from sarsen stones in the early Bronze Age.*

*Centre, Fig. 46: Chalk is not often used for building but has been used in this cottage at Shrewton on Salisbury Plain, along with flint, limestone and brick.*

*Below, Fig. 47: Another rare example of the use of chalk blocks is found in this wall at Uffcott below the Marlborough Downs. Thatch is necessary to prevent disintegration in the rain, as well as a stone foundation to guard against rising damp.*

*Above, Fig. 48: Thatched cob wall at Shrewton; note the brick foundation used here.*

*Right: Fig. 49: Flint and limestone used to give a decorative effect in this house at Shrewton.*

*Fig. 50: Brick and local flint have been utilised in the construction of these farm buildings at Fifield Bavant in the Ebble valley.*

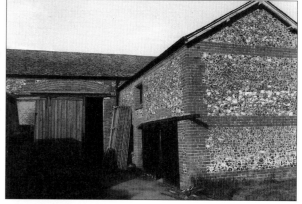

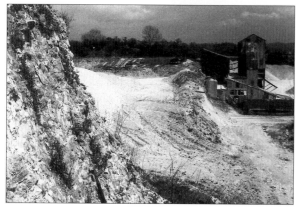

*Fig. 51: Charnage chalk quarry produces agricultural lime. The knobbly chalk on the left is the Chalk Rock hard-ground at the base of the Upper Chalk.*

been ground up and mixed with clay, water and even manure to produce a durable, if not water-resistant, building material. Wattle and daub involves daubing the mixture onto a framework of wood. Plaster is applied on top to make it waterproof. Cob walls were built up layer upon layer, the "cob" being left to dry in each layer before the next was added. The resultant broad walls can be identified by their rounded outlines; corners were avoided. Sometimes, a chalk, mud and water slurry was poured between shuttering to make pugged walls. Cob and pug, like wattle and daub, needed covering to protect them from the rain. Hence the quaint thatching which forms an attractive feature of some village walls in the Chalk country (Fig. 48). Stone or brick foundations were necessary to avoid damp rising from below.

Flints, particularly common in bands of the Upper Chalk, have been used as found, cemented with mortar. More sophisticated building involved splitting or knapping them to produce a flat face. Set facing outward, these produce a neat wall, and decorative effects have been achieved by alternating flint with bricks or stone (Figs. 49 & 50), which also serve to strengthen the wall. This can be seen throughout eastern and southeastern Wiltshire e.g. Upavon church, at Chitterne and at Berwick St. James, where a chequered pattern, characteristic of the Vale of Wardour, has been produced by using Portlandian limestone or brick with flint. In the Stone Age they were used as tools. Early Man recognised the value of their durability and characteristic way of fracturing to produce a sharp edge.

## Chalk's other uses

Chalk for agricultural lime and mortar was dug locally from small pits in many places. Now, however, with the introduction of Portland cement, quick-lime is no longer an ingredient of mortar and the lime kilns, where the chalk was heated to form quick-lime or calcium oxide (by driving off the carbon dioxide from the chalk), have been abandoned. There are numerous old lime kilns and their associated quarries about in the downs, e.g. below Warminster golf course (G.R. 875 460). Cement is made at Westbury. Chalk is crushed, mixed with water and brought down from the local quarry behind the scarp above the cement works by pipeline, as a slurry. The cement requires a certain proportion of clay, which may be naturally present in the quarrried chalk; failing this, Kimmeridge Clay, extracted from a pit on-site, is added together with iron oxide, sand, pulverised fuel ash (a by-product of power generation) and recovered cement kiln dust. They are heated in a rotary kiln to make cement clinker (calcium silicates). The clinker is ground up to produce cement powder, with the addition of gypsum (calcium sulphate) to control the setting time.

Agricultural lime is used on fields where soil is naturally acid, as in the

Tertiary outcrop area. There is a large chalk quarry at Charnage Down (Fig. 51; G.R. 837 329), which produces ground chalk for this purpose.

English China Clays have a huge quarry and processing plant a mile east of Wilton (G.R. 112 314), where they extract a very pure fine chalk. It is used in a wide range of industries as a filler, e.g. in paper, paint and fillers for the building trade.

## Sand and gravel

There are three current sources of sand and gravel in Wiltshire: the Lower Greensand east of Calne, the relatively recent old river terrace gravels of the upper River Thames and the Tertiary Bracklesham Beds in the southeast of the county. Sand and gravel are essential to the building and road-construction industries. Demand has risen steadily in the last fifty years.

The Lower Greensand is extracted by two companies from pits east of Calne (G.R. 015 710), where, as well as producing sand for concrete and roads, it is made into concrete blocks and slabs for building. It was until recently also obtained from the lower Corallian Beds at the Sahara Sand Pit (G.R. 939 648), but planning permission has not been renewed so it had to close at the end of 1998, in spite of being the only yellow building sand available in Wiltshire.

Sand continues to be extracted near the Hampshire border at Pound Bottom (G.R. 220 178), from the Tertiary Bracklesham Beds. The pit is used for waste disposal at one end, while extraction proceeds at the other.

By far the greatest source of sand and gravel is from the upper Thames valley in north Wiltshire. Numerous pits are been worked between Ashton Keynes and Cricklade. Concrete products (blocks, slabs and reconstituted "Cotswold stone" - Fig. 52) are produced on site there for the construction industry. In addition, there is sharp sand, with its special properties due to its angular grains and coarse texture. The Cotswold Water Park is being created as sand and gravel are extracted, the old pits being turned into lakes, providing leisure activities such as fishing and sailing, as well as nature reserves.

## Clay

Clay has been worked in many localities over the years as the need arose for bricks. In addition, its impermeability has been utilised for various purposes, ranging from lining farmers' dew ponds on the porous chalk high in the downs (Fig. 53), to filling cracks in the Kennet and Avon canal. The latter was notoriously leaky between Bradford-on Avon and Limpley Stoke. Land-slips eventuallly caused so much damage to the canal that it has since been re-built and lined with PVC and re-inforced concrete. More recent landfill sites for waste disposal are also clay-lined to prevent leakage (Fig. 54). The only large clay pit now

*Above, Fig. 52: Concrete products produced by Bardon Aggregates from ancient river sands in the Thames valley near Ashton Keynes.*

*Below, Fig. 53: Dew pond on the Marlborough Downs. The permeable Chalk was traditionally made to hold rainwater by breaking up the surface chalk in a suitable hollow then lining it with clay and straw, which was trampled into the surface cracks by sheep and cattle. Such ponds provided a much-needed water supply.*

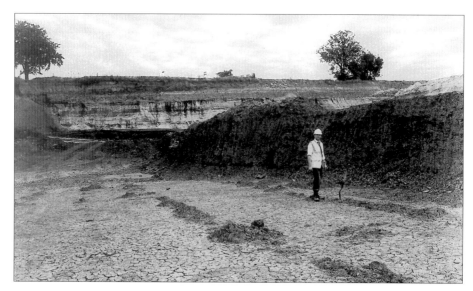

*Above, Fig. 54: Kimmeridge Clay beneath the Lower Greensand in the Hills Minerals and Waste pit, east of Calne; after extraction of the sand for building, the quarry, lined by impermeable clay forms an ideal landfill site.*

*Below, Fig. 55: Kimmeridge Clay used in cement manufacture at Westbury.*

being worked in Wiltshire is at Westbury (Fig. 55), where the Kimmeridge Clay is dug as required for cement manufacture at the adjacent works.

The bricks produced, before the local brickworks closed down, were various shades of red and gave a local character to each area. The small brick-yards tended to flourish while there was a local demand, then they declined and eventually closed. There were four possible sources of clay for Wiltshire brick-making: the Oxford Clay, the Kimmeridge Clay, the Gault Clay and the London Clay. The large brickworks at Purton (G.R. 086 888), used the Oxford Clay, which here has a chemically useful carbonaceous content. There were many small brick pits in the Oxford Clay around Dauntsey too at one time. If the clay is too pure, the plastic properties cause warping on firing, although sand can be added to combat this. The Gault Clay at Devizes contains sand and has an iron content, which produced a good red colour and a non-warping brick. The Caen Hill pit (G.R. 982 613) was opened when the construction of the long flight of locks on the Kennet and Avon canal here revealed this excellent clay supply. A million bricks were taken along the canal to build the Savernake tunnel (through which the canal passes). The Devizes Brick and Tile works, opened in 1845, was closed down about 25 years ago. There were many other Gault Clay brickworks e.g. at Crockerton, near Market Lavington and at Badbury, south of Swindon.

Tanner's Brickworks at Oakridge Wood south of Salisbury (G.R. 202 261) used the London Clay, as did the Dodsdown brickworks near Wilton (G.R. 275 620) in the east of the county. They were both very small scale and are now closed.

## Iron ore

There are two iron-bearing formations in Wiltshire's rocks: the Lower Greensand and the Corallian Beds. They have both been exploited in the past. Iron ore and slags have been found at Iron Age hill forts at Lidbury and Casterley as well as at All Cannings Cross. In the Seend and Bromham areas (both on the Lower Greensand), ash and slag have been found in association with Romano-British remains. A Saxon smelting furnace has been located at Ramsbury.

More recently, Seend was one of the two centres of iron ore extraction. Working started commercially in 1856, when records show the sale of 2,000 tonnes to South Wales. A tramway was built to carry the ore to the Kennet and Avon canal in 1857, when there were exports to Staffordshire as well as South Wales. That same year, a company was set up to smelt the ore at Seend and, after initial problems, was producing 300 tonnes per week in 1860. But several companies later, in 1889, beset by financial problems, the blast furnaces were demolished. Ore was again extracted for several years from 1904, but after the First World War a fall-off in demand resulted in closure. There is still much

low-grade ore remaining. The Lower Greensand at Seend has 65% iron oxide in concretions (Fig. 17), which are found in irregular bands up to seven metres thick. They can be seen in the old quarry at Seend (G.R. 937 610).

Along the northwest edge of Westbury, parallel to the railway, a local iron-rich development in the upper Corallian Beds was first utilised by the Romans. The deposits were found during the construction of the Great Western Railway line in 1841. The iron ore was profitably worked from 1857 until 1901 and then, after a brief period of closure, from 1903 until 1925. Furnaces produced 250 tonnes of iron per week. The old workings now contain lakes (Fig. 56) and are used for recreational purposes.

*Fig. 56: Old iron ore pit by Westbury railway station, now used for fishing and boating.*

## Soils

Soils are directly related to the parent rock below, which breaks down during weathering and becomes mixed with decomposing plant material (humus) as a result of the activity of bacteria and creatures living in the soil, noteably earthworms. Rainwater also has an important effect, as it percolates through the soil, washing out minerals and soluble components of the humus. The permeability of the underlying rock is therefore an important factor in determining the degree of this leaching process, as is the amount of humus present; this retains moisture and impedes water percolation. Impermeable rocks such as clay may support waterlogged soils, lacking sufficient oxygen for the decay of dead vegetation and humus formation -although this may only be during seasons of particularly high rainfall.

The Jurassic limestones have limey, well-drained, humus-rich brown alkaline

soils. The clays of that period are calcareous and produce heavier brown, slightly alkaline soils, which may, however, be waterlogged.

Typical trees of these limestone soils are beech and oak, beech on the hillsides and oak elsewhere, as beech can grow on all soil types but can't tolerate its roots being waterlogged. Oak can grow on waterlogged clay, but can't compete with beech on the dry hill-sides. Beech has been planted on a large scale during the last 200 years. The ash and field maple are typical woodland trees of the Jurassic clays. The clay vales, formerly entirely forested, now contain rich pastures. The farming is mainly dairying, with some sheep and mixed farming. Crop-growing is limited by poor drainage, although cereals grow well where the land has been drained. The well-drained soils of the limestone plateau are used for cereal growing. The deep valley sides are frequently wooded.

The Lower Greensand soils are sandy and well drained. They are acid brown earths with a high iron content, that encourages, notably, the growth of the lovely rhododendrons of Bowood. They are also suitable for market gardening, as is apparent around Bromham. The Gault Clay is non-calcareous and produces a heavy poorly-drained soil, but as it occurs in a band at the foot of the Chalk escarpments, its soils are modified by downwash from the Chalk and Greensand above. The Upper Greensand is often calcareous and it, too, receives downwashed marl and chalk, which improves the texture of its soils. It produces a good, light, neutral-calcareous humus-rich sandy loam which is excellent for agriculture, especially cherries and plums, as it has a high iron content (from the glauconite it contains). The Vale of Pewsey supports a mixture of grazing, cereals and horticulture. Many years of leaf-fall and leaching in the woods of Longleat and Stourhead have resulted in slighty acid soils on the Upper Greensand there, with a flora that includes rhododendrons and heathers.

As chalk weathers, the calcium carbonate is dissolved, leaving only the clay component, insoluble flints, fragments of chalk and humus to form soil. Hence soils on the Chalk are thin, light, alkaline loams, which produce good turf for sheep-grazing. They are highly calcareous and free-draining. The Lower Chalk, with its higher clay content, has stiff marly soils. Centuries of sheep-grazing have increased the amount of humus to produce rich loams suitable for cereals and some mixed farming too. Though large flints are a nuisance, small flints are actually valuable in helping prevent wind erosion and also assisting germination of the seeds by transmitting heat, whilst at the same time reducing evaporation and providing better root anchorage. The steeper scarps and combes are used for grazing. Ash and sycamore as well as beech are the typical trees.

The Clay-with-Flints, and the Tertiary sands and clays covering the Chalk in places, are deficient in lime and often waterlogged. They have neutral to acid soils generally on the higher ground, allowing carpets of bluebells to flourish in

the West Woods and Savernake Forest. Bluebells don't thrive on calcareous soils, particularly those of the Chalk, although a forest cover will yield lots of humic acids, and bluebells will grow where there is a build-up of leaf-litter. Even the acid-loving heathers can be found in places, both here and on the northern fringes of the New Forest.

## Water supplies

The Chalk is the U.K.'s principal groundwater reservoir (or aquifer) and can store prodigious amounts of water, because chalk is not only highly porous (about 45%) but is permeated by small fractures which can fill with water. It is estimated that it contains half the capacity of all the reservoirs of Britain. The network of cracks, with rough, irregular surfaces, gives the rock its high permeability. The water in the actual pore-space tends to be held by capillary forces, as the chalk is so fine grained. Downward movement of rainwater is stopped by impervious bands of rock, such as marls in the Lower Chalk. These in turn rest on permeable Upper Greensand lying on impermeable Gault Clay, and, as fractures provide water conduits through the marl bands separating them, the Chalk and Upper Greensand are in effect parts of the same reservoir. Given unlimited rainfall, the reservoir rocks will eventually become completely saturated with water as thick clays below prevent further downward movement. The top of the zone of groundwater saturation is known as the water table. Its level will vary according to the amount of rainfall. It takes about three weeks, at least, for the rain-water to affect the water table level, which tends to be higher in winter. Wells at higher levels in the aquifer rarely need to be very deep in the British climate. Individual boreholes in the Chalk can yield over ten million litres of water a day. Where the water table meets the surface of the ground, a spring will emerge. The springs appear at one or other of two possible levels in the Chalk / Greensand reservoir. The chalk springs come out just above the base of the Chalk, above the marl bands, their flow reflecting seasonal rainfall variations. In valley bottoms which are above the water table in summer, but below it in winter, streams will be seasonal bournes, flowing only in wet seasons. Because of the time-lag between the rain falling and the water actually reaching the groundwater reservoir, the winterbournes may continue flowing until June before drying up. Some valleys are always without streams. These dry valleys, so typical of the Chalk country, were cut at a time when the water table was higher during the last Ice Age, and when permafrost would have rendered the chalk impermeable so that valleys could be cut by surface streams, augmented by melt-waters from the glaciers. Further springs emerge from the Upper Greensand below the Chalk, from a level between the Chalk and Gault Clay which will depend on the local water table. The flow from these springs is remarkably constant as they are independent

of rainfall from the preceeding months; they are at such a low level in the groundwater reservoir that they are constantly under the pressure of a massive head of water. The direct result of this constant supply of water is that settlements were located along the Greensand outcrop where, in addition, there was a variety of soils for arable crops (Greensand and Lower Chalk), cattle meadows (Gault Clay) and sheep pasture (Chalk downs). A brief glance at the Ordnance Survey maps will reveal numerous examples of these spring-line villages around the edges of Salisbury Plain and the Marlborough Downs. Springs at the foot of the Chalk escarpment feed streams which, for example, in the Vale of Pewsey form the source of the Hampshire Avon; while the Thames and the Bristol Avon are in part fed by streams flowing north from below the scarp of the Marlborough Downs.

The Jurassic limestones in the Cotswold Hills are important aquifers too, particularly the Great and Inferior Oolite which may yield up to 5000 cubic metres a day. Again it is the extensive fracture system that gives them such high permeability. The Thames and Bristol Avon both have their sources in the Cotswolds. Local groundwater abstraction has lowered the water table and has caused the perennial head of the Thames to move down the valley. Where the limestones are confined above by poorly permeable younger rocks (the Kellaways and Oxford clays), the groundwater becomes more saline and is unsuitable for

*Fig. 57: Watercress beds at Broad Chalke where springs emerge from the Chalk in the Ebble valley.*

public supply where it is more than a few kilometres down-dip of the outcrop.

The Corallian limestones are only of local significance as aquifers.

The water authorities make use of these natural underground reservoirs. Groundwater is mainly extracted by drilling boreholes. Pumping from a borehole causes a depression in the water-table and it is obviously important to maintain acceptable levels of surface flow in streams and rivers. There are thus various management schemes. In dry periods, river flow is augmented with groundwater pumped from wells, which can be used as natural aqueducts to supply centres of demand downstream. Careful siting of the borehole is necessary. The converse is the artificial recharge of aquifers during wet periods when supplies are plentiful. Excess surface water is injected into boreholes to top up the aquifers, storing the water for use in drier periods.

The pure water emerging from the Chalk / Greensand aquifer is ideal for watercress cultivation (Fig. 57). This is carried out at several localities in southeastern Wiltshire e.g. in the Ebble valley at Broad Chalke and Bishopstone; also at Idmiston on the River Bourne.

# Part 2

# EXPLORING WILTSHIRE

W hilst respecting farm crops and fences, I tend to exercise, with discretion, the 'Right to Roam'. Many of the places mentioned, whether Sites of Special Scientific Interest or Regionally Important Geological Sites, are on private land, and permission from the owner should strictly be obtained. Even where they are close to roads or public footpaths, access to the rock is frequently not easy, and a determined effort might be needed to find the outcrops in the more impenetrable thickets. Serious geologists may want to visit the excellent exposures to be found in working quarries. The managers are usually obliging, even keen to demonstrate that they are not out to wreck the environment but simply providing the requirements of civilisation; however, the trip will need advance planning. The less dedicated may prefer more informal investigations and confine themselves to the old pits scatterered about the countryside, regarding the expedition as more of an excuse for a bit of fresh air and exercise. A look at the geology will certainly add a new perspective to any country ramble.

I don't, personally, enjoy visiting working quarries very much, although you can, of course, see the rocks! But their particular combination of mud, rubble, dust and noise do not make them my idea of a pleasant place to be. Old quarries are a different matter, as long as they haven't become rubbish dumps. Their weathered surfaces have had structures and fossils picked out by the elements, and it is frequently not necessary to hammer in order to see what is there. Fresh rock surfaces are nevertheless needed in order to distinguish rock types; so a geological hammer is useful, and fossil extraction will definitely require such a tool. It will become apparent in the following pages that a certain degree of patience is required to find fossils, together with a fair amount of luck.

The author and publishers can accept no responsibility for torn clothing, wet feet, or bodily injury sustained while attempting to inspect any of the locations mentioned in this guide. You do so entirely at your own risk. Good luck!

Maps: The 1:50,000 scale Ordnance Survey Landranger maps are essential equipment, adequate to follow the expeditions. Five are needed to cover Wiltshire (Sheets 172, 173, 174,183 & 184). Even better, of course, are the 1:25,000 maps; with them you can at least be sure of being in the right place! Many of the localities are, at this scale, marked as "old pit", and the lack of rock outcrops in Wiltshire actually makes the larger scale topographic map the best tool for locating those that do exist. Fifteen geological maps (see page 213), at a scale of 1: 50,000, are required to cover the county so, in order to simplify things, appropriate sketch maps of the most interesting geology are provided here.

To aid precise location of points of interest, six-figure Ordnance Survey map grid references are given (prefixed with G.R.). Those not familiar with their use will find an explanation on the 1:50 000 Ordnance Survey maps. The British National Grid square identification letters (ST, SU etc.) have not been used, as it is always obvious from the context which map sheet you should be using.

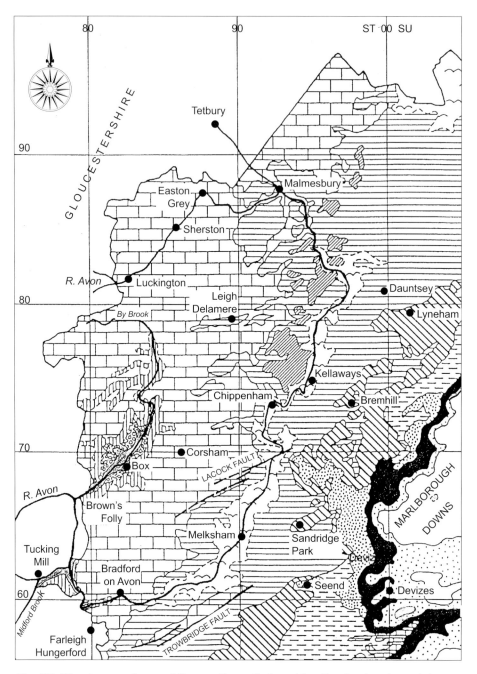

*Fig. 58: The Avon valley and the southern Cotswolds. For the key to rock types, see page 142. Based on information from the Geological Survey maps, drawn by G.W. Green. Grid lines are 10km (6.25 miles) apart.*

96

# 4: The Avon Valley and the Southern Cotswolds

The River Avon rises in the Jurassic limestones of the Cotswolds and has its source just across the county border at Badminton Park in Gloucestershire. From thence it flows southeast of Malmesbury, passes down into the vale of the Oxford Clay, following it southwards through Chippenham and Melksham until, unexpectedly, it turns west, a couple of miles north of Trowbridge, to re-enter the limestone hill country at Bradford-on-Avon. From here to Bath it has cut a deep steep-sided valley, through which it leaves the county beyond Limpley Stoke (Fig. 58). Why it should have returned to the harder limestones of its source is not clear. The reasons for this rather odd behaviour possibly date back to times when drainage patterns were different from those of today (i.e. the drainage pattern has been superimposed upon the present rock outcrops). At one time, the Jurassic rocks, including the Oxford Clay, were still covered by the Chalk, as is still the case fifty miles south of here, in Dorset, where the Oxford Clay is covered by Cretaceous rocks, (which extend westward to rest directly on the Great Oolite). The Oxford Clay does not reappear from beneath this unconformity until Weymouth on the south coast. It is hard to know just which rocks were exposed and what the relief of the land was like at the time when the drainage systems were established. Tilting to the southeast during the formation of the Alps caused an originally southeastward drainage pattern, later modified as streams picked out the softer layers of rock. One theory is that something, either glacial debris or ice, dammed the obvious likely southward route along the clay. The idea is that a lake would then have formed, which might eventually have overflowed through a notch in the limestones to the west, thus draining the lake. The problem with this theory is that if such a lake had formed, it would have been more likely to overflow the low ridge between Malmesbury and Swindon into the valley of the Thames, unless, of course, the latter was still covered by ice. The deep valley cut through the limestones may simply be due to a gradual rising of the land / falling of the sea-level since the Ice Age, at a rate with which the rivers could keep pace as they eroded their valleys downwards. The same situation is found in the Avon gorge at Bristol and in the nearby Wye valley, which leaves its broad floodplain on the sandstones of Herefordshire to cut through the limestones between Monmouth and Chepstow. In the latter

case, the meanders have incised a deep winding valley in response to the slow rising of the land. West of Bath there are terraces along the Avon (at 24 metres), representing what remains of higher valley floors; and around Portishead, there are raised beaches on the Severn at heights of three metres and fifteen metres, indicating higher sea levels in the past.

## The upper reaches of the Avon

The upper Avon can be followed on the B4040 road from its source at Badminton Park, through Luckington and Sherston, to Malmesbury. The valley here is not deeply incised, but open, owing to the small size of the young river flowing down the dip slope of the Forest Marble's limestones and clays. The scenery on the dip-slope of the Cotswolds is not nearly as spectacular as that of the scarp found a few miles away to the west in Gloucestershire, where the steep edges of the Great Oolite and Inferior Oolite limestones overlook the Severn Valley. The landforms in Wiltshire's Cotswolds tend to follow the rock layers as the limestones of the undulating plateau dip gently southeastwards under the Oxford Clay.

The River Avon has cut through the Forest Marble at Luckington to expose the Great Oolite below along its valley. Just south of the river here, (near the lane to Alderton), beds of the Forest Marble Formation and the top of the Great Oolite beneath can be seen above the footpath, at the side of the field (G.R. 835 833). These old quarries show cross-bedded, shelly oolitic limestones; some pale and pinkish, others brown, sandy and full of burrows. The beds dip very gently southwards. There are a few centimetres of thin brown clay between the limestone units. Fossil brachiopods, bivalves, gastropods (snails) and sea-mats are common, if you can find bits big enough to identify.

Whether you bother with an even smaller outcrop, below the public footpath north of the road before you get to Sherston (G.R. 849 856) will depend on how desperate you are to see some coral limestone. Cream-coloured limestones, full of coarse shell debris and cross-bedding typical of the Forest Marble, pass westwards around the corner from the main rock face, hidden behind a bramble and nettle patch, into more rubbly brownish-looking limestone with less distinct bedding. Hammering it reveals coarsely recrystallised corals, circular in cross-section; but you would have to be a bit expert to recognise them as such.

The overlying Cornbrash limestones appear for the three miles between Easton Grey (Fig. 59) and Malmesbury. Here, the Avon valley sides steepen as it cuts through them, their combination of hardness and permeability making them more resistant to erosion. Malmesbury is a picturesque old town sited at the edge of the Cotswolds, on a sloping platform of Cornbrash limestone overlain by a thin capping of Kellaways Clay. It is situated at the confluence of the main

*Fig. 59: The River Avon at Easton Grey in the southern Cotswolds.*

River Avon and its tributary, the Tetbury Avon. Both have cut deep valleys through the Cornbrash limestone into the underlying clays and limestones of the Forest Marble, producing a narrow ridge which is followed by the High Street of the town. A castle used to guard the entrance to this promontory, which was formerly surrounded by a wall. The Bell Hotel, next to Malmesbury Abbey, now occupies the site. Explore the partially ruined abbey and the town while you are here. Blick Hill cuts through the shelly Cornbrash limestone (G.R. 938 875), a lane running west from the by-pass. This exposure is, however, rather small and scruffy (and there is nowhere to park). A disused quarry east of Lower Stanton St. Quintin (G.R. 920 806) provides better exposure, just south of the road to Upper Seagry. A small tributary of the Avon here cuts through the Cornbrash into the Forest Marble, producing short, steep slopes on the hard limestones of the valley sides. The yellow-weathering rocks are rubbly near the top of the section, but lower down they are more solid, and some cross-bedding is visible where the top of a shell bank has been truncated by subsequent erosion, followed by deposition of the next bed. The rock is cream-coloured and packed with broken shell fragments and ooliths - these are most easily spotted where they have been picked out on the weathered surfaces of pieces found lying around. The site has yielded notable fossils, especially ammonites.

If you want another look at the Forest Marble, there is a particularly good example behind the back lawns of the Travelodge at Leigh Delamere service station on the M4 motorway (G.R. 892 793; it can be accessed from the minor road over the motorway too). The characteristic cross-bedding is magnificently displayed (Fig. 60). The shelly detrital limestones are a bluish colour when freshly broken, but the shells are best seen on the yellow weathered surfaces.

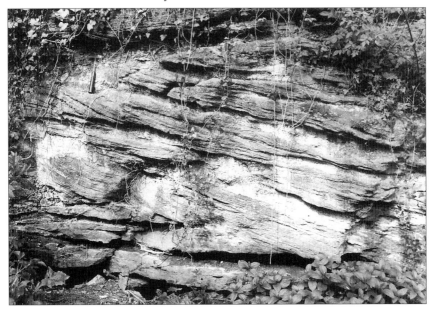

*Fig. 60: Limestones of the Forest Marble at Leigh Delamere showing cross-bedding, the result of deposition by currents of broken shell debris on the forward edge of migrating ripples in the sediments of the sea floor (comparable with the forward movement of sand dunes due to prevailing winds).*

## The clay vale below Malmesbury

From Malmesbury, the Avon meanders southwards up the geological sequence into the Kellaways and Oxford clays. These are hardly ever exposed, except in temporary excavations. The building of the Great Western Railway in the last century revealed remarkably well-preserved fossil remains, even with some soft body parts, of belemnites, fish and reptiles. There were several small clay pits for brick-making at Dauntsey, but they are no longer visible. The river can be followed on a back road through Great Somerford, where river gravels were once extracted. The old pits are now lakes (G.R. 966 820), but they are not accessible.

There are some harder beds in these clays. A calcareous sandstone band, known as the Kellaways Rock, was used between Langley Burrell and Kellaways (northeast of Chippenham) to build Maud Heath's Causeway, a 15th Century foot-bridge over the floodplain, with sixty arches to accommodate floodwaters (Fig. 61); it was paid for by a certain Maud Heath. The road runs below the causeway. The Kellaways Rock appears in the west bank of the Avon below the bridge (Fig. 62). However, it is easier to get at half a mile downstream, if you take the footpath southwards along the east side of the Avon. Underneath a convenient footbridge, on the west side, the Kellaways Rock can be examined (G.R. 944 749). Highly fossiliferous calcareous sandstones are underlain by grey Kellaways Clay; there are some orange, iron-rich sandy bits in it. The fields above are scattered with well-washed specimens of a variety of fossil shells, in particular the oysters known as Devil's Toenails (Fig. 63). Another fossiliferous sandstone outcrop appears beneath the alder tree on the west bank 150 metres beyond the footbridge (Fig. 64). Well-preserved bivalves, snails, brachiopods, belemnites and ammonites have been found. On your return, note the low Corallian limestone escarpment, forming the southeastern side of the valley towards Bremhill.

South of Chippenham, faulting west of Lacock has caused the valley of the Avon to narrow, by reducing the thickness of the Oxford Clay (Figs. 58 & 65). This has brought the Cornbrash limestone, which rise westwards towards Corsham, nearer to the Corallian limestones above the Oxford Clay just to the east of the river. The newly opened section of the Chippenham by-pass, west of Chippenham, crosses the Cornbrash, so there should still be lots of fossils lying around any recently exposed bits; they can, in fact, be found in the soil of ploughed fields anywhere on the outcrop (Fig. 14).

A detour up the scarp formed by the Corallian Beds on Naish Hill will give a broader view of the Avon valley at this point and help get things into perspective. From the track just beyond Ash Farm (G.R. 939 694) there is a superb view of the Avon valley, narrow around Laycock, broadening out towards Chippenham. The escarpment can be traced past Derry Hill northeastwards towards Lyneham. This hill is actually capped by the Cretaceous Lower Greensand formation (overlying the Jurassic rocks -see Fig. 65). There was once a quarry up here not so long ago, to the north and west of Kilima Farm, but now the sandstone is simply marked by a change to heathy-looking vegetation, with silver birches; the odd lump of dark orange iron-stained sandstone, typical of the Lower Greensand, can be found in the hedgerows. A remnant of the old pit has been preserved (for the sand martins) in the field north of the main lane, which can be seen from the lane bank immediately opposite the point (G.R. 938 692) where the public footpath emerges from Bowden Park. If this footpath is

Fig. 61: Maude Heath's causeway -a footbridge over the Avon floodplain, built of Kellaways Rock, a calcareous sandstone, in 1474. The wall along the path is brick.

Left, Fig. 62: Kellaways Rock exposed in the bank of the River Avon at Maud Heath's causeway.

Below, Fig. 63: Devil's Toenails (Gryphaea bilobata) from the Kellaways Beds.

*Above, Fig. 64: Fossiliferous sandstone of the Kellaways Rock in the bank of the River Avon southeast of Kellaways.*

*Below, Fig. 65: Section across the Avon valley from the Cotswold limestones near Corsham to the Corallian Beds and Lower Greensand of Bowden Hill.*

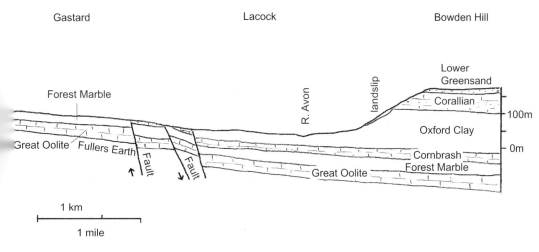

followed southwards along the hill for about a mile, there are some beautiful views over the narrowed Oxford Clay of the valley at Laycock as well as a view of the lovely Bath Stone mansion. Return to the Avon valley via Bowden Hill, the same hill, but a mile or so farther south. It too gives another lovely panorama from above the church (G.R. 938 678), in a southwesterly direction over the clay vale, much wider here away from the effects of the fault.

The river meanders onwards to Melksham, the vale widening again. Artificial straightening of the meanders actually increased flooding problems around the town, which shows that the consequences of interfering with nature are not always predictable! In 1770, during the search for coal, a spring was discovered to the southeast of Melksham: "After penetrating to a great depth, the miners came to a hard rock, on piercing through which this water rushed in upon them, and was so abundant, that the scheme for finding coal was entirely abandoned" (The Melksham Guide, early 19th century). They must have gone right through the Oxford Clay, into the Kellaways Beds below, where they hit a water-bearing sand at a depth of 100 metres. Hydrostatic pressure would have been such that "a spring gushed forth". The local people noticed "salutary effects" from drinking the water, having observed such on their cattle, not to mention the wood pigeons! Several "respectable gentlemen" formed the "Melksham Spa Company" around 1814, with the object of developing a spa here, along the lines of Bath - they were all the rage at that time. The spring had been analysed and found to have a high iron content, so they sunk a second well into the field in the hopes of finding a saline well to complement the chalybeate (iron-rich) spring. Saline waters have a purgative effect and the iron was considered to reduce the side effects of this! So providing the two side by side was a good business proposition. Drinking and bathing in the water was considered efficaceous in the treatment of "sores of a scrophulous nature". The venture failed, but water was bottled and sold to cure skin diseases into the 1850s. The three lodging houses are still there at the end of Spa Road, at the back of the roundabout on the A 365 road to Devizes (G.R. 914 628; Fig. 66), but neither well is now visible. There are only some remains left of the coach houses and the pump house built over the original well (which became a school in 1842 for fifteen years). They are a poignant reminder of the days when Melksham hoped to compete with the fashionable Bath Spa.

East of Melksham, some of the Corallian rocks of this side of the valley can be seen in the Sahara Sandpit, up the A3102 road at Sandridge Park (G.R. 939 647). The pit, closed at the end of 1998, worked sands of the lower Corallian Beds. Although I don't normally like working quarries, or recently closed ones where nature has not yet had a chance to make good the damage, I do recommend this one. Along the eastern edge of the pit is a face which shows several metres

of spectacularly coloured soft sand, alternately yellow-buff, orange and dark orange, showing up the cross-bedding clearly. There are hard calcareous sandstone interbeds jutting out of the cliff. Fossils have weathered out of these harder sandstones, including sea urchins and occasional ammonites. To visit, permission will be needed from the house alongside. As you return down the hill, there is a lay-by (G.R. 936 646) on the left. Stop to appreciate the view to the south. Rising above the Oxford Clay of the Avon valley and Melksham, the stepped structure of the Seend ridge is clearly visible (described in Chapter 6), the Corallian Beds forming the lower step, the Lower Greensand the upper (Fig. 119).

*Fig. 66: The Melksham Spa.*

As Trowbridge is approached, turn west at Hilperton on the B3105 road towards Staverton and Bradford-on-Avon. You may notice that the Hilperton by-pass rises uphill, and that Hilperton overlooks the clay vale. The reason for this is that there is a faulted anticline here raising Cornbrash limestone, over a distance of five miles, up through the Oxford Clay to form a hill - hence the village's name. From Hilperton, descend back into the Avon valley to cross the river at Staverton, traversing the dip-slope of the Forest Marble to reach Bradford-on-Avon, where the valley sides suddenly rear up, at first on the north side of the town. Here, on the outside of the meander bend, the river has cut into the Great Oolite limestones, with their capping of Forest Marble.

## The limestone valley west from Bradford-on Avon

A good view of the geography can be obtained from this northern slope of the valley at Bradford-on-Avon, a fascinating small town which deserves exploration. An exhilarating, if strenuous, climb up the narrow alleys and steps linking the main streets takes you up to a vantage point in St. Mary's Tory, by the Victorian chapel at the end of one of a series of terraces ranging up the hillside (G.R. 822 609). It is on the site of the earliest non-conformist chapel in the town. A spring comes out of the limestone here, probably the water supply of the early Iron Age village, fortified by double ditches (called Budbury), located on this hill top. Roman coins have been found here too. This was the beginning of Bradford-on-Avon's long history. It became rich with the growth of the woollen industry in the 17th and18th centuries. The old mill buildings are still there by the river, some in a state of decay, others renovated as flats. There are many fine houses made of local stone.

But to get back to the geology, from here the southward continuation of the broad clay vale can be viewed, with the Chalk scarp of Salisbury Plain beyond identifiable by the Westbury White Horse and the cement works chimney. Eastwards, the escarpment stretches into the distance along the Vale of Pewsey. An even better view can be obtained by wending your way up the footpath from the topmost terrace (behind St Mary's Tory). The geological panorama extends to include the end of the Marlborough Downs above Devizes, on the northern edge of the Vale of Pewsey, and the wooded Upper Greensand hills of Longleat, with the chalk outlier of Cley Hill stranded alone, in front. This upper viewpoint (G. R. 823 610) can in fact be accessed easily by car from a convenient car park at the end of Budbury Place, south from the B3108 road to Winsley. The less energetic can also get a similar view over the wall opposite the lay-by on the B3109 just south of its junction with the B3105 road at the cross-roads by the Leigh Park Hotel (G.R. 831 619). Here the vista includes not only Longleat and Cley Hill, but expands further northeastwards to the Corallian escarpment east of Melksham, lying below the Chalk of the western Marlborough Downs. The escarpment of the latter is on the horizon, with the woods of Roundway Down at the southern corner and the distinctive sparse trees and grass of Oliver's Castle projecting out in front to the left. The rock layers laid out before you can actually be envisaged: Chalk lying on top of the Greensand hills, themselves resting on clay, then limestone, all above the Oxford Clay of the vale below (Fig. 2 & 10).

The Avon did not continue down the clay outcrop. Instead, it turned westwards, toward Avoncliff, and the south side of the valley soon steepens to match the northern one as you leave Bradford. Some oolitic freestone can be seen in an old mine entrance on the south side of Bridge Street (G.R. 827 607).

Many of the pre-Victorian buildings are built of it. There are fossiliferous, marly limestones above the oolite, with extra-large ooliths (termed pisoliths), but the exposure is very overgrown and the same rocks can be better viewed elsewhere (at Avoncliff, for example). A footpath will take you all the way to Bath from just beyond the railway station, either following the river or the Kennet and Avon canal running parallel to it. It is a lovely walk, about nine miles, full of interest and well worth doing. There are good pubs at Avoncliff, Limpley Stoke and Bathampton. There is no need to do it all in one go! In any case, head for the fourteenth century tithe barn, one of the biggest in England, located between the river and the canal on the western edge of Bradford. Apart from its remarkable rafters, it is built of local limestone (showing some interesting bedding features!) and tiled with stone tiles of thinly-bedded Forest Marble (Fig. 67).

Avoncliff is fascinating too; there are delapidated structures that once housed the mills, and a magnificent aqueduct carrying the canal over the Avon (Fig. 37). A tramway from Westwood, high on the valley side above, brought stone down to the railway siding. The Westwood mine was opened to provide a supply of stone for the building of the Great Western Railway, and mining has been fairly continuous since, producing a labyrinth of tunnels which have subsequently been put to a number of imaginative uses, including mushroom-growing, storage of art treasures from London's Victoria and Albert Museum during the last war, and motor bike manufacture. It is still used for document storage, mainly from the City of London (where office space is considerably more expensive!). The limestone has been widely used for buildings, including Bradford-on-Avon's new library, and for restoration work.

By car, this deeply incised part of the Avon valley is most spectacularly seen by approaching either via Winsley on the B3108, or from the south on the A36 as it descends to Limpley Stoke (Fig. 68). I would recommend a route, first of all, from Bradford to Avoncliff, following the north side of the Avon. At the end of the road, by the railway station and the Kennet & Avon canal aqueduct, in the bushes on the north side (G.R. 804 601), there is a rather overgrown exposure of the highly fossiliferous Inferior Oolite. The aqueduct is under repair at the time of writing, using stone from the Stoke Hill mine at Limpley Stoke (Fig. 38). This mine was re-opened in the 1980s and has supplied stone to repair Windsor Castle (carried by barge on the Kennet & Avon canal). Take a detour across the aqueduct to an old quarry in the woods a few hundred metres beyond the last house (opposite the gate into a field, G.R. 807 599). Here the lowest freestones are found. Hard, creamy pure oolite, with a smooth texture, is overlain by more bumpy-looking fossiliferous beds with an irregular erosion surface at their base (Fig. 69). The freestone beds are thick and gently dipping. Look at weathered

*Above, Fig. 67: The 14th century tithe barn at Bradford-on-Avon built of local limestone, with tiles of thinly bedded Forest Marble.*

*Below, Fig. 68: The Avon valley from Limpley Stoke to Bathford.*

fragments on the ground to spot the fossils and the ooliths. This locality has several small, near-vertical faults, displacing the beds by 20-30 centimetres. These are superficial structures related to movement towards the valley. The extremely steep, wooded limestone slopes can be appreciated here, the hidden lanes, overhung by trees, have a timeless air of mystery, luring the explorer onward. However, there are plenty of these on the other side of the river, so retrace your steps now, back to the lane next to Avoncliff station (and perhaps your transport). Return towards Bradford, but take the first turning left (less than a mile), up the valley side to Turleigh. Here, a spring gushes out of the valley sides, formerly the village water supply. The water was brought down the hill via the Turleigh Trows (or Troughs), a series of seven moss-covered stone channels. They are just after the bend leaving the village, as the lane rises up to Winsley (G.R. 804 607).

An old quarry (closed in the 1930s) in the Great Oolite limestones is still in existence at Murhill, down another lane from the southwest end of Winsley. There is a car parking area in the woods almost opposite the quarry (G.R. 795 607). Though the main face remaining today, with its walled tunnels into the hillside, has been fenced off, the upper slopes in the woods have further mine entrances, with smaller rock outcrops of the pale, creamy-yellow limestone. Shell fragments and ooliths show up best on weathered surfaces. Just inside the lowest tunnel entrance, the junction of the Great Oolite and the underlying Fullers Earth can be seen -the only place in Wiltshire! Grey clays alternate with muddy limestones (Fig. 11). Bat colonies inhabit the tunnels. The quarry was opened in 1803 to supply stone for the Kennet and Avon canal below; Murhill Wharf (down the steep lane opposite the quarry) has recently been cleared of undergrowth. A trolley-way linked it to the quarries. The rails can still be seen, in and to the left of the footpath to the wharf (G.R. 796 605); bear left below the last house. Again, springs emerging below the road, around the 90 metre contour, supplied this hamlet; it has only recently been connected to the mains.

Farther along (i.e. to the northwest), rock faces can be found in the overgrown, often precipitous, upper slopes below the lane by Conkwell pig farm (G.R. 792 624). There were more quarries here, supplying the canal-builders via another trolley-way. The Dundas Aqueduct at the foot of the slope (Fig. 70) below Conkwell is a short scramble down, but a tough climb back up! Construction started in 1796, but it wasn't opened until 1805 due to financial problems and a stone crisis. The canal company insisted on using their own quarries to provide stone for the canal, in spite of protests from the engineers, who in fact favoured the more reliable brick. The stone did prove to be of poor quality both here and at Murhill and the canal structure suffered from its crumbling. The aqueducts

*Left, Fig. 69: The Great Oolite at Avoncliff showing the uniform "freestones" of the Combe Down Oolite beneath the fossiliferous Twinhoe Beds.*

*Below, Fig. 70: The Dundas aqueduct, built of Bath stone from the hillside, carries the Kennet & Avon canal over the River Avon.*

can be seen to have been patched up many times. This part of the canal, between Bradford and Bathampton also had a severe problem with water loss resulting from land slippage caused by the geology (see below). The cracks used to be filled with clay from the Forest Marble, used as a lining. The old quarries on either side of the canal at Bradford-on-Avon (G.R. 822 603 & 826 601) are now so overgrown that there is little to be seen today. The canal has now been renovated and lined with PVC and concrete.

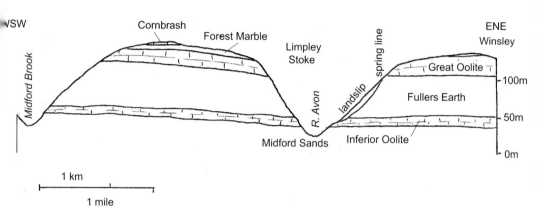

Fig. 71: Section from Midford to Winsley across the Jurassic rocks in the valleys of the River Avon and the Midford Brook.

Wiltshire's oldest rocks, of early Jurassic age, can be found at the bottom of the valley below Stokeford Weir, in the steep eastern bank of the Avon opposite Limpley Stoke. The cross-section through the valley (Fig. 71) shows why they appear here and in the valley of the Midford Brook a few miles away, where the rivers have cut right through the younger layers of rock above. Access is not easy: you may feel safer roped to the hedge above, in view of the slippery nature of the descent to the river! There are some oolitic and crystalline pink-grey limestones, weathering orange and containing youngest early Jurassic fossils (Upper Lias to the initiated), including ammonites (Fig. 72), belemnites, brachiopods and bivalves. These are the rocks underlying the Midford Sands, which were formerly exposed higher up the bank and are 30 metres thick here. These sands can actually be seen by making a slight detour up the Midford Brook to Tucking Mill (G.R. 766 615), the one-time home of William Smith (see Chapter 1). It is just over the border with Somerset, which runs along the brook. There is a tablet on the wall of Tucking Mill Cottage stating that he lived here, although in fact it should be on Tucking Mill House down the road. The mill itself was demolished in 1931. It was a fulling mill which used the Fullers Earth

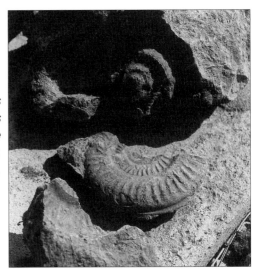

*Fig. 72: Ammonite (Hildoceras bifrons) from the Upper Lias limestones in the bank of the River Avon at Stokeford Weir. Photograph by Peter Geddes.*

clay found up the valley of the Horsecombe Brook, that enters the Midford Brook here. The bottom of this tributary valley now contains a small reservoir built by Wessex Water in 1976 (not marked on the O.S. map). A footpath goes along the northern side from the road (G.R. 766 616) and on the slope, just above, there are exposures of the Midford Sands. These localised sands are about 30 metres thick at this point (the base being below the level of the Midford Brook). They are soft, friable, pale beige-coloured rocks, overlain by the shelly, oolitic limestones of the Inferior Oolite. Although you cannot tell this from looking at the rock outcrop, the junction is in fact an unconformity, representing some millions of years of erosion. During this period there were crustal movements, and no sedimentary rocks remain to record the history of that gap in the rock sequence here (although some are present further north in the Cotswolds). Shell debris of bivalves, brachiopods, gastropods, occasional ammonites and also corals are easily visible on the hard, weathered surface that juts out, overhanging the softer sands below. Some of the shells are very large indeed (Fig. 73). These limestones have an irregular, rubbly appearance, in spite of being very hard. In places, chunks of broken limestone are mixed with shell debris which often has a worn appearance, the result of being rolled around on the sea floor prior to being buried. There were periods of current activity when there was no build-up of sediment; evidence can be found in the form of bored surfaces encrusted with calcareous worm tubes and oysters.

Beyond the reservoir the valley is crossed by an eight-arched viaduct, part of the Somerset & Dorset Railway. Opened in 1874, this carried coal from the mines

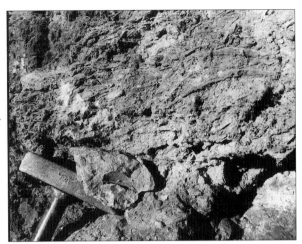

*Fig. 73: Shelly limestone of the Inferior Oolite at Tucking Mill.*

of the eastern Mendips to Bath, through the Combe Down tunnel, the longest unventilated tunnel in England. The line was closed in 1966 by Dr. Beeching. There is a good section of the Inferior Oolite at the south end of this viaduct, reached by another public footpath on the south side of the lake (G.R. 764 616). These outcrops are far better than any now found in Wiltshire -but the county boundary is only 300 metres away in the main valley!

The sequence of Middle Jurassic limestones and clays lying above the Inferior Oolite can be examined in detail five or six miles down the Avon valley, above Bathford, at Brown's Folly nature reserve. For once, access is easy, with a car park (G.R. 797 663) and lots of footpaths around the rock exposures in the upper valley sides. They are looked after by the Avon Wildlife Trust and kept clear with the help of the more dedicated members of the Bath Geological Society. The folly itself was built by Wade Brown in 1845, or thereabouts, and is of no particular architectural interest. It does have a magnficent site, however, with a view over the Avon valley and the hills surrounding Bath. The old quarries, where the Bath Oolite was once cut and carried by tramway to the canal below, have been used for storage of military ordnance for decades, but many tunnels have long ago been left to nature. Bats, including the endangered (but now protected) Greater Horseshoe Bat, live in the abandoned underground workings.

There are many interesting rocks visible, waiting to be inspected. It is quite hard to locate specific exposures here as there are so many! A detailed guide is available (see book list). I would suggest heading straight for Brown's Folly in order to get your bearings (G.R. 795 661). The viewpoint just before it provides a panorama of the hills surrounding Bath, all capped by the Great Oolite at a roughly similar height as dips are very gentle here. The Forest Marble forms the top of this cliff, capping the sequence of rocks in this locality (Fig. 74). Along

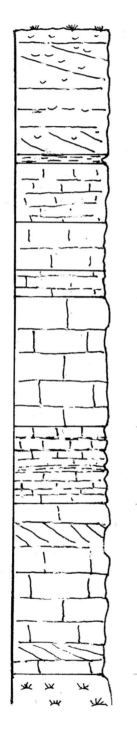

## FOREST MARBLE
Hard, shelly limestone (7m.)

Bradford Clay (20-30cm.)

Shelly limestone, coral reefs (3m.)

## UPPER RAGS
White Oolite (2.6m.)

Roof Bed: hard Limestone with corals (1.4m.)

## BATH OOLITE
White Oolite (7m.) – building stone

## TWINHOE BEDS
Variable lard limestone with clay bands (4m.)

## COMBE DOWN OOLITE
Shelly oolite (9m.) – building stone

## FULLERS EARTH

**GREAT OOLITE**

the cliff, beyond the Folly, it can be examined in the deep hollow of an old working below the edge. It is a hard shelly limestone (Fig. 75), darkish brown in colour on the surface. Some beds were laid down at an angle to the main bedding -the result of currents building up shell banks side-ways (as opposed to vertical sedimentation, layer upon layer). In some places, current scouring has caused erosion of the tops of the beds. There are clays interbedded in the Forest Marble Formation and by making your way northwards down below the cliffs, you can see, if you look carefully, the Bradford Clay at its base, overlying the Great Oolite limestone, which forms the exposed rock face. A footpath runs along the bottom of about five separate outcrops. This clay is very thin here, a brown band only 20-30 centimetres thick. It contains fragments of crinoids, together with brachiopod shells. The fossils often weather out and fall down the slope. The clay, blue-grey when unweathered, is famous for the fossil sea-lilies (or crinoids) found in its type locality at Bradford-on-Avon, which is actually at a higher level in the sequence there than it is here.

The Great Oolite below is made up of a variety of limestones. The uppermost one here, below the clay, is brown and shelly and in some places contains *in situ* patch reefs of coral, together with the remains of associated reef-dwellers. Some highly fossiliferous beds contain bivalves, such as oysters, brachiopods and snails (gastropods), as well as bits of coral; burrows can also be seen. The most common rock to be found is a mixture of ooliths and fossils. Some layers are thickly bedded enough and sufficiently uniform in texture to be classed as "freestone" (see Chapter 3), which was extracted from the old mines for building. They can here be seen tunnelling into the hillside. The small (about 1 mm. diameter) spheres of calcium carbonate (ooliths), which make up the rock are easily visible; they may be mixed with shell debris. The more shelly, thinly bedded layers were known as "ragstones" by builders, being of poorer quality. They are more abundant at the top of the sequence (Fig. 74).

Lower down, below the limestones, the steep valley sides are particularly prone to land-slips which frequently extend to the bottom of the valley (Fig. 70). Here the Great Oolite has been undermined by spring water seeping out at its base, at the contact with the clays of the Fullers Earth Formation below. The result is a jumble of silt, clay and angular blocks of limestone forming a mantle on the valley slopes. The slides frequently obscure the underlying Inferior Oolite. Repeated slippage may produce a scar which eats into the plateau edge to form an arcuate notch.

---

*Opposite, Fig. 74: Composite section of the middle Jurassic rocks at Brown's Folly above Bathford.*

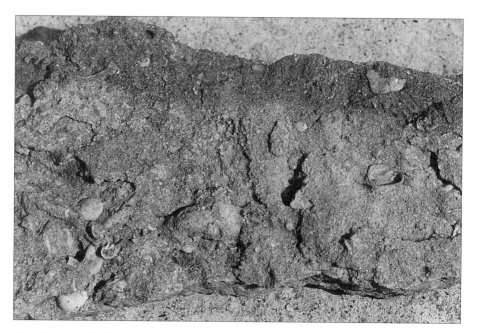

*Fig. 75: Shelly limestone from the Forest Marble at Brown's Folly.*

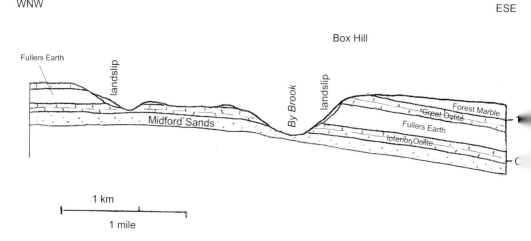

*Fig. 76: Section across the By Brook valley at Box through the early-middle Jurassic sequence.*

## The By Brook valley around Box

In the By Brook valley, a tributary of the Avon, the geology is more or less identical (Fig. 76). However, at Box the bench of the Inferior Oolite limestone can actually be recognised on the west side behind Middle Hill, rising to 117 metres above Ditteridge (it has a capping of Fullers Earth). Beyond is the steep hill up to Colerne marking the Great Oolite, which lies above the Fullers Earth Formation. The latter occupies a zone of landslips down onto the Inferior Oolite. There is an excellent view point on the green by Grove Farm (G.R. 834 691), just off the back lane from Box up towards Rudloe. It looks towards the railway tunnel under Middle Hill, which is in Midford Sands topped by a separate outlier of Inferior Oolite. There are more old quarries in the Great Oolite in woods just down the lane here, once famous throughout the south-west (G.R. 833 687). Take one of the several footpaths into this wood and head for the eastern edge. Cross-bedding can be seen on both small and large scales in these limestones (Fig. 77), showing how the shell / oolith banks were built up by currents on the sea floor. This stone was used to build a large Roman villa at Box and it may have been used, together with stone from Combe Down, in the Temple of Sulis Minerva at what is now Bath. It was also used for the 13th Century Laycock Abbey. There are 84 kilometres of tunnels here, formed during the extraction of the excellent freestone which, during the construction of the two-mile long Box railway tunnel (at the time the longest in the country), was found to be much more extensive than previously thought. A pub, the Quarryman's Arms, at the top of the hill (G.R. 837 693) displays excellent plans of the workings. The food is good too!

*Fig. 77: Old limestone quarries in the Great Oolite on Box Hill.*

At Corsham, now only a couple of miles away, there are two working underground quarries, at Monk's Park (G.R. 877 683) and Hartham Park (G.R. 856 704); the latter was open to the public, until stone extraction resumed in 1998.

*Fig. 78: The Marlborough Downs, Swindon and the Thames valley: geology. For the key to rock types, see page 142. Geology drawn by G. W. Green from the British Geological Survey maps.*

# 5: The Marlborough Downs, Swindon and the Thames Valley

## The western Marlborough Downs and their borders

It is hard to decide on the best place to start a geological tour of this part of the Marlborough Downs (Fig. 78). The southern escarpment, where Middle Chalk drops down to the Vale of Pewsey, is covered in Chapter 6. My favourite hills are Oliver's Castle and King's Play Hill. They look back westward and northward over the Avon Valley, with the southern tip of the Cotswolds beyond.

Oliver's Castle, northwest of Devizes (G.R. 000 647) has a very distinctive grassy profile from a distance, standing out from the main bulk of Roundway Hill and visible from as far away as Bratton Camp above Westbury (Fig. 79). It is topped with just a few windswept beeches, bordering one side of the inevitable Iron Age banks and ditches fortifying the summit. Access is up from Roundway village; the lane turns into an unsurfaced track (G. R. 004 647), which is driveable, provided you don't mind the pot-holes. Once there, it gives a tremendous view over the western approaches to the Vale of Pewsey, with Salisbury Plain's escarpment behind, its end marked by the chimney of Westbury cement works. The Avon valley lies below the Corallian ledge, here made higher by a capping of Lower Greensand stretching from Rowde below, northwards to Bowden Hill. The Seend outlier looks quite insignificant from here, a mere mound. Beyond lie Melksham and Chippenham, with the dip-slope of the Cotswolds rising gently in the distance. The steepest part of this scarp is Lower Chalk; the Upper Greensand beneath is below the break in slope, forming the lower 30 metres, in the field below the woods to the left (a lovely place to walk). The intriguingly named Mother Anthony's Well is on the spring-line, where Upper Greensand is underlain by Gault Clay. There are several springs in a copse below the footpath (G.R. 999 642). The rather odd-looking gully-like dry valleys in the side of the adjacent Beacon Hill are natural (Fig. 80). They have their origin back in Ice Age times, when the chalk was completely frozen and surface water (in summertime) could flow over it without sinking and thus carve valleys. Spring meltwaters would have flowed down from the plateau above. The ubiquitous "sheep-tracks", known as terracettes, on the slopes are simply the result of soil-creep downslope, possibly encouraged by waterlogging of the surface soil during summer, at a time when permafrost still persisted.

*Above, Fig. 79: Oliver's Castle hill-fort on the western edge of the Marlborough Downs near Devizes; the scarp is Lower Chalk, with Upper Greensand below the lowermost break in slope.*

*Below, Fig. 80: Dry valleys in the Chalk escarpment of Beacon Hill; they were formed by surface streams at the time of the Ice Age, when permafrost made the Chalk impermeable.*

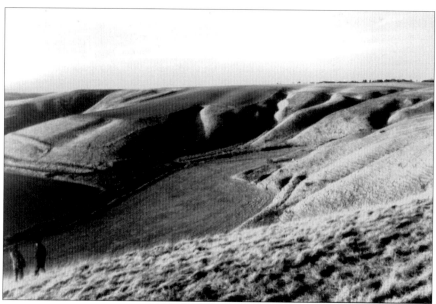

Skirting around the western edge of the Marlborough Downs from Roundway, the A342 road follows the Lower Greensand outcrop through Rowde and Bromham to Sandy Lane. This village will convince you that you really are on the Lower Greensand. Most of the houses here are built of the orange-brown iron-impregnated sandstone (Fig. 42). Don't worry about the fact that it isn't green; the iron-potassium silicate mineral glauconite, which would have given the rock a greenish tinge when it was originally scattered throughout the rock, has invariably been altered by weathering, at some point in its history, to orange-brown iron oxides. Beyond, the road passes the Bowood estate. Its spectacular rhododendron woods thrive on the iron-rich acid soils this rock provides (G.R. 960 689). If you are lucky enough to have timed things perfectly, there will be a carpet of bluebells too; they are open to the public only during flowering time (around May). The hillside from Great Wood to the Mausoleum marks the edge of the sandstones. The rhododendrons do not grow beyond this slope. The Corallian beds appear below, stretching over to the edge of the Avon valley at Derry Hill. By the pub here (G. R. 957 705), there is a superb view looking down the scarp over the clay vale at Chippenham. There has been a lot of land slippage on this scarp, as limestones are underlain by clays. The lake of Bowood House is in a tributary valley cutting through the Corallian limestones down into the Oxford Clay, which has insured its permanence, even though the lake is artificial (the result of damming the stream).

Calne is on the flat lands of Kimmeridge Clay, lying on top of the Corallian limestone ledge, to the east of Bowood. The Lower Greensand rests unconformably above to the southeast, forming the lower part of the gentle rise up to the Marlborough Downs. It is currently quarried for building sand (by Hills Minerals & Waste and Bardon Aggregates) in a series of large pits a mile west of Calne (G.R. 015 710). The sand is used for building, concrete products and roads; the pits are filled with rubbish as sand extraction proceeds. The Kimmeridge Clay below provides an excellent seal, and the landfill sites are engineered in such a way that the pits are lined with clay, not just at the base, but on the sides too, to prevent leaching of material from the rubbish by rainwater. Current regulations are very strict. Twelve metres or so of yellow-orange or grey sand overlie dark grey fossiliferous Kimmeridge Clay (Fig. 81). The Lower Greensand at Calne lacks the iron impregation characterising the equivalent rocks at Seend (see Chapter 6), although there are some better cemented beds and round iron-cemented concretions, resembling cannon balls, can be found (Fig. 82). The sands are mostly soft and yellow with highly oxidised iron (originally from the iron mineral glauconite), or grey where there has been less oxygen available. There are some thin, hard clay beds near the base and the sands are very dark grey in the few centimetres above the Kimmeridge Clay. A

*Fig. 81: Lower Greensand overlying Kimmeridge Clay east of Calne.
Groundwater flows from the base of the permeable sand where it overlies the*
impermeable clay - the ditch in the
foreground is for drainage. Between
the two formations is an unconformity,
representing a gap of 40 million years.

Fig. 82: Ironstone concretion (9cm. in
diameter) from the Lower Greensand
at Calne.

Fig. 83: The Lower Greensand east of
Calne contains dark partings with plant
remains which highlight the cross-
bedding; the sands were moved along and deposited by currents (flowing from
right to left), which formed dune-like ripples  on the sea floor.

near-shore environment is suggested by the layers containing dark coaly lignite fragments (fossil wood), which pick out the cross-bedding (Fig. 83). The quarry face shows a section through dune-like ripples which were created by strong currents sweeping the sand along. Fossils are not common in the Lower Greensand at this locality, in contrast to the Kimmeridge Clay below, which has marine reptile bones as well as innumerable white irridescent shell fragments. There was a 40 million year gap in time between the laying down of the two formations. The water running out of the base of the permeable sand, where it rests on the impermeable clay, leaves a bright orange stain of iron oxide (Fig. 81).

Heddington is three mile south of Calne, another spring-line village at the Upper Greensand / Gault Clay junction. The Greensand slopes up under the fields to the foot of the chalk scarp here, a good access point from which to climb King's Play Hill. From the lane southeast of Heddington it is a lovely short, yet exhilarating, ascent; there is a stile at G.R. 004 657, or thereabouts.

Alternatively, you could walk the couple of miles from Oliver's Castle via Beacon Hill, and make an afternoon of it. I would advise keeping to the edge of the escarpment to get the full benefit of the wonderful views; you will be skirting the site of the Civil War Battle of Roundway Down (1643). Unfortunately, there is no avoiding the descent to the lane from Heddington. This hillside southwest of the lane has a somewhat unnatural-looking series of ridges and hollows (Fig. 84) which are the long-abandoned tips and gullies of ancient chalk workings. There is a relatively easy scramble back up to King's Play Hill. Notice the ubiquitous terracettes again (Fig. 33). The views from here, through the hanging beeches on the vertiginous scarp are breath-taking! They are to the northwest over Derry Hill and Calne. The Stone Age barrows on top are an added bonus. The roots of fallen beech trees, victims of the wind, reveal the Lower Chalk they were growing on (Fig. 85). The hard Melbourn Rock (basal Middle Chalk) caps the hill, protecting the scarp below. Over to the east of here, along the downs, the distinctive clump of trees on Furze Knoll (G.R. 031 667) beckons. This rises to 260 metres and is topped by flinty Upper Chalk. You can walk up there following the Wansdyke path from the picnic site on Morgan's Hill (G.R. 019 671), a mile distant. The Wansdyke is an impressive bank-and-ditch fortification stretching from Portishead on the Bristol Channel to the western borders of Berkshire, dating from the Dark Ages in the mid-5th century AD. There is a twelve-mile section left along the Marlborough Downs. As well as a superb view, you will be rewarded by a rare exposure of the Clay-with-Flints in the roots of a fallen beech tree (Fig. 86) at the top of an old quarry there, hidden by the trees. This deposit caps large areas of the Marlborough Downs (see Chapter 2). The brown sandy clay has abundant angular flint pebbles. The material is

*Above, Fig. 84: Old Chalk workings have resulted in unnatural gullies in the northern slope of Beacon Hill above Heddington.*

*Below, Fig. 85: King's Play Hill, where the roots of a fallen tree uncover the Lower Chalk of the escarpment. The view is to the northwest towards Chippenham in the Avon valley.*

*Above, Fig. 86: Exposed roots among the beeches of Furze Knoll, at the top of Morgan's Hill, reveal the Clay-with-Flints which covers the Upper Chalk here.*

*Below. Fig. 87: Cherhill white horse on the Middle Chalk escarpment north of the Marlborough Downs .*

thought to be mainly made up of insoluble residues left over as the chalk, upon which it rests, was dissolved over the years by percolating acid rainwater. There may be an upper component of the remains of the Tertiary sands and clays, no longer preserved here, except where there are sarsen stones.

Cherhill Down can be identified from many angles by its monument. It also has all three levels of Chalk present and is the same height as Furze Knoll (260 m.). Like Westbury, Cherhill too can boast both a white horse (yet another!) and a hillfort (Iron Age again). The spur with the horse is Middle Chalk, which here produces the steepest scarps (Fig. 87); the monument and Oldbury Castle (the hillfort) are on Upper Chalk. Cherhill village below is, again, on the spring-line at the Upper Greensand / Gault Clay junction.

Avebury is now only a few miles to the east, along the A4 road, and is famous for its ancient Neolithic earthworks and stone circles. The latter are over 4000 years old and are made of sarsen stones. It is a good place to look at the root-holes in the stones, which give a clue as to their origin (Figs. 26 & 29), which must have been terrestrial. If you want to see the sarsens in their natural state, there are lots of places east of here. The National Trust has bought up large areas of Fyfield and Overton downs, to preserve what is considered to be the best remaining assemblage of sarsen stones in Britain. Sarsens are, indeed, scattered everywhere over this plateau of chalk, dissected by dry valleys, which appear to have "collected" more stones, to form what are known as "sarsen trains". It is now thought that these remains of Tertiary river sands were cemented only along the main drainage courses by the percolating waters of the streams (see Chapter 2); so their occurrence in valleys is an original feature. If you want to go on foot, there are lots of possible places, such as east of the Ridge Way path on Overton Down (G.R. 130 708) and Fyfield Down (G.R. 140 704) mentioned later in this chapter. Piggledean, less than two miles to the south (G.R. 142 686) has the dubious advantage of being nearer the A4! It stretches northward for about half a mile, but parking is a problem here, so for ease of access, I recommend Lockeridge Dean south of the Kennet valley (G.R. 142 673), which has sarsens lying in a field by the road (Fig. 25). In each of these combes, one can imagine an ancient river valley full of vegetation, with the sarsens hardening beneath the ground along underground drainage lines. The cementation of the grains by silica occurred fairly near the surface, accounting for the typical presence of root-holes and silicified roots. There may have been some slippage of the stones down into the valley during the periods of waterlogged soil conditions, which must have been common during the Ice Age, when spring thaws occurred, the sub-soil, however, remaining frozen. The shallow dry valleys of Piggledean and Lockeridge also contains deposits of ancient late Ice Age valley gravel.

West Woods nearby (G.R. 153 673) has beautiful bluebells in May (cover photograph). The woods are on Clay-with-Flints, which overlie the Upper Chalk west and south of Marlborough, providing soils on which the masses of bluebells thrive. This extensive, though patchy, cover of Clay-with-Flints, partly derived from the Chalk and also partly from Tertiary deposits, disintegrated by weathering, suggests that the Tertiary sediments once extended much further west.

## Wootton Bassett to Broad Town and Hackpen Hill

Wootton Bassett lies at the edge of the Corallian escarpment, overlooking the Oxford Clay vale. The scarcely discernable watershed between the Thames and the Avon runs northwestwards from here. To the south of the town, the Corallian limestone rocks are overlain by the succeeding Jurassic clays. Wootton Bassett is, among other attributes, noted for its mud springs. These are an interesting phenomenon, which has received remarkably little publicity, though I must admit that, after the build-up, the actual viewing of them is something of a disappointment. In fact, at the time of my visit, they were indistinguishable from any small pond (Fig. 88), although there were signs of a previous mud-inundation (i.e. muddy grass; Fig. 89). The whole area is boggy and, bearing in mind the established fact that the area is underlain by very soft clay to a depth of up to twenty metres, it is perhaps understandable that "the powers that be" do not encourage you to go there (Fig. 90). I'm sure they could be a major tourist attraction with some clever marketing -a spa, maybe. After reading about Melksham Spa (see Chapter 4), I can see lots of potential...

The springs are located to the southeast of Wootton Bassett near the road to Broad Town; after crossing the railway, there is a track to the left (with adjacent car park -G.R. 071 815), just at the edge of the town. The track leads to the Wilts and Berks canal towpath. This canal was built in 1795 from Semington, on the Kennet and Avon canal, to Abingdon on the Thames. It carried coal from the Somerset coalfields. Abandoned in 1914, there are only isolated stretches containing water today. Follow the canal to the foot-bridge, when the copse concealing the mud springs can be seen at the far corner of the field beyond, diagonally opposite the bridge. It is about 150 metres south of the towpath (G. R. 078 815), surrounded by a barbed wire fence! Five springs emerge from the Kimmeridge Clay, emitting mud; they are especially prolific one month after wet periods. Sometimes the mud dries and builds up around the vents so that they are now located on slight mounds about 10 metres across. However, as a result of human interference, only the mound in the southwest corner remains intact; its cover of vegetation makes it hard to discern. The vegetation forms a "skin" which rises under pressure. This is eventually breached and the pressure

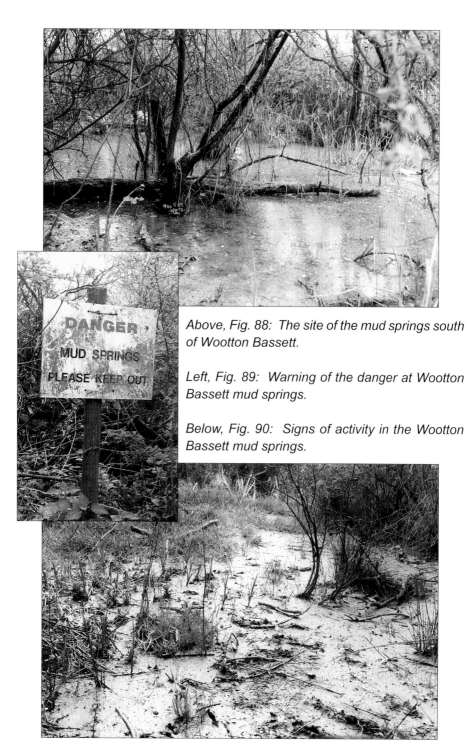

*Above, Fig. 88: The site of the mud springs south of Wootton Bassett.*

*Left, Fig. 89: Warning of the danger at Wootton Bassett mud springs.*

*Below, Fig. 90: Signs of activity in the Wootton Bassett mud springs.*

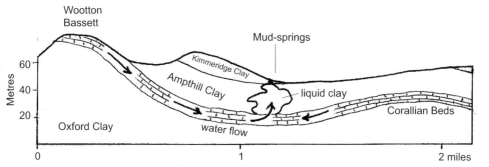

NW                                                                          SE

Wootton
Bassett

Mud-springs

60

Metres

40

20

Kimmeridge Clay

Ampthill Clay

liquid clay

Oxford Clay

water flow

Corallian Beds

0                                        1                              2 miles

*Above, Fig. 91: Cross-section of the Wootton Bassett area, showing the geological structure and the flow of groundwater towards the axis of the gentle syncline. The Corallian limestone aquifer rises to the surface at Wootton Bassett (where it collects rainwater) and there is sufficient hydrostatic pressure at the lowest part of the downfold to cause upward movement of water through the overlying clays, which have become liquified, emerging at the surface in the mud springs. Based on a British Geological Survey Technical Report.*

*Below, Fig. 92: Ammonites (Ringsteadia and Amoeboceras) washed out of the Wootton Bassett mud springs.*
*Photograph by Neville Hollingworth, Natural Environment Research Council.*

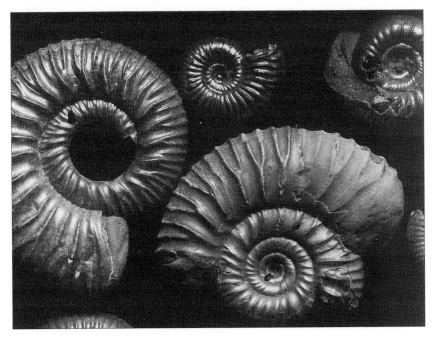

is released by the mud flow. There is liquid mud to a depth of six metres below the vents. The Corallian limestones, which are twenty metres below the clays, are gently down-folded into a syncline here (Fig. 91). The surface outcrop of these limestones is less than a mile away, from where they dip southeastwards under the Kimmeridge Clay in this direction. They form an aquifer with enough hydrostatic pressure to drive the water up through the overlying clay, resulting in the upwelling of pale grey creamy mud which flows from the vents and drains into the adjacent stream. Well-preserved fossils have been brought up in the mud and washed into the stream, where oysters, belemnite guards and small pyritised ammonites with their irridescent mother-of-pearl shell still intact have been found (Fig. 92). Their age is that of the clay (the Ampthill Clay) now known to be present in this area between the Corallian limestones and the Kimmeridge Clay above, which has a different fauna. There has been a long history of dumping in the vents, which may account for the occasional "rogue" specimens found. There are other mud spring localities nearby, but they are less spectacular; there is a line of them forming a boggy area at Greenhill Common Farm (G.R. 062 808). There are only a few other similar springs known in Britain.

There have been long-term problems with sinking ground beneath the railway to the northeast of the springs, and also slippage of the M4 motorway embankment a couple of miles to the north.

Travelling south from Wootton Bassett will bring you to the Chalk above Broad Town. This village lies mainly on the Gault Clay; the Upper Greensand is very thin here. It is interesting that this edge of the Marlborough Downs has two scarps; this first one is made of Lower Chalk, with Upper Greensand at its base. There is a recently renovated bright-white horse here (G.R. 098 784). A footpath leads to it east of Broadtown Hill, as the road ascends onto a broadly undulating shelf of Lower Chalk, with a width of over two miles, before the next escarpment at Hackpen Hill. Here the back road to Marlborough rises up past another, rather unusual, white horse on the Middle Chalk escarpment; this one is capped by the hard Chalk Rock of the basal Upper Chalk. Stop at the view point here (G.R. 128 747), looking northwards to Swindon and the Thames vale beyond, as well as along the Avon valley towards Malmesbury and the Cotswolds to the northwest.

Beyond Hackpen Hill, the road continues over the brow of Upper Chalk and then descends after a mile or two back into Middle Chalk. If the Hackpen Hill white horse isn't proof enough that you are on the Chalk, you could drive southwestward towards Marlborough over attractively undulating downland, before turning off to descend in the valley of the River Og. Ogbourne St. George had a lime works at one time; the old quarry is now filled in and only a bit of scruffy, flinty Upper Chalk is left at the top of the former quarry face, beside the

*Fig. 93: The Devil's Den north of Fyfield. Constructed of sarsen stones, it is thought to be the remains of the burial chamber within a Neolithic long barrow.*

*Fig. 94: Sarsen stones on Fyfield Down, the result of local cementation of sub-surface sands along underground drainage lines focusing on the valley bottom.*

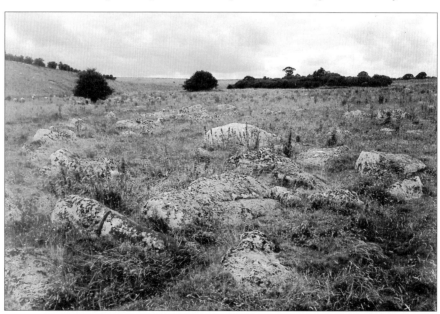

track southeast of the village (G.R. 207 738). Marlborough is a lovely town on the River Kennet, built predominantly of red brick, like Devizes.

From Hackpen Hill, there is a footpath along the Ridgeway, via Overton Down to Avebury, a distance of five miles, which could form the basis of an investigation of the sarsen stones, taking in such curiosities as the Templars Bath (G.R. 128 715), the Polissoir stone (G.R. 128 715 -a Stone Age sharpening stone) and the Devil's Den (G.R. 153 696; Fig. 93). The walk between the latter two spots will take you down an ancient river valley on Fyfield Down (now dry due to a lowering of the water table), densely strewn with sarsens (G.R. 142 703, Fig. 94). The underlying sands at that time covering the Chalk became locally cemented by the silica carried in the ground water as it moved towards the valley bottom, which then may have contained a seasonal stream. The Ridgeway was an important trade route as long ago as the Bronze Age, when the valleys were heavily wooded and upland tracks were easier for travel. Man has gradually removed England's original forest cover over the ages and turned the countryside into farmland, leaving only remnants of the natural vegetation.

## Swindon Old Town

Jurassic rocks, even higher than the Kimmeridge Clay, appear in an isolated outlier at Swindon (Fig. 95). The original town was built upon them, on a hill above the flat-lands of Kimmeridge Clay, which is, in most of Wiltshire, the youngest Jurassic rock to be found at the surface.

They are of particular interest as the sequence not only represents the final stages of the Jurassic Period (Fig. 1), but contains the latest Jurassic Purbeck Formation, the rocks of which represent coastal environments, developing as the region rose above sea level at the boundary with the succeeding Cretaceous Period; there is more commonly in southern England an unconformity, with a gap in the rock record, at this boundary. These disruptions were related to crustal movements associated with the gradual opening of the North Atlantic.

A certain degree of dedication will be needed to investigate the lower part of the succession in the old railway cutting, which in theory exposes the junction between Kimmeridge Clay and Portland Beds. You may not want to bother as the rock outcrops have become somewhat degraded over time. However, if you are serious, there is, at least, a public path which can be accessed southeast of the bridge at the junction of Springfield Road and Grovelands Avenue (by the Bowls Club entrance). For those not equipped with a street map of Swindon, this bridge over the cutting is at the southwestern corner of the park known as Town Gardens, and can be picked out on the 1:50 000 Ordnance Survey Map (G.R. 153 832). In the lower banks are hard reddish sandstones (almost under the bridge). Hard shelly limestone beds are more easily found higher up the

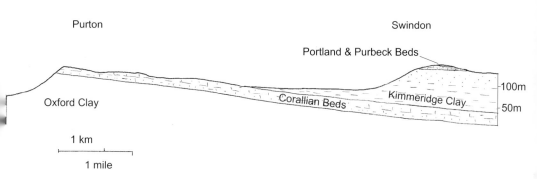

*Fig. 95:  Section from Purton to Swindon.*

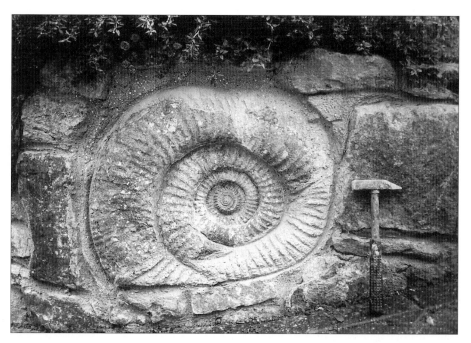

*Fig. 96:  Large ammonite (Titanites giganteus), found in the Portland Beds beneath Swindon's Old Town, displayed in a wall near Town Gardens, a former quarry.*

banks. They are famous for their giant ammonites (Fig. 96). They have a gentle dip to the south-southeast and alternate with soft pale orange sands with fine bedding. You may even want to hunt for the two pebble beds (called the Lower and Upper Lydite Beds), which can be traced from Wiltshire into Buckinghamshire. They mark periods of non-deposition, when all fine material on the sea floor was winnowed away. The upper one is at the base of the Portland Formation, the lower is above the sands in the upper part of the Kimmeridge Clay here.

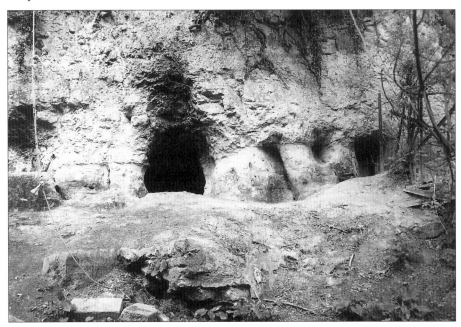

*Fig. 97: The Portland Beds at Town Gardens, Swindon; sandstones soft enough to be excavated overlie shelly limestones (in the foreground). Above the tunnelled sands are fine limestones of the Purbeck Beds.*

The higher part of the sequence is to be found around the northwestern and western boundaries of Town Gardens, literally almost above the cutting. It was once a huge quarry. Just outside the gate at the northwest corner (G.R. 151 836), beyond a grassy patch, is a cliff several metres high, dominated by the soft sands (seen in the railway cutting) overlying thick, well-bedded, hard, shelly limestones, all belonging to the Portland Formation (Fig. 97). It takes a while to get your eye into the various rock types of the sequence, but it does come, with perseverance, quite suddenly, the more you look at the different outcrops. Above the pale orange sands, which have had "caves" excavated in them, is a distinctive

fine grained limestone permeated by fine cracks. These are the uppermost Jurassic beds, known as the Purbeck Formation. They were deposited by algae in lagoons at the edge of the sea, which retreated at this time as southern England became land. These higher beds can be better seen in the rock face along the western edge of the Wildlife Garden, also beyond the main park (G.R. 150 834). It is located up a lane called "The Quarries" running along the outside of the west fence; turn left down a footpath to the entrance before the lane bends to the right. There is a map, fortunately, at each park entrance gate, if you are lost. The upper part of the sequence can be seen here, representing the change to hypersaline lagoons and freshwater environments at the end of the Jurassic Period, confirmed by fossils (bivalves, gastropods and ostracods). In the top of the bank at the north end is a thin bed of greenish clay, with fossils, overlying iron oxide-impregnated orange sand and sandy ironstone, which is packed with shell casts of non-marine bivalves and gastropods. These highest beds here were thought to be Wealden Beds (of earliest Cretaceous age), but non-marine Purbeck Formation fossils have since been recognised. Below are the very fine algal limestones of the Purbeck Formation, then the soft, shelly pale orange sands and hard limestones of the Portland Formation (seen at the previous locality).

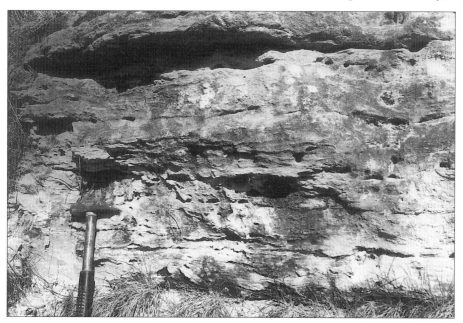

*Fig. 98: Soft cross-bedded sandstones of the Portland Beds at Coate Water south of Swindon; just below are fossil-rich limestones.*

## Coate Water

If the thought of a day out in Swindon does not appeal, Coate Water, a "country park" just to the south (G.R. 177 822), has a metre or two of the Portlandian cross-bedded soft sandstones (Fig. 98), overlying limestones with lots of fossil bivalves and bits of large ammonites. They are near the east side of the reservoir, built to supply the Wilts and Berks canal (a surviving section of which was encountered on our itinerary at Wootton Bassett).

A mile or so to the southeast of Coate Water is the site of the former Badbury brickworks (G.R. 190 815) which utilised the Cretaceous Gault Clay. The escarpment of Upper Greensand, capped by Lower Chalk, rises up some 80 metres south of here. The B4005 road beween Chiseldon and Wroughton provides good views over Swindon. Wroughton is on Gault Clay lower down the hill; Chiseldon rests on the Lower Chalk ledge (the Upper Greensand is very thin here. The edge of the Lower Chalk scarp can be reached from a footpath to Burderop Wood (G.R. 161 806). From the field next to the path, there is a view across the M4 motorway over to Swindon. The Portland Beds form the bulk of the hill of Old Swindon, rising up above the Kimmeridge Clay. Beyond, to the left (northwest), is the shelf of Corallian limestones extending over towards Purton. It falls away in the distance to the Thames valley down on the Oxford Clay.

Two Iron Age hill-forts rear up to the south and east: Barbury Castle and Liddington Castle respectively. Their Middle Chalk escarpments are capped by hard Upper Chalk. Clay-with-Flints gives both hills a patchy final topping. Barbury Castle can be reached by car from Wroughton (G.R. 150 764). From the car park at the top there is a view stretching well beyond Swindon, over the Thames valley, to the Cotswolds on the horizon.

## Northward to the Thames Valley

Head northwest out of Swindon, down the hill from the Portlandian rocks just described, onto the Kimmeridge Clay of the "new town", which sprawls northward for several miles, forming the greater part of the Swindon of today. Kimmeridge Clay was extensively worked for bricks used during the rapid expansion of the town after the coming of the railway in the last century. There are actually some sandstones near the top of the Kimmeridge Clay Formation here, a foretaste of what was to follow.

The Corallian Beds eventually appear from below, a few miles north, at the outer edge of the shelf overlooking the Oxford Clay vale. Just before Purton, some incredibly shelly limestone, containing coral debris too, can be seen at Fox Mill Farm (G.R. 103 872). If you don't feel like asking permission to root about in the farmyard, I suggest you just look at the wall by the stile (G. R. 103 873).

Although the rock is called the Coral Rag, shell fragments are more obvious than the corals. To spot them, you will need to know what to look for (Fig. 6, or better still, a copy of British Mesozoic Fossils -see book list). Further east, there are, locally, iron sands in the clays above the Coral Rag, the same age as the Westbury Ironstone (see Chapter 6). They produce a rusty red-brown sandy soil, for example, at Red Down (G.R.193 910), a mile south of Highworth.

Carry on into Purton; the village sits right on the edge of the low Corallian limestone escarpment (Fig. 95). Here there is an old building stone quarry south of the main street and relatively easily accessible (G.R. 093 875). Park by the Methodist church, then follow the footpath along the side of St. Mary's primary school. Climb the stile into a field, where the quarry is in a copse on the left, down below the field boundary; the dank pool it contains is something of an obstacle, and it is liable to flooding at times. The limestone forms thick beds and is composed of a variety of shell, coral and sea-urchin fragments, solidly cemented by crystalline calcite, representing the accumulations of debris around the periphery of the coral reefs. It has been widely used locally for building (Fig. 99), including Purton church.

*Fig. 99: Local Corallian limestone has been widely used for building in Purton.*

The River Thames follows this part of the Oxford Clay outcrop to the north. Its upper reaches cross northern Wiltshire before flowing into the Vale of White Horse in Oxfordshire. Various tributaries of the Thames, such as the River Cole, rise at the edge of the Marlborough Downs. The site of the Purton Brickworks lies below (G.R. 086 887), now completely filled in. It was in operation for about one hundred years. At the time of writing I found the final remnants of the pit, which I have recorded for posterity (Fig. 100); there are many bits of the grey clay scattered around north of the railway, but they won't last long as they will quickly degrade into the soil.

*Fig. 100: The last remains of the Oxford Clay pit on the site of the former Purton brickworks, in the process of being filled in.*

A few miles north of here are the extensive sand and gravel deposits dating from the Ice Age when, during and after the successive ice advances and retreats, a lot of debris must have accumulated south of the main ice sheet, which failed to surmount the Cotswold Hills. The rock debris was probably mostly formed by weathering as a result of freeze-thaw action on the limestone slopes. Downhill movement of this material would have occurred, aided by mudflows over the frozen sub-soil in spring and summer. During this seasonal thaw, tributary streams, swollen by meltwater, would have then carried the material down to the main valley of the River Thames, which was established during this time,

*Above, Fig. 101: Valley gravels of the River Thames in the Bardon Aggregates pit east of Ashton Keynes. They are predominantly derived from local Jurassic limestone and were deposited on the Oxford Clay of the valley floor (bottom left).*
*Below, Fig. 102: Ammonites (Kosmoceras jason) from the Oxford Clay.*
*Photograph by Neville Hollingworth, Natural Environment Research Council.*

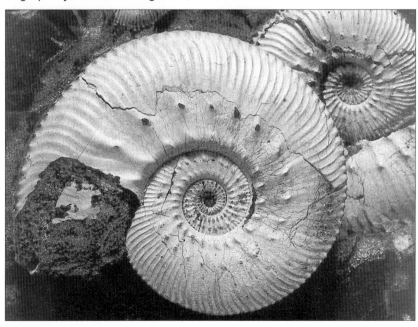

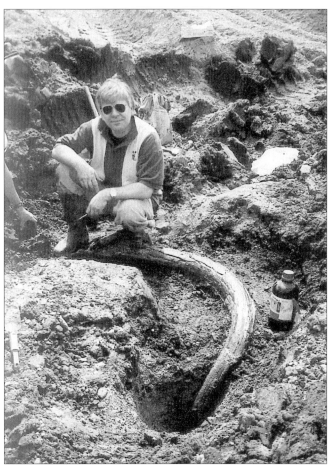

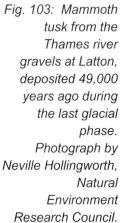

*Fig. 103: Mammoth tusk from the Thames river gravels at Latton, deposited 49,000 years ago during the last glacial phase. Photograph by Neville Hollingworth, Natural Environment Research Council.*

some 250,000 - 65,000 years ago. It redistributed the material in a series of terraces, each representing the contemporaneous valley floor. Younger terraces cut into older ones; the height of each is related to the sea level at the time. Four have been recognised in this area. Around Ashton Keynes, the gravels have been extensively removed for construction purposes, leaving many water-filled pits, used for fishing, boating, other water-sports and wildlife, and forming part of the Cotswold Water Park.

The gravels are unsorted, containing a variety of grain sizes. They are mainly composed of locally derived, yellowish limestone debris, including rounded pebbles and sand-sized material comprised of ooliths and shell fragments. They are several metres thick and rest upon dark blue-grey Oxford Clay (Fig. 101), itself containing lots of marine fossils: ammonites (Fig. 102), gastropods, bivalves and occasionally marine reptiles. Pine branches, though rare have been found

too. Large calcareous concretions -hard lumps formed where patches of clay have become cemented by calcium carbonate- are common, the cement having been derived from shells which are particularly abundant and well preserved in the nodules. The bulk of the gravels were deposited some 40-50,000 years ago in a deteriorating climate of an Arctic tundra type; contained pollen indicates that the vegetation was dominated by grasses and herbaceous plants, with few trees. The gravels are rich in the remains of animals living in this river valley during the late Ice Age. Bones, teeth and tusks of reindeer, bison, mammoths (Fig. 103) and crocodiles have been found along with freshwater mussels, snails, fish remains and plant material which date back to the late Ice Age (about 50,000 years ago). At the base of the gravel, much older rare flint implements such as hand axes and scrapers have been recently discovered, along with more mammoth remains (Figs. 31 & 32). They are all 250,000 years old. Whether there is a link between the large numbers of bones and the flint axes found with them has not yet been established.

The gravels are extracted to be made into concrete products for the construction industry, such as blocks, paving slabs and reconstituted "Cotswold Stone" ("Bradstone").

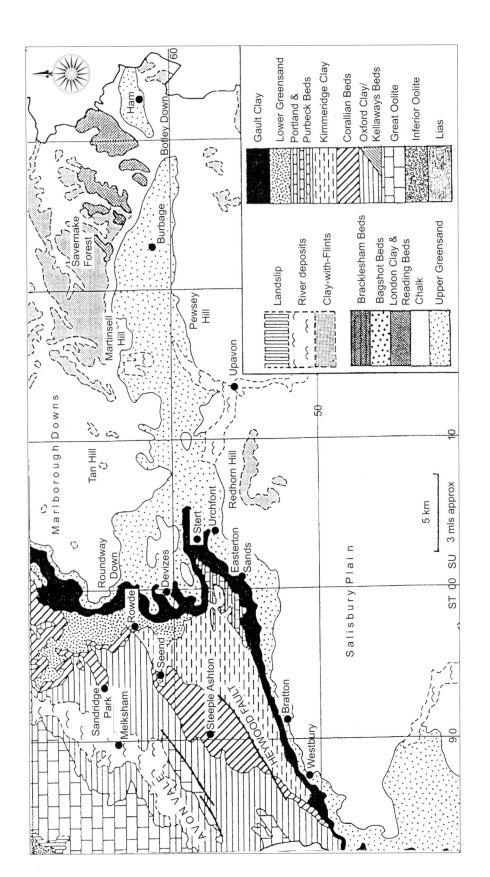

Fig. 104: The Vale of Pewsey and its western approaches: geology.
Geology drawn by G. W. Green from the British Geological Survey maps.

# 6:  The Vale of Pewsey and its Western Approaches

The Vale of Pewsey is generally considered to be east of Devizes, in the hollow below the opposing scarps of the Marlborough Downs and Salisbury Plain, an area made up entirely of Chalk and Upper Greensand.  However, from a geological viewpoint, the vale is a larger structural feature.  Looking at the geological map (Fig. 104), the upfolded structure can be seen to extend from the edge of the Oxford Clay east of Trowbridge right through to the far end of the vale, south of Savernake Forest, closed by the Chalk of Botley Down.  Actually, the structure does continue into the Vale of Ham, described in the next chapter.  It owes its existence to the fact that it is on a line of weakness in the Earth's crust developed during the mountain building episode separating the Palaeozoic Era from the Mesozoic -250 million years ago.  When later subjected to Cainozoic compression (originating in the Alpine mountain region around the Mediterranean), the result was upwarping of the rocks here;  the top of the fold, being weaker due to tensional cracking, has been removed by surface erosion (mainly running water), exposing the older rocks below.

As the vale cuts into the Chalk outcrop from the west, it is bounded to the north and south by Chalk downlands.  On the south side, the escarpment at the edge of Salisbury Plain extends from above Westbury, beyond Pewsey, Tidcombe and Wexcombe Downs, on to Botley Down at the head of the vale.  To the north, the Chalk scarp stretches from Roundway Down, north of Devizes, past Tan Hill and Milk Hill, the highest points in Wiltshire (294 m.), to Martinsell Hill.  Beyond here, for reasons discussed at the end of this chapter, the chalk is less pronounced as it skirts Savernake Forest (Fig. 123).

In spite of the local upfold, there is still an overall southeasterly dip of the rocks, which means that erosion has exposed the oldest rocks in the northwest.  A glance at the geological map will show that it is convenient to define the western end of the Vale of Pewsey anticline as running along the Corallian limestone escarpment, which bounds the Oxford Clay vale on its southeastern side.  This broader definition means the inclusion of what I will call the "western approaches", taking in the area not just between the Chalk downland escarpments, but also including the Corallian bench linking the Marlborough Downs and Salisbury Plain in the west.  This area contains a much larger range

of rocks than that found in the Vale of Pewsey sensu stricto. With this definition, and for the purpose of devising a tour of the geology, we can divide the Vale of Pewsey into three zones:

- The southwestern approach, taking in Westbury, Bratton, Edington, Erlestoke, Market Lavington, Easterton and Urchfont. This runs along the foot of the Salisbury Plain escarpment, entering the main vale from the south.
- The western approach, from West Ashton to Steeple Ashton, Seend, Devizes and Potterne.
- The eastern (main) part of the vale, starting at its entrance south of Etchilhampton Hill, then going eastwards towards Pewsey and Burbage.

The unconformity at the base of the Cretaceous Period, the result of Earth movements 145 million years ago, means that the Jurassic beds were truncated by erosion before the Cretaceous Lower Greensand was laid down on top (Fig. 9). All these older rock layers appear only at the vale's entrance, the bulk of which is composed of Cretaceous strata only. The Lower Greensand appears only locally below the Gault Clay, on the fringes of the northern side, stretching northward from Poulshot through Rowde, below the edge of the Chalk of Roundway Down. There are patches at Seend and south of Potterne too, but generally, the Lower Greensand below Salisbury Plain has been removed in this area by yet more erosion prior to Gault Clay deposition. The succeeding Gault Clay produces flat land below the Upper Greensand, which frequently forms a significant landscape feature -a hilly step- below the scarp of the Chalk above. The Chalk escarpments, except in the broad western approaches, everywhere dominate the vale.

## The south-western approach: Westbury and Bratton to Easterton and Urchfont

Westbury is perhaps the best place to start this general examination of Pewsey Vale. The town spans the Corallian Beds, the Kimmeridge Clay, Gault Clay and Upper Greensand, and now extends onto the slopes of the Lower Chalk (Fig. 104). The Corallian ironstones have been of importance to the town in the past as they have a remarkably high iron content in this area, a fact known to the Romans. After that time, it was not until the construction of the Great Western Railway in 1841 that the extent of the ore was again noticed. Further development of this resource was by a group of colliers from Radstock in northeast Somerset. The ore was dug out of a number of opencast workings between 1857 and 1925, smelted, and conveniently loaded onto the railway. Coal was brought in by rail from Somerset for the several blast furnaces located near the station; there was

plenty of local limestone. There are now a number of flooded pits between the railway lines in the vicinity of the Westbury station (Fig. 56); they are now used for boating and fishing. However, one working has survived half a mile northeast of the station, below the southwest side of Hawkeridge Road (G.R. 866 525). The barbed wire fences indicate that this is not a tourist spot but, beyond, there is a cave-like excavation into a rock face of thinly bedded, iron-impregnated, dark rust-stained ironstones (Fig. 105). The rock is packed full of oyster shells 8-10cm across (Fig. 106) and close examination reveals orange iron oxide-stained ooliths too. Beneath the opposite side of the road, in a hollow used as a dump, is some normal typical pale Corallian limestone, with ooliths and broken bits of shell. I doubt if this *in situ*, but these blocks serve as a useful comparison.

While in Westbury, you may like to inspect the overlying Kimmeridge Clay, which is there open to the sky (Fig. 107) in the large clay pit at Westbury Cement Works (belonging to Blue Circle Industries). You will need to get permission to visit this one! The grey clay is loaded with shells, including ammonites and bivalves, which often have an irridescent quality as a result a film of iron sulphide. The pit has achieved fame with the fairly recent discovery of the fossilised bones of the large marine reptiles known as pliosaurs, or sea dragons. They have been carefully removed and are now in the City Museum next to the University in Bristol. One is a current exhibit; the other, the latest find, in 1994 (Figs. 16 & 108), is one of the most complete specimens found anywhere in the world. It is still being prepared for display. Pliosaurs were air-breathing reptiles, about the size of a crocodile, with four fins and a long neck and tail (Frontispiece). At some point in their evolution they took to the sea, as have whales (although they are air-breathing mammals).

An interesting feature of the pit is the superficial chalky head deposit up to about two metres in thickness above the Kimmeridge Clay (Fig. 107). This is one of the few sections through these very widespread deposits, which are the result of downhill soil-creep over the millenia – mostly during the Ice Age (see Chapter 2). Here it contains bits of chalk, sand and clay – derived from all of the three rock types found up-slope.

If you have chosen to contact Blue Circle, ask also to see their chalk quarry at Beggar's Knoll; it is at G.R. 890 505, at the top of the hill. There is a tremendous section of chalk here (Fig. 109), showing all the Middle, and most of the Lower Chalk, with the Chalk Rock (basal Upper Chalk) at or near the top. The prominent Melbourn Rock band separates the lower two subdivisions. You can view the quarry from the track above (a public footpath) to get an idea of the scale of it (G.R. 888 505). The chalk from the quarry, which has several different levels with differing clay contents, is crushed and turned into a slurry on site. It is then carried by gravity through a buried pipeline down to the cement works.

*Above, Fig. 105: Abandoned excavations into the Westbury Ironstone.*

*Below, Fig. 106: Westbury Ironstone comprised of large oyster shells (Liostrea delta) and ooliths, impregnated with iron oxide. Photograph by Peter Geddes.*

*Above, Fig. 107: The Kimmeridge Clay pit at Westbury Cement Works after the discovery of the pliosaur remains (covered to protect them). Note also the upper layer of pale, chalky, head deposits, which crept slowly down from the Chalk and Greensand hills behind during the tundra conditions of the Ice Age, when vegetation was less well established.*
*Photograph by David Beatty, Blue Circle Industries.*

*Below, Fig. 108: The careful process of extraction of the pliosaur fossils from their bed of Kimmeridge Clay. At the bottom left is the skull, about a metre long.*
*Photograph by David Beatty, Blue Circle Industries.*

Depending on the clay content of the chalk being used, Kimmeridge Clay may or may not be added at this stage, along with iron oxide and sand. The latter traditional raw materials are now supplemented by pulverised fuel ash (a by-product of the electricity generating industry), and recycled kiln dust extracted by electrostatic precipitators before the "smoke" (mostly water vapour and carbon dioxide) gets to the chimney. The chemistry has to be very precise. The nearby Gault Clay above is too variable in composition to be used, and even the Kimmeridge Clay south of the railway line is too high in sulphur. The closely controlled proportions of raw materials are mixed in giant slurry tanks, before being pumped into the back end of the massive kilns. The slurry travels along the kiln by gravity (the kiln is tilted) towards the other end, the temperature rising along the length of the kiln from 125 degrees to 1400 degrees centigrade. At the conclusion of this journey, water and carbon dioxide (from the chalk slurry) have been driven off and the calcium silicates comprising cement have formed (silica and alumina coming from the sand and clay). The resulting clinker is then cooled and ground up, with the addition of gypsum (calcium sulphate), which controls the setting time of the cement. Without this, the cement would stiffen so quickly that it would be impossible to use. Tyres are being used experimentally as a fuel, which is proving cheaper and cleaner than the coal they partially replace.

Just along from the quarry is the Westbury White Horse (Fig. 110), originally cut in the turf of the Lower Chalk escarpment in 1778. There was an earlier horse here, smaller and facing the opposite way. It is said to have commemorated the Battle of Edington in 878 (when Alfred and his army encountered the Danes), though it is possibly a tribal symbol of the local tribe which lived here before the Roman Invasion! After all, we are on an Iron Age hill-fort here, known as Bratton Camp. English Heritage have, in their wisdom, spent enormous sums of money covering the natural chalk with some kind of concrete, which will undoubtedly save on maintenance costs, but does, to my mind, defeat the object of having a white horse: if they aren't virgin chalk, we could have white horses stuck on the side of any old hill! However, there are plenty more natural white horses (in varying states of preservation) to be seen on the chalk scarps of Wiltshire, most of which will be encountered on subsequent geological trips.

On a clear day the view from the White Horse encompasses the Vale of Pewsey, the Avon Valley, the Cotswolds, even the Mendips. There is a plinth with pointers showing the direction of the various landmarks. With the aid of a geological map, as well as the Ordnance Survey 1:50 000 map, you will be able to pick out the Cotswold limestones to the northeast beyond Bradford-on-Avon; on the horizon is Brown's Folly (see Chapter 4), above the Avon valley near Bath. They dip gently down under the Oxford Clay vale containing Trowbridge

*Above, Fig. 109: The chalk pit at Beggar's Knoll, Westbury, provides a superb section from the base of the Upper Chalk down to the Lower Chalk. The prominent Melbourn Rock band supports the access road to the bottom of the quarry. Photograph by David Beatty, Blue Circle Industries.*

*Below, Fig. 110: The Westbury white horse on the Lower Chalk below Bratton Camp, an Iron Age hill-fort.*

and Melksham. By moving to the corner of the hillfort, beyond the white horse, there is a view up the Vale of Pewsey, in its broader sense, stretching northeastwards from here: The Marlborough Downs rise above Devizes, continuing as far as the eye can see. Here on this southern side, the steep scarp of Lower Chalk falls away to the field below (Fig. 111), the top protected by the hard Melbourn Rock band at the base of the Middle Chalk, which has a more gentle slope above. The road along the top of the hill by the car park (G.R. 898 513) is on the Upper Chalk. The top of the Upper Greensand can be discerned at the break in slope below the scarp. The Gault Clay underneath starts where the land flattens off towards the cement works. The hill of Seend described shortly doesn't look much from here, its cap of Lower Greensand being at a height of only 100 metres. We are at 225 metres. The Corallian limestone shelf is not easy to pick out as it is actually only around 50 metres or less above the Oxford Clay, though it increases in height markedly towards the north, beyond Melksham.

Continuing beyond Bratton Camp, the road descends the escarpment to Bratton. This charming village spans the Upper Greensand and Gault Clay, nestling in an idyllic setting at the end of a branching valley which cuts back into the base of the Chalk rising to the south (Fig. 112). There are two crystal-clear springs here which can be visited. Both emerge at the same level, at clay bands near the base of the Lower Chalk, where the ground water held in the porous chalk can sink no further, and so seeps out to form a spring. Church Springs, behind Bratton Church (G.R. 913 519) have carved out a steep concavity in the side of the hill just below the churchyard. The strongest spring, as it emerges, has eroded its surroundings, producing an amphitheatre-like hollow and a deep gully (Fig. 113); the back wall will, with time, be cut back further into the scarp. Luccombe Springs (G.R. 924 521), approachable from both Imber Road and Luccombe Bottom, have a walled outlet pipe at the main spring (Fig. 114). Their stream supports prolific watercress beds. The dry valleys like Combe Bottom, which by-pass the springs, cut much further back into both hills. They remain from Ice Age times, when permafrost rendered the chalk impermeable and surface streams flowed down the hills, excavating valleys in the process.

There is a second spring line below the B3098 road through the village, at the base of the Upper Greensand, underlain by the impermeable Gault Clay. This road follows the Upper Greensand at the sloping foot of the chalk escarpment from Westbury, through Bratton, Edington, Erlestoke, Market Lavington and Easterton into the Vale of Pewsey proper at Urchfont. The sandstones form a broad ledge, below the Chalk, yet raised about 20 metres above the flat clays below. There are breaks in slope at each junction, particularly well marked at Edington. Here, 150 metres up Sandy Lane, (the first track to the right as you enter the village from the west - G.R. 923 526), the Greensand appears high in

*Above, Fig. 111: The Lower Chalk escarpment above Westbury, forming the edge of Salisbury Plain. The top is protected by the hard Melbourn Rock band.*

*Below, Fig. 112: Combe Bottom. Church Springs emerge from the base of the Chalk in the wooded hollow (to the right). Note the terracettes in the left foreground, the result of downhill soil movement.*

*Right, Fig. 113: Church Springs at Bratton, emerging from near the bottom of the Chalk, have excavated a steep hollow over time, as they cut back into the base of the hill.*

*Below, Fig. 114: The main spring at Luccombe Springs, Bratton, has been channelled into a pipe; there is a large boggy area up the valley behind, where water seeps from the Chalk when it can sink no further owing to impermeable clay layers in the rock.*

the western bank of this "hollow way".

The soft greenish-grey sand is gently dipping and full of fossil burrows. It has a harder calcium carbonate-cemented layer on top. Another couple of hundred metres further up, rubbly chalk appears high in the eastern bank. You have crossed the boundary! The junction is rarely exposed unless the badgers have been obliging. At the other end of the village it was possible to actually see it in an old sand quarry (G.R. 934 533) at Tinhead. Unfortunately, it is now somewhat overgrown and there is no chalk visible in the steep face cutting into the down.

Continuing onwards along the Greensand outcrop, you pass through Erlestoke. The sunken lane has sandstone cropping out high on its banks in several places on both sides of the village, where the road crosses spurs of Greensand.

Easterton Sands beyond has lots of Greensand exposed in the woods on its edge, overlooking the railway. Concealed in Folly Wood (G.R. 019 568), about a mile along a public footpath north of Easterton is the most spectacular section (Fig. 115) of Upper Greensand I have seen. This remarkable "hollow way" (the result of erosion of the soft sand by countless cart wheels over the ages) cuts through the greenish grey sands, burrowed by marine worms and molluscs (Fig. 116). The projecting layers are harder, cemented by calcium carbonate. The Greensand slopes steeply down to the flat Gault Clay along which the railway line runs.

If you don't feel up to the walk, there is more of the Greensand to be seen in Urchfont, a pretty spot, in a valley cut into this rock, with the usual springs at its base. The several rock exposures, although visible from the lane to the east of the village (G.R. 043 573), are mostly in private gardens.

To check that the scarp to the south really is made of chalk, go up to Redhorn Hill (G.R. 058 558). Here, an old (dumped-in) pit by a wood to the east the bend in the lane, reveals a couple of metres of Melbourn Rock. This hard, nodular chalk band has quite a few fossils, as a greater variety of bottom-dwelling sea creatures could live on the "hard ground" of this level of the chalk. Here bottom currents winnowed away the soft sediment, leaving just the more consolidated lumps -hence the knobbly appearance. There is also a small fault at its downhill end. You will notice that you are at the top of the main escarpment, the road rising less steeply above as it passes over the Middle, then the Upper Chalk before the "Danger Area" of Salisbury Plain. The more resistant chalk of the Melbourn Rock protects the softer Lower Chalk below, giving rise to the steep scarp.

We are now at the beginning of the Vale of Pewsey proper. The tour continues shortly, in the following pages, from Etchilhampton Hill, a separate outlier of

*Above, Fig. 115: Hollow way cutting through the Upper Greensand in Folly Wood, north of Easterton. Horses and carts have, over the centuries, caused the erosion of this lane to a level well below that of the surrounding countryside where it crosses the relatively soft sandstone outcrop.*

*Right, Fig. 116: Burrows and shells in the Upper Greensand of Folly Wood; the photo in 20cm. across.*

Lower Chalk. It can be seen four miles to the northwest, with Roundway Down, another chalk sentinel standing at the vale's entrance, to the rear. Potterne Field is a similar but smaller outlier of Lower Chalk, to the southwest of Etchilhampton Hill. Together they partially block the vale. In front of these hills, below the Greensand shelves on either side, the oldest rocks in the core of the Vale of Pewsey fold lie exposed in the valley of the Stert Brook (Fig. 121). They are described at the end of the next section.

## The western approach: West Ashton to Seend, Devizes and Potterne

From West Ashton northward (G.R. 878 558), the A350 road follows the low escarpment of the Jurassic Corallian sands and limestones rising above the the Oxford Clay vale (Fig. 117). Trowbridge can be seen less than two miles away below. These limestones form a broad shelf at the entrance to Pewsey Vale. Upon this shelf lies the Kimmeridge Clay (which being soft doesn't form a landscape feature) and, further west, the Portland Beds, which appear south of Devizes, in the core of the fold.

As the name would suggest, the limestones of the Corallian Beds are noted for their corals. Steeple Ashton is the location of an actual coral reef, one of the sources of the fossil corals found elsewhere in the formation. Having read that the fields southwest of the village, overlying the reef, were littered with corals, I was curious to see if this was still so. I did, indeed, find a few bits of coral (Fig. 118), but they were hardly the sort of thing I would want to display on my mantlepiece! The area to look in is south of the road to Keevil Airfield (a public footpath) over a distance of about half a mile centred on G.R. 913 561, before you get to Spiers Piece Farm, and I am assured that there have been plenty of spectacular finds.

From here, you could cross to the northern edge of the vale, by following the Corallian rocks over to Seend, five miles to the northeast. Seend is on a small ridge, the result of an outlying lump of Cretaceous Lower Greensand being left isolated from the main outcrop to the east, at Bromham and Rowde. It has been cut off by the Summerham Brook at the bottom of the hill, half a mile east of the village at Seend Fork. The Lower Greensand ironstones lie atop the Corallian Beds (Fig. 119). The hill is further accentuated by the valleys of the Semington Brook and its tributaries cutting down to the south of the hill, while to the north, the escarpment descends to the Oxford Clay in the valley of another of the Avon's tributaries . The Bell Inn car park (G.R. 940 608) on the main A361 road provides a good vantage point to view the landscape and visualise the structure at the entrance to Pewsey Vale, looking as it does over the flattish Corallian bench to the Chalk scarp of Salisbury Plain. The landmark of Westbury cement works chimney, on the overlying Kimmeridge Clay, is away to the southwest.

155

*Above, Fig. 117: The low escarpment formed by the Corallian Beds at Ashton Common. Across Wiltshire, this feature can be seen along much of the southeastern boundary with the underlying Oxford Clay, forming one side of the valleys of both the Avon and the Thames.*

*Right, Fig. 118: Corals (Thamnasteria) from the fields around Steeple Ashton on the Corallian limestone outcrop. Specimens are 40 and 60cm. long.*

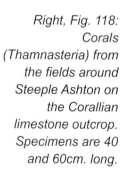
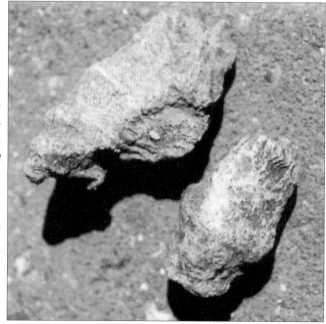

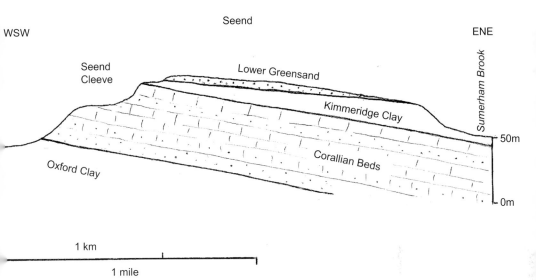

*Fig. 119: Cross-section through Seend hill, topped by an outlier of Lower Greensand cut off from the main outcrop by Sumerham Brook's valley.*

The Corallian rocks, which form the lower part of the hill, were once quarried at Seend Cleeve. Except in the houses and walls, there is not much left now, just a bit of fossiliferous calcareous sandstone, alternating with soft orange sands and marls, in a former quarry (now a cow field). The site has yielded a large collection of bivalves and ammonites, and there are plenty of fossils still to be found in the old quarry wall (G.R. 934 609), at the overgrown edge of the field (immediately below the footpath beside the farmyard).

The road rises eastwards onto the Lower Greensand, which can be seen in the old ironstone quarry (G.R. 937 610). These iron-rich sandstones have a diverse fauna. They represent the deposits of a sea which spread over the area in early Cretaceous time, after a prolonged period of erosion. This resulted from crustal uplift at the end of the Jurassic Period, which raised southern England above sea level for about 20 million years. The base of the sands is thus an unconformity. Though not visible today, limestones below the junction have been seen, bored by molluscs of the Lower Greensand sea. Their shells have been found *in situ*, the borings filled by iron-rich orange sand. On top, and still exposed, are gravelly, orange and brown, fossiliferous sands. These show cross-bedding and contain irregular bands of lenticular ironstone concretions several metres across. The beds dip at ten degrees in a southerly direction. Some are hard, others are soft and sandy. Weathering has produced a "boxstone" effect

with hard, dark brown shells of iron oxide surrounding soft orange sand (Fig. 17). The most common fossils are casts of bivalves and brachiopods, although snails, sea-urchins and ammonites have also been found. Ferruginous material sometimes replaces the original shells.

The road by the ironstone quarry, as it descends the hill, looks out to the north over the Avon valley. The Corallian limestone spur of Sandridge Park rises up to the east. In fact, that spur is likewise a good place from which to view the Seend ridge, standing above the Oxford Clay (as is mentioned in Chapter 4); there is a lay-by (G.R. 935 646) as you go down the hill, from which the two-tier structure of Seend's hill can easily be made out, the Corallian Beds forming a lower ledge below the cap of Lower Greensand (Fig. 119).

The main A361 to Devizes takes us up onto the Upper Greensand, having passed over the Gault Clay at the foot of the hill, just at the end of the dual carriageway (by the turn-off to Potterne). This clay is normally only seen in temporary excavations. Clay can still be found, however, just off the footpath along the remarkable flight of locks on the Kennet and Avon canal at Caen Hill. The clay here was discovered during the building of the locks, and a brick pit was opened adjacent to the canal in the early 19th century. Transport of the bricks by barge encouraged their widespread use along the canal (a fine example is in the Savernake tunnel -see Chapter 7), as well as locally (Fig. 120). The bricks have a red colour (due to the clay's iron oxide content), giving Devizes its character. A natural sandy component prevents the bricks warping when fired. At the top of lock No. 33, on the right of the tow-path (G.R. 984 614) you can get into the end of the old clay pit, nettles permitting! Dark brownish-grey clay, with paler sandy brown patches, can be seen by scraping the bank. The clay is fossiliferous and fine ammonites have been discovered.

Devizes is regarded as the main road gateway to the Vale of Pewsey. It is situated on a promontory of Upper Greensand rising above the Gault Clay, a good defensive position, and the site of Devizes Castle. Approaching the town from the west, via the A361, there is the odd vantage point from which its site can be appreciated (G.R. 995 616). The Upper Greensand falls away down to the Gault Clay, with Rowde in the valley below on the Lower Greensand; the latter rises gently up behind Rowde some 30 metres to the broad hill covered by fruit and vegetable farms, which shelters Bromham. To the northeast, Oliver's Castle and Beacon Hill rear up above the Gault Clay on the 100 metre-high scarp at the edge of the Marlborough Downs' Chalk (Fig. 79). The Upper Greensand here forms the lower 30 metres of the escarpment, below a break in slope. Around the corner, Roundway Down sports a beautiful new white horse, cut in the autumn of 1999 and facing the A361 as it leaves Devizes for Avebury.

Geologically, the vale is better approached from just south of Potterne. Like

*Fig. 120: An advertisement for the local bricks, this building is at the entrance to the former Caen Hill brickworks at Devizes. The Gault Clay contains sufficient sand to prevent the bricks warping on firing and its iron oxide content gives them their characteristic red colour.*

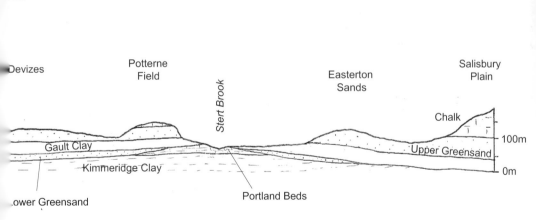

*Fig. 121: Section across the entrance to the main part of the Vale of Pewsey from Devizes to Salisbury Plain above Market Lavington.*

Devizes, Potterne is located on a promontory of Upper Greensand, at its junction with the Gault Clay. In both cases, there is a spring line where the waters in the porous sand flow out onto the surface when they reach the impermeable clay. The main A360 road from Devizes to Potterne (a mile distant) follows a "hollow way" through the Upper Greensand (Fig. 18). These old sunken roads originated as cart-tracks which cut deeper and deeper into the sands over the years, well below the general ground level. Harder, calcium carbonate-cemented layers and patches, known as "doggers", project out of the sandy banks of the road. There are lots of burrows and some shell and crinoid fragments can be seen too. It is, however, rather noisy and traffic-ridden here. There are plenty more, less used, lanes around, in which the sands can be examined. A really peaceful hollow way can be visited just east of Potterne at the end of Coxhill Lane. This runs eastwards out of Potterne; turn left, off the main road at the cross-roads just south of the church (opposite the lane from Worton). If you continue more or less straight ahead up a deteriorating track (G.R. 002 584), you will find yourself surrounded by excellent exposures of Upper Greensand on either side. Soft sands alternate with harder, better cemented beds -some calcareous sandstone, others limestone. In some bands, the cementation is less complete, giving rise to the characteristic rows of separate "doggers". The sands contain shell fragments and orange lumpy concretions cemented by iron oxide as well as the ubiquitous fossil burrows. The Potterne Stone has been used in local buildings. It has good damp course properties and was often used for the lower parts of brick and timber-framed houses (Fig. 44). It can be seen at the base of the half-timbered house at the junction of Coxhill Lane and the main road.

This track can also be approached on foot via the public footpath at the sharp bend (G.R. 007 585) in the lane to Urchfont. It cuts through the same Upper Greensand; small, not particularly inspiring outcrops can be seen in the high banks. It is not until the path turns down into the valley towards Potterne that the rocks become more exciting. The top of this hill (above the 130 m. contour), known as Potterne Field, is capped by about fifteen metres of chalk -an isolated outlier of the main outcrops north and south of the Vale of Pewsey. Together with Etchilhampton Hill, it stands guarding the entrance to the vale (Fig. 121).

The Stert Brook's valley is crossed further along the lane from Potterne towards Urchfont; the stream has picked out the older Jurassic rocks in the core of the upfolded structure which has produced Pewsey Vale. In the brook at Crookwood Farm is the only exposure of these Portlandian rocks in the Vale of Pewsey anticline. It has therefore been designated as a Site of Special Scientific Interest, but in truth there is not a lot to see and, although I went before the nettles were up, there are both brambles and the stream to negotiate. I would recommend wellies, as well as a hammer, before attempting to inspect them.

There are some small outcrops of extremely hard cherty sandstone and limestone (only the latter will scratch with a hammer), containing fossils (G.R. 017 584). They are not really worth the effort unless you happen to be doing research into Portlandian environments, or are simply determined to prove the map right! You will need to ask the farmer too, as you have to walk just behind the farmhouse, then about half a mile upstream as far as a sharp elbow-bend in the brook.

Having exhausted the rocks below the Upper Greensand, we will move on to the main part of the vale....

## The eastern (main) part of the vale

Etchilhampton Hill makes a good starting point for studying this section of the Pewsey Vale as, from a lay-by near the top by a "No Tipping" sign (G.R. 033 599), there is a view of a good part of it. Of course, if you climb to the top and the weather is clear, you will see even more. There is a chalk pit here, which is already being infilled. If it is still there, you will see solid grey-white Lower Chalk, which becomes much more shattered looking towards the ground surface. This is the effect of weathering, which includes frost-shattering during the Ice Age. The bedding is hard to pick out, dipping just a couple of degrees to the north, and fossils are a bit hard to come by -but maybe I was just lacking in patience! From Etchilhampton Hill, you can see, immediately to the southwest, the hump of Lower Chalk capping Potterne Field, with Potterne Wood on its southeastern slopes, on the underlying Upper Greensand. Beyond is the chalk scarp of Salisbury Plain, with the Bratton hillfort rising above the Westbury cement works chimney. The core of the fold extends northeastward between these hills through the centre of the main part of Pewsey Vale. At this point, it is followed by Stert Brook's valley, cut in Gault Clay from Stert; a mile or so beyond it cuts down through the Jurassic Portland Beds lying below the Cretaceous unconformity (which you may have seen at Crookwood Farm, described at the end of the previous section). The prominent Upper Greensand hills, topped by Oakfrith Wood and Folly Wood (both west of Urchfont) stretch from the foot of the Salisbury Plain escarpment northeastwards, forming a step along the far side of the valley.

Going over the hill, the rest of the Vale of Pewsey comes into view, stretching away to the east along the Upper Greensand, here the core of the fold. The scarp of the Marlborough Downs forms the northern edge, while the ridge of Lower Chalk with Woodborough Hill and Picked Hill stands up in the foreground. The Tan Hill Way follows along the top of this scarp. At 294 metres, Tan Hill and Milk Hill are the highest points not just on the Marlborough Downs, but in all Wiltshire. Eastwards, it curves round to Walkers Hill. Then comes

Knap Hill, with its Neolithic causewayed enclosure, and Golden Ball Hill, with more evidence of pre-historic settlement. A couple of miles beyond is the distinctive rounded profile of Martinsell. The scarps are prominent here because of the gentle dip of the rocks (as explained in Fig. 123). Etchilhampton Hill is on the watershed between Wiltshire's two Avon rivers. The Salisbury Avon rises below, its tributaries flowing eastwards. In contrast, Stert Brook in the valley below the main A342 road to the south, drains westwards from the Greensand down over the Gault Clay onto the Jurassic rocks which you may have already seen, eventually reaching the Bristol Avon down on the Oxford Clay between Melksham and Trowbridge.

Many of these hills to the north have earthworks dating from as far back as Neolithic times (about 5000 years ago). Most impressive are the Iron Age hill forts of Rybury and Martinsell. On the north of the vale, more chalk can be seen, if you so desire, by walking the mile or so to Kitchen Barrow Hill (G.R. 067 647). Below the burial mound at the base of the Middle Chalk, is a pit in Lower Chalk, where the beds can be seen to dip at 18 degrees to the northwest, confirming the fact that we are on the northern side of the Vale of Pewsey anticline structure here. Fossils certainly don't leap out at you (in contrast to the brown rat population!), but there are rusty-looking rounded nodules of iron sulphide (pyrite) in the chalk, with radiating crystals inside if you are lucky (Figs. 19 & 122).

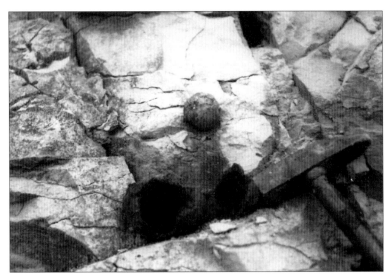

*Fig. 122: Iron pyrites nodules from the Lower Chalk on Kitchen Barrow Hill. Some contain radiating crystals of iron sulphide (Fig. 19), others have been completely oxidised and are hollow, apart from some rusty iron oxide deposits.*

All the way along, there is a wide selection of inviting hills to explore, all rising high enough to include the Upper Chalk. I make no apology for encouraging everyone to climb as many of these hills as they have the energy for. The views from this particular Chalk escarpment are magnificent. There is a car park well up on the ridge below Knap Hill, topped by Middle Chalk (one of my favourites (G.R. 116 638). It is on the Tan Hill Way. Below, the spur of Lower Chalk can again be seen, extending out into the centre of the vale, with Picked Hill and the distinctive tree-crowned Woodborough Hill at its end. Golden Ball Hill beyond, on the Upper Chalk, is a must too, with its magnificent views across to Salisbury Plain on the opposite side of the vale. The exceptionally high scarps here include both Lower and Middle Chalk. If you want to see a proper white horse, climb westwards over Walkers Hill, topped by its long barrow known as Adam's Grave. On the scarp of Milk Hill beyond (G.R.107 637) is a nice traditional horse, simply cut by removing the turf cover to reveal bare chalk. The landmark of Martinsell is another good Upper Chalk-topped hill, again surrounded by Iron Age ramparts, with the pitted northeastern slope above the car park (G.R. 185 645) thought to be the scars of old flint or chalk pits. The Giants Grave on the spur beyond, also bearing Iron Age fortifications, is well worth the walk; you leave this ridge's cap of hard Chalk Rock (basal Upper Chalk) just at its ramparts (the bank).

To the south, on Pewsey Hill, marked by its sweet little white horse (kept white with chalk rubble), the Melbourn Rock can again be found at the top of the Lower Chalk escarpment (G.R. 173 579). There is an old quarry above the public footpath to the east of the road, opposite a lay-by (round the bend as you come over the brow of the hill). The beds here are more or less horizontal. A couple of metres of nodular chalk (Fig. 23) are overlain by softer more normal chalk containing one or two bivalve shells. There are no flints. From the Pewsey white horse below, there is a good view over the vale. Etchilhampton Hill is to the west-northwest, with Roundway Down beyond. East of Martinsell, the scarp fades away as the dip of the rocks steepens. The southern scarp continues to the end of the vale. To the west, south of Potterne Field hill, with its Upper Greensand shelf below, you can locate the valley of Stert Brook cutting into the core of the anticline.

If you want to see even more of the Melbourn Rock, the pit up the narrow lane south of Milton Lilbourne will provide some (G.R. 200 594). The chalk here is hard and nodular, with lots more fossil bivalves than usual. Again it is at the top of the scarp, protecting the Lower Chalk from erosion. Milton Lilbourne itself is below the scarp, on the Upper Greensand, where there is a good water supply from springs near the base of the aquifer.

Nearing the end of the vale at Leigh Hill, the rather overgrown old railway

cutting (G.R. 217 594) exposes the Chalk Rock (basal Upper Chalk). The rock can be examined at the top of the cutting. The steep northward dip of the bedding (30 degrees) confirms that we are on the northern side of the Vale of Pewsey upfold here. The steep inclination of the beds explains why there is no scarp in this area; the harder beds of the Chalk Rock dip too steeply to form a cap, so erosion has removed softer layers and thus produced more irregular topography (Fig. 123). The chalk is hard and nodular; fossils aren't obvious.

*Fig. 123: Section across the eastern end of the Vale of Pewsey from Savernake Forest to Easton Hill on Salisbury Plain. Note the asymmetry of the fold structure, with a steeply dipping northern limb (with no Chalk escarpment) but gentle dips on the southern side, where there is a steep escarpment at the edge of the Chalk, protected at its top by a hard-ground layer (the Chalk Rock).*

The Chalk outcrop curves around to close off the eastern end of the vale at Botley Down, now forming the edge of Salisbury Plain.

# 7:   Savernake Forest and the Vale of Ham

The most remote corners of the county for some reason always seem the most fascinating, and the southeastern fringes of Savernake Forest and the Vale of Ham on the borders of Berkshire are well worth exploring (Fig. 124). The geological objective of such an expedition would be to examine the relationship between the Chalk and the outliers of overlying Tertiary rocks around Savernake, while the Vale of Ham demonstrates the effect of the removal of the top of an anticline, or upfold, to expose the older rocks beneath, forming what in known geologically as an inlier (Fig. 125). The dissected platform of chalk is, on the rounded flat-topped hills in the eastern part of the Marlborough Downs, surmounted by a patchy cover of Tertiary sands and clays. Eastwards, the platform descends to the London Basin.

## Savernake Forest

Savernake Forest lies southeast of Marlborough and is, like the New Forest, the remains of an ancient royal hunting forest. The area is let at a peppercorn rent to the Forestry Commission and is accessible to the general public. The forest used to extend west as far as West Woods, just south of Lockeridge, a village known for its sarsen stones (Cover photograph). This part of the Marlborough Downs is still underlain by the Chalk, but it generally has a superficial mantle of Clay-with-Flints, which increases the acidity of the soil, making it less suitable for farmland; hence the forest cover. The Clay-with-Flints is thought to be partly derived by dissolution of the Chalk and partly from the Tertiary rocks which originally lay above the Chalk everywhere. The latter are still present here as just a few outlying patches of  sand and clay topping the hills within and on the eastern fringes of Savernake Forest and on the opposite side of the Kennet and Avon canal between Wilton and Bagshot, where they produce a distinctive type of scenery, supporting heath as a result of their acid soils, as well as extensive woodlands. In the London and Hampshire basins (see Chapter 1), they reach considerable thicknesses, but within Wiltshire they are better represented southeast of Salisbury (see Chapter 8).

It is not always easy to see exactly where the Tertiary beds lie above the Chalk, as they consist of soft sands and clays and are only around 12-18 metres

Fig. 124: Savernake Forest and the Vale of Ham: geology.
Geology drawn by G. W. Green from the British Geological Survey maps.

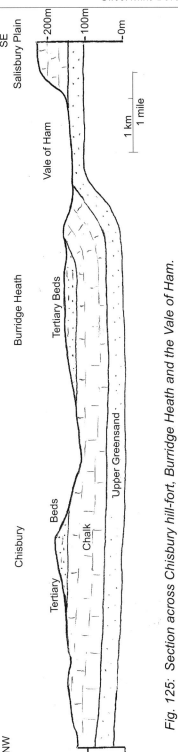

*Fig. 125: Section across Chisbury hill-fort, Burridge Heath and the Vale of Ham.*

thick. The basal beds, part of the Reading Beds, contain green-coated flint pebbles, ironstones and hardened pebble beds. A bed of fossil oysters, which are marine, was observed (in 1815) in old pits on Bagshot Hill, beneath clayey yellow-green sands. The clays are blue, brown or mottled, and often sandy. Today it is not easy to actually view these rocks *in situ*, as all the old brick pits closed long ago, and the dedicated geological explorer is reduced to examining the roots of fallen trees and the vegetation for evidence of their existence (bracken, for example, likes acid or at least neutral soil). The geology map tells you that the wooded hills of Wilton and Bedwyn Brail, Castle Copse, Burridge Heath and Stype Wood, which are to the south and east of Great Bedwyn, are capped by Tertiary clays and sands (the Reading Beds and London Clay), which here rise above the Chalk. About ninety years ago there was an exposure in Castle Copse (G.R. 286 633) where the unconformable junction with the rather weathered rubbly Chalk below could be seen. There was a break of around 15 million years at this point, during which the Chalk was consolidated into rock, raised above sea-level and subjected to weathering and erosion. Today, all that remains is an overgrown quarry, where, owing to slumping of the sides, there is no rock exposed. The Chalk below has yielded *Marsupites*, a stemless sea lily (Fig. 7), which indicates that a very high level in the Chalk is present here.

The junction of the Tertiary beds

*Above, Fig. 126: Stype Wood on the Tertiary sands and clays southwest of Hungerford.*

*Right, Fig. 127: Sink hole in Stype Wood, where surface streams on the impermeable Tertiary beds disappear as they cross over onto the outcrop of the underlying Chalk.*

with the Chalk is marked by lines of small sink holes, which can be found in several localities. They form where surface streams sink into the porous chalk at the boundary, having previously run along the surface of the impermeable clays above. The Chalk is dissolved by the acid rain-water as it sinks downwards to form a solution hollow in the chalk surface. A muddy pool in the hollow may mark the spot. There are lots of sink holes in elongated depressions near the edges of Stype Wood (G.R. 310 660). Wet weather may be needed to appreciate, or even locate, these features, but they have been shown to connect with a spring in the bank of the Bedwyn Brook, one mile west-southwest of Hungerford church. Having entered the wood along "Long Walk", from the unsurfaced lane at its north-western end (cars can be driven approximately to this point, G.R. 305 667), walk along the crest of the ridge, through the rhododendrons (definitely an indicator of acid soil), past a line of very old and gnarled beech trees. For a particularly good example, bear right down a grassy track when you reach a clearing with tall pines (Fig. 126); on the left of the track at the bottom of the hill, within sight of farm buildings at the southeastern edge of the wood, is a blind valley ending in a hollow. Here a small stream sinks into the ground, just below the path (G.R. 308 658; Fig. 127). There are many dry solution hollows on both sides of the ridge and even if you fail to find one with a stream disappearing into it, it is extremely pleasant here and uprooted trees reveal the Tertiary clays and sands, which are full of rounded flint pebbles. There is another good example in the wood northeast of Harding Farm, (G.R. 298 627), where a tiny stream disappears in a hollow. Just down the road from here, heading for Great Bedwyn, there is a copse concealing an old sand pit which still has a couple of metres of Tertiary sands, probably Reading Beds, exposed. It is on the left of the lane, 400 metres beyond the turn-off to Newtown (G.R. 296 632). In summer time, I suspect you may have to negotiate one or two nettles, but at its southern end, in the top bank, there are mottled grey-green and orange sands, with pebbly horizons of rounded flints (Fig. 128).

The Cretaceous / Tertiary boundary is also encountered on the northwest side of the Kennet and Avon canal. Terrace Hill (G.R. 230 640), made of steeply dipping chalk, rises up sharply to the south of overlying, but softer, Tertiary beds in the woods east of the main A346 road to Marlborough on Leigh Hill (G.R. 220 645) and around the column (G.R. 229 647). West of Great Bedwyn, between Tottenham Park and Chisbury, another set of sink holes marks the boundary. The Reading Beds, London Clay and Bagshot Sands are all present, comprising about 10 metres of brown, clayey sands, sandy clays with ironstone pieces and oyster shell casts, if you are lucky enough to find them exposed.

At Chisbury (G.R. 280 660), an Iron Age hill fort, there is no rock to be seen. However, the upper 20 metres of the hill are Tertiary sand and clay, with the

*Right, Fig. 128: Pebbly sands of the Tertiary Reading Beds in an old pit west of Newtown. (Photo is 40cm. across)*

*Below, Fig. 129: Chisbury hill-fort, with its abandoned church, on the Tertiary sands and clays capping the hill.*

170

*Fig. 130: Sand-filled solution hole in the surface of the Chalk southwest of Chilton Foliat. Downward-percolating rainwater dissolved out a hollow, subsequently filled with river deposits.*

chalk below, and there is a lovely view: in the foreground, on the far side of the canal, beyond the Bedwyns, are the wooded Tertiary-capped hills of Stype Wood (directly east) and Burridge Heath, to the southeast. Beyond Burridge Heath, the Chalk scarp of Rivar Down rises up to the south of the Vale of Ham (Fig. 125). The ramparts of the fort are well preserved and an abandoned flint-walled thatched church built in the late 13th century beside the earthworks, at the back of the outbuildings of Manor Farm, is certainly worth taking a look at (Fig. 129).

At last, just off the B 4192 road north of Hungerford, some solid rock can be observed. Take this road towards Chilton Foliat for about a mile, then, where the main road bends sharply to the right, carry straight on down a lane until just past the entrance to the Littlecote House Hotel, where there is a small quarry in Upper Chalk on the left (G.R. 310 700). Here, lines of more or less horizontal flints clearly pick out the bedding layers. Those armed with a hammer and some considerable patience could hunt for fossils. Cracking open flints frequently reveals a hollow interior containing a fossil burrow or a sponge. At the top, a hole in the Chalk has been dissolved out by percolating ground water and this has been filled by orange-brown sands. These are either of Tertiary age, or are younger (Quaternary) river valley gravels (see Chapter 2), which were laid down

above but now are only preserved in this hole (or "pipe", Fig. 130). While here, take the opportunity to go into the hotel for refreshments and inspect the sixteenth century manor house and the amazing Roman mosaic in a ruined villa, located not far beyond the car park by a backwater of the River Kennet.

There were, in days gone by, large numbers of small workings in the Tertiary clays, which were used to make bricks and tiles locally. Two million bricks were needed 200 years ago to make the Savernake Tunnel along the Kennet and Avon canal (G.R. 236 632), though these came from the canal company's own brick works by the Caen Hill locks at Devizes. Do stop and take a look.

Sarsen stones were utilised in the houses of Aldbourne and Great Bedwyn as they were formerly abundant. A few have also been found incorporated in the churches of both Great and Little Bedwyn, Shalbourne and Ham. However, they tend to "sweat", condensing atmospheric water vapour in damp weather when there are rapid temperature changes, so bricks were preferred, except for garden walls and out-houses. Houses in the area are traditionally made of flint, brick or both. Roofs are often thatched.

*Fig. 131: View across the Vale of Ham from the northern edge, on the Chalk east of Newtown. Erosion of the crest of an upfold in the Chalk has revealed the Upper Greensand beneath, providing a sheltered spot beneath the downs on the spring-line. The villages of Shalbourne and Ham lie in the vale, with the escarpment of Ham Hill and Rivar Hill on the horizon, the edge of Salisbury Plain (see cross-section, Fig. 125).*

# The Vale of Ham

The Vale of Ham is a hollow of about four square miles where a dome of Chalk has had its top removed by erosion to expose the earlier Cretaceous sands beneath. The result is a depression of Upper Greensand surrounded by Chalk. The structure (shown in Fig. 125) is geologically a continuation of the anticline (upfold) picked out by the Vale of Pewsey which is only a mile or two further west. If approached from this direction, the main A338 road to Hungerford crosses the dividing saddle of Chalk just south of Wilton Down, a mile or so beyond the Wilton windmill (which you can visit if you feel inclined -it is a tower mill for grinding flour, built in 1821). Interestingly, there is a prominent scarp to the south Fig. 131), which is much steeper than along the northern Chalk outcrop. This reflects the difference in the dip of the beds (see Fig.123). Gentle dips produce steep escarpments as long as there is a band of resistant rock at the top which will preserve the top edge. The Middle Chalk, about 45 metres thick, contains such a layer. The steep northward dip on the north of the vale means that the land surface intersects the beds of chalk end-on, so there is no single layer to cap the top of the ridge. Instead, beds of varying composition, degree of cementation and hardness, even within the Chalk, appear at the surface. This variation, related to environment of deposition, results in irregular ridges. The structure can be best appreciated from a vantage point on the A338 road three miles southwest of Hungerford at the junction with a minor lane on the northwest side, signposted to Newtown Store (G.R. 310 634). Here, chalk is actually exposed in the corners of the road junction and can be seen to be dipping at about 30 degrees to the north.

The inevitable springs appear in the Greensand, where the valley breaches the water table. The Gault Clay below the Greensand prevents water from sinking any deeper, resulting long ago in the establishment of the villages of Shalbourne and Ham. The sheltered position surrounded by Chalk downs, plus the fertile light mixed soils of sand and chalk, added to the areas attractions. Where roads cross the Upper Greensand, "hollow ways" have resulted, the older the road, the deeper the hollow, as the sands are usually quite soft and readily washed out by rain. A diligent search of the east bank of the lane running southward out of Shalbourne, towards Rivar, reveals a small outcrop of the typical soft greenish sandstone, with its dark green specks of the mineral glauconite. It is next to the house called "Moonrakers".

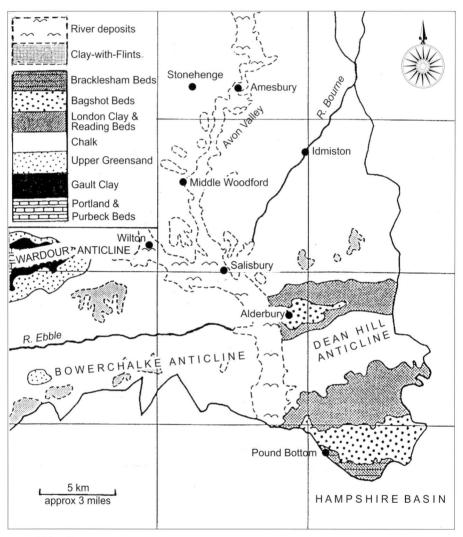

*Fig. 132: Southeastern Wiltshire: geology.*
*Geology drawn by G. W. Green from the British Geological Survey maps.*

174

# 8: The Downlands and Heaths of Southeastern Wiltshire

This part of Wiltshire is dominated by the undulating chalk downlands, deeply cut into by the tributaries of the Hampshire Avon (Fig. 132). Gentle post-Tertiary (Alpine ) folding has added some variety by preserving younger Tertiary-aged rocks in the down-folded parts (the synclines). There are two such structures present: the Alderbury syncline, south of Salisbury is the smaller; while the second is a corner (in Wiltshire) of the Hampshire Basin - a major downfold on a par with the London Basin (see Chapter 1). Linking them is the the Dean Hill anticline (Fig. 133).

The Chalk can be examined at quite a few localities. To the north of Salisbury there are some good outcrops of the Upper Chalk, which is characterised by its abundance of flints. The older houses in this area feature flint arranged in decorative patterns on the outer walls, together with bricks - there are no other building stones around here until you reach the Vale of Wardour, some miles farther west; hard bands in the Chalk have been used for interiors e.g. in some churches.

South of Amesbury, as you rise up the side of the Avon valley, there is a long outcrop in a small wood east of the main A345 road (G.R. 158 406), with lots of lovely white chalk dipping at 10-15 degrees to the southwest. The beds are clearly visible and there are burrow-shaped flints in abundance, either scattered or in rows. The fossils, as is usually the case in the Chalk, are rather elusive.

Further downstream at Middle Woodford, on the other side of the valley, an old pit west of the road along the Avon (G.R. 121 357), exposes Upper Chalk with absolutely enormous flints, large irregular masses almost a metre across; there are also layers 1-2 centimetres thick (Fig. 24). Again fossils are a bit hard to come by, just the odd broken bit of shell.

Around Salisbury there are several more quarries in Upper Chalk. A large one north of the A36 just east of Wilton is worked by English China Clays, and cannot be visited without prior arrangement. The only special feature it has - rarely seen elsewhere in this area- is a large quantity of "pipes" dissolved out of the top surface of the chalk and filled with orange-brown Plateau Gravel, probably during the Ice Age (Fig. 134). Such structures also occur in the top of

175

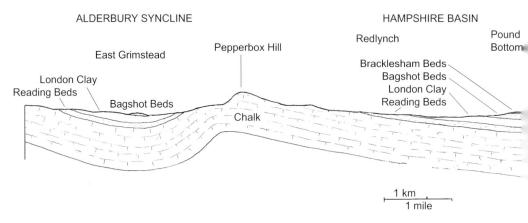

DEAN HILL ANTICLINE

ALDERBURY SYNCLINE           HAMPSHIRE BASIN

Pepperbox Hill       Redlynch      Pound Bottom

East Grimstead        Bracklesham Beds

London Clay           Bagshot Beds

Reading Beds           London Clay

Bagshot Beds        Reading Beds

Chalk

1 km
1 mile

*Above, Fig. 133: North-south section showing the structure of southeastern Wiltshire.*

*Right: Fig. 134: Solution pipe dissolved out of the Chalk surface at ground level, later filled with pebbly "Plateau Gravels" dating from the Ice Age.*

the Chalk at Littlecote (Fig. 130). They contain an unsorted mixture of rounded flint and limestone pebbles of all shapes and sizes. There is red earthy clay next to the Chalk, reminiscent of that seen in the Clay-with-Flints; it is the residue left after solution of the Chalk, when groundwater dissolved out all the calcium carbonate in the pipe.

The chalk here is particularly fine and is ground up on site, then sold as a filler for paper, paint and the various products widely used in the building and D.I.Y. industries.

South of Salisbury there is a nice, readily accessible, old pit in Upper Chalk at the back of West Harnham (G.R. 128 287). This quarry displays clear joint structures and is famous for its fossil sea urchins, though I have to admit that I failed to locate any. A Salisbury doctor named Blackmore amassed a large collection of local Chalk fossils over a hundred years ago, now kept in the Natural History Museum in London.

If you can't resist seeing more, you can go to Odstock (G.R. 145 258). Again there is fossiliferous Upper Chalk in an old quarry, dipping at 10 degrees to the north. This unusual direction is because we are between two folds here, at the south side of the Alderbury syncline and north of the parallel up-fold, the Dean Hill anticline (see below). It is typical Upper Chalk, with lots of flints, both scattered and in rows. As regards the fossils, sea urchins are reputedly fairly common, but after finding only a couple of bits of oyster, I gave up and headed for the Yew Tree Inn, which somehow seemed more attractive at the time!

The folding has raised up some Middle Chalk a mile or so to the west of Odstock, on the road to Homington (G. R. 132 261). This small old working, visible south of the road at the back of a field at present full of sheep, is on the side of the Ebble valley. The river has cut down right through the Upper Chalk, near the axis of the upfold which continues much further westwards, south of the Ebble valley, through Bowerchalke to Berwick St John (Fig. 132 & 139). It then merges into the Vale of Wardour's anticline (Chapter 9). The Lower Chalk appears further up the valley, proving that there is a structural rise here.

Well to the east of the Avon, on the A36 road from Salisbury to Southampton and further along the axis of this anticline, are Pepperbox Hill and Dean Hill, made of Upper Chalk. The Chalk here can be seen in the old quarry at East Grimstead (G.R. 227 270), which shows a northerly dip of 18 degrees, near to the point only about 300 metres to the north (by the sharp bend in the lane at the turn-off to this working) where it disappears beneath the younger Tertiary beds above. The National Trust car park by the Pepperbox, a 17th century folly (G.R. 213 248), provides a good vantage point to get a feel for the structure of southeastern Wiltshire. Here, you find yourself on the crest of the upfold, on a ridge of particularly resistant Upper Chalk, between two Tertiary-filled basins

to the north and south (Fig. 133). The land falls steeply away to the north, down towards the Tertiary rocks preserved in the syncline. There used to be a brick-works near West Grimstead down below, using the London Clay (G.R. 203 262). Now there is just a swampy hollow inhabited by moorhens, with scattered rounded flint-pebbles typical of Tertiary deposits, in the cow-churned soil. Just west of there, by the road junction, there was also an old sand pit in the Reading Beds beneath. Beyond, stretching to the northern horizon, the underlying Chalk reappears to form these hills. To the south there is another fine view. The Chalk can be seen in the massive quarry south of the main road, now used for waste disposal (and not very pleasant to visit). Tertiary beds reappear just south of here, forming the wooded hilly country of the New Forest. This is edge of the large structure known as the Hampshire Basin, stretching as far as the Isle of Wight.

Moving south, the boundary is crossed between the Chalk and the sands of the Reading Beds. As in Savernake Forest, sink-holes have been reported where streams encounter the porous Chalk. The lowest Tertiary Reading Beds can be found at the far (northern) edge of an overgrown old pit east of Redlynch (G.R 210 213). There is a public footpath in the wood to the north of the pit. Soft yellow sands appear in the bank by this wood, showing current-bedding structures (Fig. 135). Pebbles are scattered through, made of dark flint. Lithologies lower down are variable, with clays and gravel. Fossils have been found, including oysters, shark's teeth and fish bones, indicating a marine environment. The vegetation growing on the neutral and acid soils of these Tertiary sands and clays differs from that on the alkaline chalk soils. There are lots of woods, with carpets of bluebells in spring, but most striking is the open heath country encountered when heading into the New Forest on the B3080. You emerge from the forest into a landscape covered in gorse and heather, with scattered birch trees (Fig. 136). The geology is patchy Plateau Gravel lying on Tertiary sands. The highest Tertiary rocks found in Wiltshire occur just here in Pound Bottom (G.R. 220 177), and are known as the Bracklesham Beds. These are the lateral equivalent of the coloured sands of the central part of the cliffs of Alum Bay in the Isle of Wight. They are so spectacular (Fig. 137) that, although this is a working quarry (belonging to Cleansing Services), it is worth trying, at least, to get a glimpse of the range of colours in the different layers of sand. The owners are aware of the geological importance of the pit and are amenable to interested visitors, provided they get prior permission. Pound View car park (G.R. 215 177), which must be right on the county boundary, provides a distant view of the excavation, but a prowl around the woods will be rewarded with closer views of the colourful cliffs. There is a public footpath at the eastern end of the pit (G.R. 224 178). Uprooted trees in the forest have mottled yellow and

*Above, Fig. 135: Tertiary Reading Beds at Redlynch; cross-bedded sands with scattered pebbles represent a coastal marine environment.*

*Below, Fig. 136: Heathlands on the Tertiary sands and Plateau Gravels at the northern edge of the New Forest.*

*Above, Fig. 137: The Tertiary Bracklesham Beds at Pound Bottom, northern New Forest are made up of alternating clays and sands. Iron oxides have given the sands a remarkable variety of shades of orange, brown and red.*

*Below, Fig. 138: Pebbly iron oxide-cemented sandstone in the Bracklesham Beds at Pound Bottom.*

180

grey clayey sands with flints.

There are interbedded clays and sands, darker coloured near the base. Grey clays lower down are full of bits of dark, lignitic (coaly-looking) fossil wood. Fossil soil horizons, with rootlets, have been noted. Above are yellow, cross-bedded sands and red iron oxide-impregnated sandstones, some pebbly (Fig. 138). Marine fossils are scarce in Wiltshire, but the clays do contain glauconite, which proves a marine origin. Fossil sea-snake bones found suggest that the shore was not far away.

The better cemented of these rocks have actually been used in local buildings; for example, in some of the older buildings in the village, including the church, in Downton (G.R. 181 286).

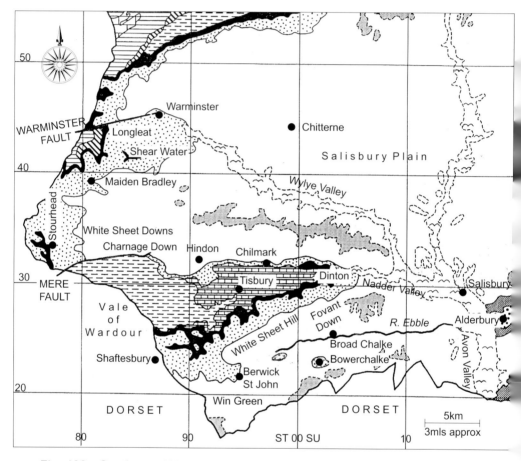

Fig. 139: Southwest Wiltshire: geology. For the key to rock types, see page 142. Geology drawn by G.W. Green from the British Geological Survey maps.

# 9: Southwest Wiltshire

This large corner of Wiltshire contains a wide range of rocks, including the whole of the Cretaceous sequence, plus the top of the Jurassic rocks lying unconformably beneath (Fig. 139).

The Vale of Wardour is cut out of the Chalk, mainly by the River Nadder, where the Earth's crust was weakened by being raised up into a fold with an axis running approximately west to east (Fig. 140). Erosion has removed the weakened chalk and exposed the underlying upfolded older rocks, from Jurassic Kimmeridge Clay to mid-Cretaceous Gault Clay and Greensands, producing a variety of scenery.

Between Mere and Shaftesbury the vale's western end is in the flat farmland underlain by the Kimmeridge Clay. The clays were in time interrupted by the appearance of sands and limestones as the sea shallowed. The higher Jurassic Portland and Purbeck formations do not appear until two miles west of Tisbury in the heart of the fold. Here the limestones produce undulating topography, dissected by the deep tributary valleys of the River Nadder which itself follows the axis of the fold eastwards to Barford St Martin, where the Chalk closes in from both sides. This Chalk and the underlying Upper Greensand actually form the most obvious landscape features bordering the vale. These sandstones in southern Wiltshire, here about 45 metres thick, contain hard chert bands in their upper levels which make the Upper Greensand form a prominent feature (around 200 metres above sea level). Chert is chemically the same as flint, but slightly more granular. Both are silica (as in sand -an extremely common and durable mineral). The folding was not symmetrical: dips are generally steep along the northern side and the sandstone here forms a wooded ridge, steep on both sides. It forms the dominant feature, with the soft Lower Chalk below to the north of it. There is a steep Chalk escarpment on the southern edge only, where the rocks dip south more gently. Here, the Upper Greensand's scarp is steeper too, also facing into the vale. The sandstones create a ledge and the dip-slope is much less dramatic as it sinks under the high Chalk escarpment rising up behind (Fig. 140). The lower beds of the Upper Chalk form the highest part of the ridge (242 m.) separating the Vale of Wardour from the parallel Ebble valley to the south. Beyond, Cranborne Chase rises to 277 metres, with even higher levels of Upper Chalk. The steep scarps, around 80 metres high, are predominantly of harder Middle Chalk, capped by the hard Chalk Rock at the base of the Upper

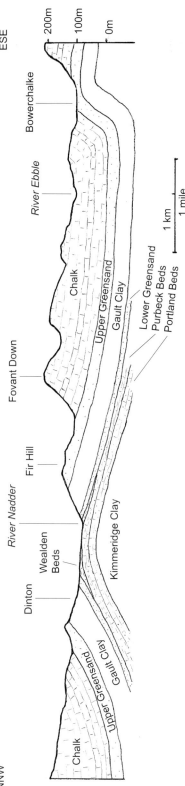

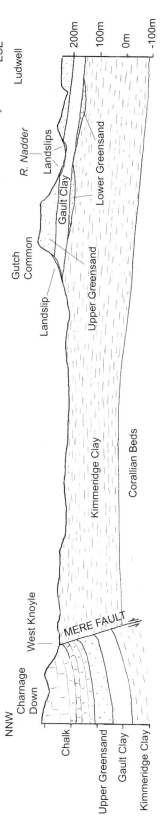

*Above, Fig. 140: Section across the eastern end of the Vale of Wardour and the Ebble valley from the downs north of Dinton to Cranborne Chase above Bowerchalke.*

*Below, Fig. 141: Section across the western end of the Vale of Wardour from Charnage Down to Ludwell (east of Shaftesbury). Note the final movements on the Mere Fault resulted in over a hundred metres of uplift on the south side. However, the Jurassic and earlier Mesozoic rocks (including the Kimmeridge Clay) are much thicker south of the fault, which was active under the sea during their deposition, when downward movement was on the south side.*

Chalk, protecting the beds below. The Lower Chalk is softer and occupies the gently sloping base of the scarp. On the north side, the steep dips mean that the softer layers go unprotected and become more prone to erosion, producing gently rolling topography. The hard layers, being individually only a few metres thick, don't then form so much of a feature (Fig. 140).

Shaftesbury (just over the border, in Dorset) is located on the end of the Greensand ledge. North of here, the vale opens out in the Kimmeridge Clay, drained by a tributary of the River Stour, and descends gently westwards to the Dorset border. Salisbury Plain rears up to the north. Most of the vale, however, is drained by the Nadder, after its confluence with the River Sem at Wardour. It then flows east along the axis of the fold, right through to Salisbury, where it runs into the Avon.

The Greensand below the Chalk is cut out by the Mere Fault, a major fault between West Knoyle and Mere (Fig. 139); this crack in the Earth's crust, along which significant movements have occurred over many millions of years (see Chapter 1), continues across the Somerset border. At this western end, Corallian Beds to the south are up-thrown first against Upper Greensand and then against the Chalk at Zeals. Further east towards Mere, it is Kimmeridge Clay south of the fault which is brought up directly against Chalk (Fig. 141). The fault has not resulted in any marked landscape features, except perhaps a break in slope or sometimes a valley, depending on the contrast of rock types on either side.

North of Mere the Greensand reappears, to border the western edge of Salisbury Plain in the estates of Stourhead and Longleat. There are several prominent hills, outliers of the Chalk, sitting atop this Greensand including, for example, Long Knoll and Little Knoll. The former rises to 288 metres south of Maiden Bradley; the smaller Manperton Hill to the north is also chalk.

## The western lands below The Plain - from Warminster to Mere

Warminster nestles in an Upper Greensand hollow, where its water supply is assured, below the Chalk of Salisbury Plain. This rises up steeply behind the town as Arn Hill (212 m), Warminster Down and Battlesbury Hill (208m) which between them have a proliferation of ancient earthworks and barrows indicating a long history of settlement. Upper Chalk can be examined on Arn Hill just down from the southwest edge of the golf course (G.R. 876 461), in a pleasant former lime works pit; access is through the woods below where the old kiln can be found shortly after entering, on the north side of the footpath (Fig. 142 - G.R. 875 460). The beds dip to the east at only eight degrees and contain lots of flints, typical of the Upper Chalk, above the prominent Chalk Rock bed at the bottom of the exposure (Fig. 143). The latter is made up of lumpy hard knobbles of chalk which have been winnowed about on the sea floor by currents which

removed all the fine soft material to form a lumpy "hard ground" on which a variety of sea creatures could live. There is an abundance of burrows and shell fragments but no flints -indicating that flints were not contemporaneous with sediment build-up. From this vantage point, the Middle-Upper Chalk outlier of Cley Hill can be seen to the west, north of the woods of Longleat. This distinctive landmark of the Warminster area, topped by a hillfort (as usual), rises from a base of Lower Chalk to a height of 245 metres. A scruffy, rubbly exposure of Chalk Rock can be found there just below the earthworks (G.R. 839 448). It is a good little hill to climb (only about 70 metres) and is less than half a mile from the car park by the A362 (G.R. 837 443). There is a tremendous view on a clear day, over west Wiltshire and Somerset. Frome lies to the northwest on the Jurassic Forest Marble and Cornbrash formations, rising gently up-dip from beneath the Oxford Clay. This Jurassic landscape is more subdued than further north because the Great Oolite limestones have been replaced by clays here. These limestones appear five miles north of Frome and the tail-end of the Cotswold Hills can be seen on the skyline, on the far side of the Avon valley at Bradford-on-Avon and Corsham. The Avon valley stretches back northward from beyond Trowbridge towards Melksham and Chippenham. The Oxford Clay vale continues southwards in the bottom of the vale below Cley Hill. To the northeast of the Avon valley, the Chalk of the Marlborough Downs stands on the horizon (to the left of Westbury's chimney). The Vale of Pewsey is in front (behind the chimney). Imagine a fault scarp along Pewsey Vale, beneath the sea, extending to the Mendip Hills, which can be seen rising on the western horizon. This fault has allowed intermittent uplift on its northern side for at least the last 180 million years. Deeper waters lay to the south, accounting for the disappearance of the Great Oolite limestones.

Above Westbury, the Chalk escarpment of Salisbury Plain runs towards Warminster, then swings south, stretching away behind Longleat Forest. Warminster is at the junction of the Lower Chalk and Upper Greensand, on the spring-line, sheltered by the downs to the northeast and guarding the Wylye valley. The forested Greensand hills of Longleat lie to the southwest; they have an abrupt scarp on their western side, overlooking Longleat Park. The latter is right down on the Oxford Clay, with the Deer Park on the overlying Corallian Beds.

It is worth walking about 800 metres from the car park in Longleat Forest to the view point known as Heaven's Gate (G.R. 822 424). The path emerges from the beech woods onto the edge of the Upper Greensand, where its escarpment overlooks the Gault Clay, Corallian limestone ledge, then Oxford Clay below. Two parallel faults run east-west between the end of the lake and the foot of the wooded Roddenbury Hill to the northwest. They raise the Upper Greensand

on the northern side, with the result that Roddenbury Hill lies beyond the main line of Greensand hills. Longleat House, lying about a mile away beyond the Safari Park, 100 metres lower down, is (like Wilton House near Salisbury), built of Box Stone (see Chapter 3). The lakes in front of the house (produced by damming the stream) are held in by the Jurassic clays below in the valley of the "long leat". After emerging from the Greensand aquifer south of Horningsham, the stream cuts right through the Cretaceous rocks, down into Jurassic Corallian and Oxford Clay formations. Wooded Upper Greensand forms the higher ground, rising to well over 200 metres. Shear Water hides in a wooded depression cut down into the Gault Clay by a tributary of the River Wylye.

A journey southwards from Warminster, along the western borders of Salisbury Plain takes you up the valley of the River Wylye, ascending from Upper Greensand onto the Lower Chalk as the valley rises. The boundary is crossed imperceptibly at Longbridge Deverill and the stream cuts into soft chalk as far as Kingston Deverill. Here take the turn-off west to Maiden Bradley, back down on the Greensand plateau, to access the B3029 road. Going southwards, this road then promptly ascends to the gap in the chalk ridge between Long Knoll (to the west) and Little Knoll, the Chalk outlier visible for miles around, which has all three levels of Chalk preserved still, accounting for its prominence. The ridge can even be seen from Win Green on the Dorset border north of Cranborne Chase (see below). This piece of chalk has been cut off from The Plain by the headwaters of the River Wylye. The latter rises around the Chalk/Greensand junction here, where the water table in this vast chalk and sandstone aquifer (underlain by Gault Clay) comes to the surface.

A few miles farther south, turn left by the Red Lion pub (G.R. 787 354) up a narrow lane to White Sheet Downs, which rear up to the east. They must have got their name from the now-abandoned Chalk quarry on its side (G.R. 797 350). This viewpoint rises to 246 metres, on the southwestern corner of Salisbury Plain and comes complete with a Neolithic causewayed camp and Bronze Age barrows, as well as the almost obligatory Iron Age ramparts (G.R. 804 346). The latter provides a prospect encompassing the entrance to the Vale of Wardour, Dorset's Stour valley and the southwestern bit of Wiltshire at the head of the River Stour (in the Upper Greensand). The end of the Chalk of Cranborne Chase forms the southeastern horizon, across the Kimmeridge Clay, on the southern side of Wardour Vale; westwards are the woodlands on the Upper Greensand hills of Stourhead; ignore Dorset in the southern distance! Immediately in front, the Chalk stretches down as far as the Mere Fault to the south of Mere, where there is a sudden change to Kimmeridge Clay along an east-west line below the downs (Fig. 139). The long ridge protruding southwards from White Sheet Hill has a stepped profile, caused by the two particularly hard bands in the Chalk

*Above, Fig. 142: The abandoned lime kiln below the old chalk pit on Arn Hill, Warminster.*

*Below, Fig. 143: The bottom of the Upper Chalk at Arn Hill. The knobbly Chalk Rock forms a prominent band at the base.*

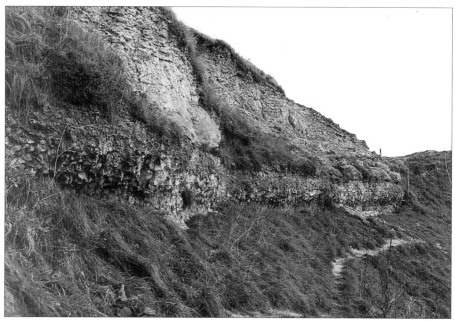

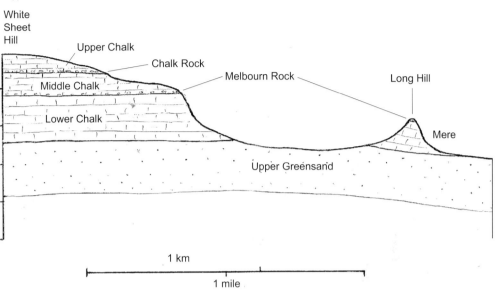

*Above, Fig. 144: Cross-section through the ridge east of White Sheet Hill down to Mere, showing the changes in slope where the hard bands marking the base of both the Upper Chalk (the Chalk Rock) and the Middle Chalk (the Melbourn Rock) reach the surface. Note how the top of Long Hill at Mere is also capped by the Melbourn Rock.*

*Below, Fig. 145: The transition from Upper Greensand to the Chalk can be seen at Mere, where a calcareous sandstone containing Greensand pebbles marks the boundary.*

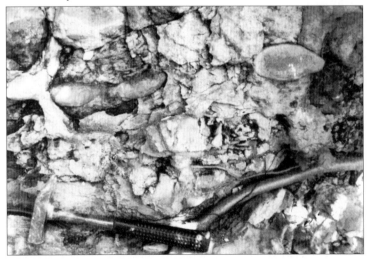

189

(the Chalk Rock and Melbourn Rock). The latter form caps to each ledge, protecting the softer chalk below, as dips are gentle (Fig. 144). Zeal's Knoll, a mile northwest of Mere, is a Chalk outlier topped by Melbourn Rock (G.R. 797 333). It was part of the main chalk outcrop we are standing on, but erosion has cut it off completely, so it sits alone on a base of Upper Greensand.

Back on the B3092, Stourhead is just off to the west on the Upper Greensand, the source of the River Stour. The water table hits the ground surface near the junction with the underlying Gault Clay and many springs emerge as, for example, at Six Wells Bottom (G.R. 767 346) where the stream was dammed in the early eighteenth century to make Stourhead's famous lakes held in by the Gault Clay. It is also renowned for its gardens full of rhododendrons and azaleas, which thrive on the iron-rich, acid, sandy soils derived from the Greensand.

There is no landform marking the fault line as it cuts through Mere, because the Lower Chalk is about as soft as the Kimmeridge Clay (though the ground over the latter is much wetter, so the fault line can be mapped quite easily). There is a lot of Greensand to be seen in Mere's older buildings, which are made of grey glauconitic ragstone (Fig. 43). On the north side, Long Hill guards the village. Like Zeal's Knoll, it is topped by two summits of Melbourn Rock (at the bottom of the Middle Chalk -Fig. 144).

The Upper Greensand / Chalk junction can be inspected at the back of the Quarry Industrial Estate at Mere -if you don't mind a few nettles! Formerly known as Dead Maid Quarry, it provides the finest available section of the transition from Upper Greensand to Chalk. It is not a well-defined boundary: soft, fine-grained, burrowed sandstone with large dark chert nodules, up to half a metre long (Fig. 145), is overlain by a hard sandstone with dark specks of glauconite and calcareous concretions; a lot of these harder lumps have, before the deposition of the bed above, been eroded out and moved around by currents to form sandstone pebbles, which were subsequently re-deposited in the overlying brown calcareous sand known as the "Popple (pebble) Bed". It is full of fossils (bivalves, snails, brachiopods, ammonites and sea urchins), which occur mainly as casts impregnated with phosphate. The Popple Bed is taken as the base of the Chalk here, and is followed by a couple of metres of fossiliferous marl which becomes more chalky upwards. The only accessible place to look is on a corner of the low cliff to the right of an oil tank, at the back of the site (G.R. 804 324).

## The Vale of Wardour's Chalk and Greensand

Having examined the transition from Upper Greensand to Chalk at Mere, it is time to head east into the vale. The A303 runs along the Chalk from Mere, not far north of the Mere Fault. Shortly after the turn-off to Charnage, a large working quarry on the left belonging to ARC Southern (G. R. 837 329) provides excellent exposures of the Upper Chalk (Fig. 51). The knobbly "hard grounds" of the Chalk Rock are well exposed; winnowing currents on the sea floor during breaks in sediment build-up removed soft material and resulted in a hard suface on which a greater variety of bottom-dwelling sea creatures could live (see Chapter 2). There are lots of flints and quite a few fossils, including corals, sea urchins and bivalves. The chalk is ground up for agricultural use.

A few miles further on, take the B3089 turn-off and head for Upton, under a mile to the south. At the far end of a small strip of woodland north of the footpath up Cleeve Hill there is Upper Greensand to be found (G.R. 869 324). An ancient hollow way leads through the wood to the outcrop. It is situated only 400 metres south of the Mere Fault, so it has a somewhat shattered look and several small fault planes as a consequence of the crustal movements. The typical burrow-ridden greenish sandstone dips steeply to the north-northeast (at about 40 degrees), in keeping with its location on the northern limb of the upfold. There are some very hard black chert beds too in the sides of the hollow way, the silica being derived from sponges.

A mile and a half to the southeast, up the lane from East Knoyle to Hindon, Upper Greensand can be found again in close proximity to the Upper Chalk. The combination of steep dips and faulting has brought them close together. On the south side of the lane, (G.R. 888 309), up a track in a rather attractive wood, rhododendrons give a hint that soils are acid. Sure enough, at the top of the hill, under an ancient bridge, some Greensand is exposed dipping at thirty degrees to the north. On the opposite side of the valley (G.R. 888 311), is an old chalk quarry face, backing a field. Nodular chalk of the Chalk Rock is again there to be studied, with a steep northerly dip like that of the Greensand. It shows several erosional features typical of the "hard grounds" formed on the sea floor when strengthening currents (probably the result of shallowing) removed all but the best cemented lumps of chalk, onto which oysters and other creatures could attach themselves. So there are fossils -if you are prepared to look hard enough! More minor fault planes, dipping steeply northwestward, cut through the rock face, a reminder of the proximity of the Mere Fault. Though the fault planes are clear (Fig. 146), the amount and direction of movement is hard to ascertain as there are so many look-alike flint bands.

Carry on along the lane here to Hindon, situated two miles on in a dry chalk valley. Its broad High Street, running down the Upper Chalk, was built of

Portlandian limestone from Tisbury's quarries after a disastrous fire in 1754 (Fig. 147). It was a staging post on the London to Exeter coach route, which accounts for its obvious former prosperity. Turn right for Fonthill Gifford, then observe the prominent ridge called "The Terraces" where the harder Chalk Rock and Middle Chalk crop out. The road tunnels through them, before descending into a valley in the soft Lower Chalk (Fig. 148). The next rise takes you up the wooded dip-slope of the Upper Greensand, which here forms a broad wooded plateau due to a small local down-fold centred on the col between the two summits of Beacon Hill (237m) and Fonthill. The road descends the scarp slope onto the Gault Clay (Fig. 148), in a broad valley stretching on down to the Fonthill lake. As at the similarly located (in a geological sense) estates of Stourhead and Longleat, the landscape architects of the Fonthill estate took advantage of the geology in their construction of artificial lakes. Only the gateway at Fonthill Bishop, built of local Portland Stone (Fig. 40), remains from the the eighteenth century (perhaps even much earlier -G.R. 933 327). The Beckfords owned the park then. Fonthill Abbey, now in ruins, was the dream of the eccentric William Beckford. He built this palatial "abbey" in the 1790s on the hill, but it collapsed in 1825, two years after he had moved to Bath.

The Upper Greensand resumes its steep northward dip east of Fonthill Gifford. Fonthill Bishop is down in a valley eroded into the soft Lower Chalk. South of here, the Upper Greensand ridge rises up from beneath, forming a striking feature (Fig.140). The village of Ridge (G.R. 954 320) is located in the woods at the top of Ridge Hill. From there, there is a lane to Chilmark, which appears down below, nestling in a chalk valley. Its valley, cut at a time back in the Ice Age when water tables were higher (it is full of Valley Gravel) is dry until the southern end of the village at the Greensand / Gault Clay junction, where a spring comes to the surface. The older buildings feature Chilmark (Portland) stone. It was quarried a mile or so further down the valley.

Before being side-tracked by these older Portlandian rocks, let us complete the tour of the Greensand, which has not actually been observed *au naturel* for quite a while. Dinton, three miles further east along the ridge, is the place for this. There are two good outcrops, one on each side of the Nadder valley. Follow the ridge-top road, rising from Teffont Magna. To the north, the dip slope of the Upper Greensand descends to a dry valley in the soft Lower Chalk. Beyond, Salisbury Plain rolls upwards. The steep dips here prevented a scarp developing. If you don't feel up to ploughing through nettles and scaling the cliffs of the more exciting exposure nearby, a narrow cross-roads on the ridge top reveals some rock (G.R. 007 324 -there is a lay-by just west of it). A deep hollow way down to Dinton cuts through the Upper Greensand, and half a metre or so above the road, on the east side, the rock can be seen dipping steeply to the north (at

*Above, Fig. 146: Fault plane cutting through knobbly beds of the Chalk Rock at East Knoyle. This is a minor fault associated with the movements on the Mere Fault nearby.*
*Below, Fig. 147: The church at Hindon (1878) is of Portlandian limestone; the impressive main street of the village was rebuilt with Tisbury stone after a fire in 1754.*

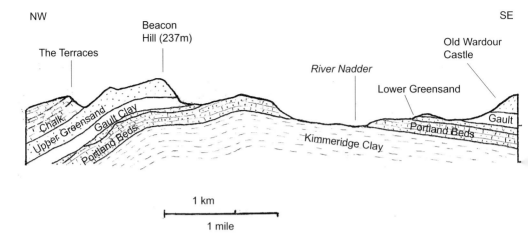

NW

Beacon
Hill (237m)

The Terraces

Old Wardour
Castle

*River Nadder*

Lower Greensand

Chalk

Upper Greensand

Gault Clay

Portland Beds

Kimmeridge Clay

Portland Beds

Gault

SE

1 km

1 mile

*Above, Fig. 148: Cross-section from southwest of Hindon, across the Vale of Wardour to the Upper Greensand hills above Old Wardour Castle. Note the slight flexure in the anticline which produces a broad Greensand outcrop at Beacon Hill.*

*Below, Fig. 149: Fossil shell bed (bivalves of the species Pycnodonte or Phygraea) in the Upper Greensand around Dinton.*

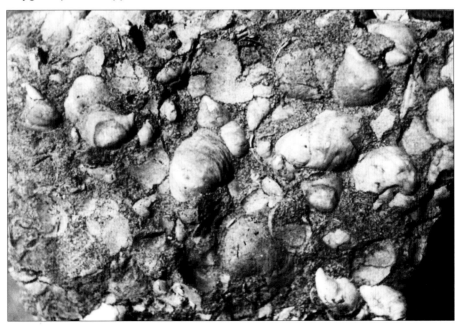

194

thirty degrees). There is a distinctive shell bed packed full of fossil oyster-like bivalves. Their white shells, stained orange by iron oxide from the sand, show up in the greenish mouldy-looking sandstone (Fig. 149). The dark specks of glauconite are the source of the iron.

Much more spectacular, though tricky to access, is a 6-8 metre-high cliff at the back of an abandoned quarry on the east of the other road to Dinton as it descends the ridge (G. R. 017 319 -opposite a track/footpath to Dinton; if you get to the right-angle bend, you've passed it!). Banded orange and pale green soft sandstones, with silicified lumps and beds of very hard chert are full of fossil burrow holes. The hard upper beds produce a vertical face (Fig. 150). A metre or so below the top of the cliff is the 30-40 centimetre-thick distinctive shell bed seen at the cross-roads. Don't worry that you can't get to it. It can be seen again close-up at the next locality on the opposite side of the River Nadder.

Dinton itself has some charming cottages in the vicinity of the church.

The mirror image of the sequence just described, on the opposite limb of the anticline, is exposed on a wooded scarp up Fir Hill (G.R. 005 297; Fig. 140). Thick beds of Upper Greensand, here dip to the southeast at 20 degrees. At the top, west of the steep track, this lovely spot reveals again, and in abundance, the shell bed spotted previously north of Dinton (Fig. 149).

The rock is actually still quarried three miles east of here at Hurdcott, near Barford St Martin (by Rare Stone). The quarry was reopened twelve years ago to supply a demand for sandstone for building renovations. The stone has good damp course properties -much better than brick. The Upper Greensand was widely quarried and used for building in the Shaftesbury area, and Hurdcott Stone was possibly that used in the Norman churches of south Wiltshire. It is the only working Greensand stone quarry in the country.

There is a good view to the south and west from the footpath at the top of Fir Hill. The Greensand shelf extends westwards to Castle Ditches Fort, standing at 193 metres, its scarp facing the vale. The dip slope of this sandstone leads to the overlying Chalk's escarpment on Fovant Down. The "Fovant Badges" - a row of military crests and emblems first cut in the turf by successive companies of soldiers camped at Fovant in 1916 - show that it is indeed chalk! The scarp sweeps westward to another White Sheet Hill, the hard Middle Chalk forming the main part of the scarp, capped by the even harder Chalk Rock (basal Upper Chalk). The scar on the hillside is an old roadside quarry, where Middle Chalk can be examined close-up (G.R. 004 273). Dipping gently into the hill are alternating beds of soft, smooth, greyish chalk and harder white chalk containing bits of shell. There are small orange-weathering pyrite nodules (fool's gold), but a notable lack of flints.

The Lower Chalk, with a few fossils , can be examined at the lower corner of

*Right, Fig. 150: The Upper Greensand northeast of Dinton forms a steep cliff as the top is protected by the hard, cherty upper beds.*

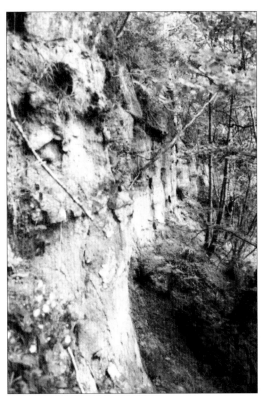

*Below, Fig. 151: Ark Farm on the Gault Clay, at the end of Old Wardour Castle's Fish Pond. The wooded, flat-topped Upper Greensand hills rise up behind.*

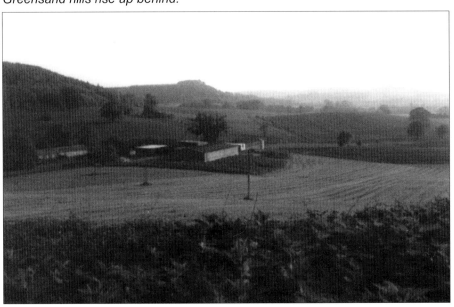

White Sheet Hill (G.R. 935 240), in a disused quarry reached by a track. It is soft, smooth and greyish in colour.

Donhead St Mary is not far away, on the broad band of Upper Greensand on the south side of the Vale of Wardour. The source of the River Nadder is near here, on the Wiltshire border at Wincombe Park (G.R. 883 241), east of Shaftesbury. The broadness of the Greensand outcrop in this area is due the gentle dips of the hard cherty rocks, which give rise to a plateau (Fig. 141). The latter is dissected by the Nadder's tributaries, all arising as springs, and including the River Don (south of the Donheads). The result is a confusing array of angular wooded hills, separated by deeply incised valleys. The streams have cut right through, down into Gault Clay (Fig. 151). Donhead Clift is a good example of one of these flat-topped hills. You can drive along the base of its steep scarp, cloaked by fern and bluebell-carpeted woods, and then up over Gutch Common (G.R. 005 257; Fig. 141). At the foot of the cherty sandstone scarp, there are more poorly cemented sands. These are water-bearing, being situated at the base of the Chalk/Greensand aquifer. The impermeable Gault Clay below causes seepage of water from the soft basal sandstones. The result is undermining which has resulted in downward slippage, into the valley, of the harder sandstones above. There have been extensive landslides, sometimes covering the basal beds and extending onto the Gault Clay outcrop. From the lane at Barker's Hill (G.R. 907 256), there are good views across the Nadder valley: the wooded hills of the dissected Greensand scarp form a backdrop to the ruins of Old Wardour Castle; the Chalk scarp rises up behind. Below, the Sem and the Nadder join at the centre of the vale, where the latest Jurassic Portlandian and Purbeck beds occur, including the building stones, eroded out by the river along the axis of the fold. The Greensand church of Donhead St Andrew is worth seeing, next to the infant River Nadder (G.R. 914 248). Its doorway displays the sandstone well, with its characteristic dark specks of glauconite, fossil fragments and burrows. There is an air of remoteness about this lovely spot. "Nadder" is Old English for "snake".

An attempt to inspect the base of the Gault Clay, at its junction with the Lower Greensand, will provide an excuse to visit Old Wardour Castle (G.R. 938 263), a romantic ruin since the Civil War, standing at the base of the Upper Greensand, sheltered by its hills. The fish pond below it is, yet again, on the underlying clay (Fig. 148). A mile away is New Wardour Castle (G.R. 928 269), an impressive Georgian mansion - the largest in England, built in the 1770s and now converted into flats. A walk along the public footpath (on Gault Clay), from the new castle towards the old, gives views of both, as well as the profusion of Upper Greensand hills (Fig. 151). The base of the Gault Clay, where it overlies Lower Greensand, is in the wood to the northeast. You would be well advised

to take my word for the existence of the junction, but if you must see for yourself, here's how: 300 metres northwest of Ark farm, skirt the field adjacent to the footpath and head for the large trees at the projecting corner of the wood (G.R. 934 267); having penetrated the luxuriant vegetation of the forest edge, savour the primaeval atmosphere of the place. There is a dark pond (on the clay), then further in, over somewhat hummocky terrain, with luck you will come upon elongate hollows in the ground, apparently inexplicable until you notice a diminutive stream trickling down one such depression, then sinking into the ground at the deepest end. This, in case you have forgotten, is the reason for even attempting to penetrate the thicket -the junction between the Gault Clay and underlying permeable Lower Greensand! The latter is of very little consequence in this area. Laid down after a gap of quite a few million years on top of latest Jurassic and possible earliest Cretaceous non-marine beds, the Lower Greensand was largely eroded away again (it is only five or six metres thick here), before Gault Clay deposition. The sink holes are identical in appearance to those found in the woods around Savernake Forest, but between different rock formations (see Chapter 7). A delve into the banks reveals brown sandy clay.

## Cranborne Chase and the Ebble valley

A diversion to get an overview of the Vale of Wardour, before heading into its heart at Tisbury and Teffont Evias, is a trip up Win Green (G.R. 925 206) on top of Cranborne Chase. This viewpoint, at 277 metres, will give an unsurpassed panorama of all the localities and rocks already described, as well as views in every other direction too: the whole of southwest Wiltshire, and more, comes into view. There is a landmark-indicating plinth at the top, by the unusual rounded clump of beech trees, to help locate things.

To the east-southeast are the Tertiary hills of the New Forest, with the Chalk of Cranborne Chase in front and to the south. Tollard Royal is two miles away, just north of the border with Dorset. The gently undulating Salisbury Plain lies on the north and northeastern horizon, with Milk Hill in the Marlborough Downs projecting up behind at 294 metres, the highest point in Wiltshire. Salisbury is 15 miles away, northeastward along the Vale of Wardour. To the northwest, on the horizon, is the distinctive Chalk outlier of Long Knoll (288m), sticking up behind the Greensand ridge (241m) stretching west from Donhead Clift. East of the scarp are more angular tree-covered hills of Upper Greensand bordering the Nadder valley, which runs between Barker's Hill and Nower's Copse, just two miles away to the north below. Behind the Nadder valley is the Greensand Beacon Hill on the opposite side of the vale, in front of the Chalk of Salisbury Plain. The back-sloping sandstone shelf topped by Nower's Copse dips down under the Chalk of White Sheet Hill, rising up immediately northeast of here.

There is a subsidiary anticline branching off eastwards from the main upfold in the Vale of Wardour, towards Berwick St John. This has created a deep inroad into the chalk outcrop, exposing the underlying Upper Greensand, which thus has a broad outcrop, stretching eastward from below Win Green, in front of Whitesheet Hill (Fig. 139). There are actually three or four domes arranged along the fold axis which continues through Bowerchalke (on the cross-section, Fig. 140), then over the River Avon south of Salisbury to the Pepperbox and Dean Hill (described in Chapter 8). There it indents the edge of the Tertiary outcrop in the Hampshire Basin (Fig. 132). The inliers of Greensand at Alvediston and Bowerchalke, isolated by overlying chalk, mark the tops of two of the domes (Fig. 139).

The road through Berwick St John to Alvediston, both delightful villages, occasionally reveals this Greensand in the corners of the sunken lane junctions (e.g. G.R. 945 216 and 951 223). The source of the River Ebble is near the Lower Chalk / Greensand junction, just west of Alvediston. Where it runs over the Chalk outcrop, from Ebbesbourne Wake to Fifield Bavant, the stream disappears except after wet seasons. This is typical of chalk streams when the water-table falls -hence the occurrence of place-names containing the word "bourne" (a seasonal stream). A mile or two down the valley at Broad Chalke are commercial watercress beds (G.R. 030 251), taking advantage of the pure water from the chalk (Fig. 57). Springs rise from the underlying Chalk aquifer beneath the beds, which drain into the Ebble. There are more watercress beds three miles further downstream at Bishopstone, again where springs rise from the floor of the Ebble valley. If the water table drops during dry periods, then pumping is necessary to maintain the beds.

## Tisbury and Teffont Evias: the latest Jurassic limestones and clays

Now to the source of the famed watery grey Portlandian building stones, widely used locally (Fig. 152), as well as further afield, and known as Tisbury and Chilmark Stone. These limestones and the Purbeck limestones above belong to the uppermost beds of the Late Jurassic sequence - everywhere underlying the Greensand and Chalk (described above).

Tucking Mill west of Tisbury (G.R. 931 291) had a quarry in Portlandian limestones; it closed in 1975. The Tisbury Stone is a grey-weathering sandy limestone, creamy grey-coloured when fresh. The chert in the fine-grained limestones comes from sponge spicules found in the oolite shoals and banks which once covered the area, renowned for its silicified coral fossils, called "star agate". The source is located now in a private garden. Only the quarry at Upper Chicksgrove and the underground workings in the "Chilmark Ravine" (G.R. 975 312) are still operating. The "ravine" is actually a deep wooded valley with

*Fig. 152: Lower Chicksgrove Manor built of local Portlandian stone in the late sixteenth century.*

*Salisbury Cathedral, built of Chilmark Stone in the thirteenth century.*

large abandoned quarries and mines cut into both sides, hidden in the woods. There is, unfortunately, no access to these at present as they are owned (and fenced off ) by the Ministry of Defence and the area is riddled with old mine tunnels which were used for bomb storage during the war, among other things. A minor upfold along this valley was responsible for the reappearance of these Portland Beds in this location within the general area of outcrop of the younger Purbeck Beds.

The ruins of lime kilns lie on the west side of the lane up the valley. The present mine (G.R. 976 312; Fig. 39), owned by Rare Stone, was re-opened in 1993 to obtain more Chilmark Stone to repair Salisbury Cathedral (Fig. 153). It is also used for other restoration work as well as general (up-market) building. There are a variety of limestones in the forty metre sequence. Chilmark oolite is restricted to the "ravine".

The Purbeck limestones above the Portland Beds crop out farther east, down the Nadder valley in the core of the anticline around Teffont Evias. Lady Down, northwest of Tisbury, has an old pit (G.R. 961 307) in Purbeck limestones and clays. I do not recommend this one. Key locality it may be (it is a Site of Special Scientific Interest), but it is not a pleasant place, full of nettles and farmyard dumpings! At the back are a couple of metres of gently dipping limestones and cream and brown clays with layers of calcite crystals known as "beef" (see below). There is, however, a good view over the low limestone ridge at Tisbury, north of the Nadder valley. The undulations are due to the variations in hardness of the beds. The large working quarry of Upper Chicksgrove is visible on the far side. Rising behind is the wooded Upper Greensand ledge topped by Castle Ditches hill-fort (193m). Behind again, the Chalk scarp of White Sheet Hill (242m) rises up in front of Cranborne Chase.

At Upper Chicksgrove the working quarry (G.R. 962 296 -owned by Sally Collins), has an excellent section of Portlandian and Purbeck limestones and clays by the entrance, dipping at ten degrees to the east (Fig. 154). At the top are alternating clays and the thinly bedded fine marly limestones typical of the Purbeck Beds. There are dark, coaly lignite bands in the clays formed by accumulated plant debris. These are shoreline deposits. Below there is a distinctive bed of large bivalve shells 30 centimetres thick (Fig. 155) which is near the top of the Portland Beds. The boundary between Portland and Purbeck beds is gradational, as the sea shallowed and lagoons developed at the shoreline. Beneath the shell bed, at ground level, the limestone is very fine grained and chalky-looking, with thin beds of dark chert (Fig. 156), derived from sea creatures like sponges. The large Portlandian ammonites from low levels of the quarry have been used to embelish local walls. The Upper Chicksgrove quarry is currently operating to provide building stone, including stone for the restoration

of Salisbury Cathedral. It has yielded a variety of fossils: fish, reptiles and mammals, giving a picture of life in late Jurassic Britain.

The same Purbeck limestones can be seen again in a more tranquil environment in the woods at Teffont Evias (G.R. 990 310). A convenient lay-by at the wood's edge (G.R. 993 308) provides good views to the south over the Nadder valley, with the chalk on the horizon again and the Upper Greensand scarp descending steeply down into Fovant's valley.

At the south-western edge of the wood is a long-abandoned excavation which has left a small cliff below the field boundary showing a variety of limestones, some marly beds and thinly-bedded calcareous mudstones which are quite distinctive and reminiscent of the Purbeck Beds seen at Swindon (Chapter 5), as are the very fine-grained limestones of algal origin. Other limestones are coarser and full of shell fragments. The marls contain layers of fibrous calcite known as "beef", which crystallised within the marls. Fossils abound in the hard grey limestones, both vertebrates (fish, crocodiles, turtles) and invertebrates. Insects have been documented, though they are not common, as well as brackish-water bivalves and ostracods; the latter are important for correlation as there are none of the usual marine fossils to indicate rocks of the same age in different areas and differing rock types. Chilmark has yielded the best examples of the abundant conifer and cycad fragments, occurring in carbonaceous shales; a conifer stump 1-8 metres tall has been found in position of growth. The fauna indicates an alternation of marine and non-marine conditions, probably caused by the growth of a reef barrier, breached from time to time by the sea, when normal marine limestones were laid down. The reef was made of blue-green algae which formed mats and mounds; they occur today, for example, in northwestern Australia, and their metabolism results in the precipitation of calcium carbonate from the water, producing the typical very fine, smooth white limestone. Behind the reef were hypersaline lagoons with a fauna restricted to specialised molluscs, ostracods and algae, the site of deposition of lime muds. The rock types show that the climate was warm and semi-arid.

There is no "Purbeck Marble" shell bed of the type found in Dorset, but the limestones have been used for building and the flaggy beds for tile-stone as, for example, in Teffont Evias.

Teffont Evias is a beautiful tranquil spot, its buildings dominated by local stone. A lovely clear stream (the Teff) runs along the road beside the elegant church and adjacent manor, crossed by lots of small stone bridges. At the northern end of the village, up a side road, is a partly restored lime kiln (Fig. 41), which used to have a railway linking it to the quarry. There is a public footpath to the north of the wood from here (G.R. 989 313). The Teff is supplied by strong springs from the Chalk above Teffont Magna, just up the lane. The source is

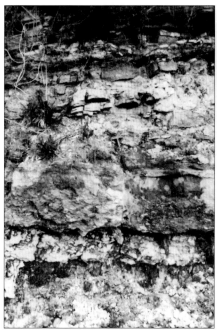

Above, Fig. 155: Bivalve shell bed near the top of the Portland Beds at Upper Chicksgrove.
(Photo is 57cm. across).

Left, Fig. 154: Portland and Purbeck rocks at the Upper Chicksgrove quarry.

Right, Fig. 156: Fine chalky limestone with thin chert beds (below the hammer) in the Portland Beds at Upper Chicksgrove. The silica in the chert was derived from the skeletons of sponges and plankton.

203

opposite Farmer Giles' open farm, amongst the trees of an amphitheatre-shaped depression below the cornfields (G.R. 985 328). I don't advise looking for it in high summer; the hollow created by the springs becomes somewhat nettle-ridden (a particularly tall variety) and the cress filling the stream bed disguises its true depth: knee-high wellies are definitely a necessity! I don't think it is possible to see anything without getting into the water. But it is beautifully clear as it emerges from the chalk to fill a pool, the level of which obviously fluctuates with the water table. In drier periods, the back of the depression is dry, but surfaced with well-washed chalk rubble.

At Dinton, above the Purbeck, are the even younger Wealden Beds: up to nine metres of mottled clays and marls with sands, possibly of earliest Cretaceous age, though all they contain are some undateable wood fragments. As they are now so overgrown that it is impossible to examine them, they need not concern us. However, they are part of an environmental picture which has emerged from the study of the complete sequence. As at Swindon, we have been looking at an upward transition through coastal deposits from the Jurassic to the Cretaceous Period, marking the retreat of the Jurassic seas. Marine Portlandian limestones pass up into alternating marine and non-marine Purbeck limestones and clays, then non-marine river sediments. The sea did not return to the region until Lower Greensand times, some 30 million years later. There was then some erosion and reworking of the beds below, although it isn't possible to see it here. The unconformity is clear from the geological maps.

# Glossary

**Algae** Simple plants with no differentiation into leaf, stem and root. Calcareous algae are blue-green algae (cyanobacteria) which produce calcium carbonate. This builds up to form a reef limestone.

**Alluvium** Sediment deposited by rivers.

**Anticline** Fold bending the rocks up into an arch.

**Ammonite** Extinct cephalopod mollusc with coiled shell divided into internal compartments with crenulated walls separating them.

**Aquifer** A permeable water-bearing rock containing enough pore-space to supply a significant amount of water.

**Aragonite** A form of calcium carbonate which is the usual component of the skeletons or shells of sea creatures. It is unstable, changing with time to calcite.

**Ashlar** Cut stone, squared and smoothed for building.

**Basin** A down-folded (synclinal) structure in the rock, rising up on all sides. It can also mean a topographic depression containing or receiving sediment.

**Bed / Bedding** Single layer/layering of sediment due to variations in the environment and sediment supply as it is deposited. Bedding planes separate each bed and mark a break in the continuity of sedimentation caused by either erosion or cessation of sediment supply.

**Beef** Fibrous calcite, crystallised in layers with a texture resembling steak.

**Belemnite** A group of extinct molluscs related to cuttle-fish and squids, with an internal bullet-shaped rigid skeletal support.

**Bivalve** Mollusc with two shells joined by a hinge; common both today and as fossils.

**Bourne** Seasonal stream of chalklands, flowing only during wet periods when the aquifers are sufficiently full of water (usually in winter) to raise the water

table to the level of a normally dry valley.

**Brachiopod** Marine two-valved shellfish much more common as fossils than today. They commonly had a small hole, either between the valves (shells) at the hinged end or through just one shell, from which an anchoring organ protruded.

**Bryozoan** Colonial sea-creatures with a branching calcareous skeleton housing the individual animals.

**Cainozoic** The most recent era of geological time starting 65 million years ago at the end of the Mesozoic Era.

**Calcite** Crystalline mineral form of calcium carbonate, the chief component of limestones.

**Cementation** The welding together of individual grains in a sedimentary rock by the growth of crystals in the pore spaces.

**Cephalopod** A class of molluscs with a shell coiled in one plane and internal partitions.

**Chert** A type of quartz with such fine crystals that it appears dark; it may be granular or glassy.

**Concretion** A well-cemented nodule found within a sedimentary rock.

**Cretaceous** The latest period of the Mesozoic Era, from 145 to 65 million years ago.

**Crinoid** Sea lily; a type of echinoderm, usually fixed by a stalk, with branching arms; it has a skeleton of hundreds of round plates commonly found as foosils.

**Cross-bedding** Partings or laminations at an angle to the main bedding planes as a result of deposition of the sediment on migrating sand / shell banks or ripples - occurs on a variety of scales.

**Crustacean** A type of arthropod, mainly marine, including crabs and shrimps.

**Cycad** A palm-like plant.

**Dip** The inclination of a bed of rock; it is measured as the angle the beds are inclined downwards from horizontal.

**Disconformity** An unconformity where there is evidence of missing sediments and a time-gap, but no difference in dip in the rocks above and below.

**Detrital** Describes residual resistant particles eroded from a pre-existing rock, subsequently re-deposited.

**Doggers** Patches of harder calcite-cemented sandstone characteristically found in rows in the Upper Greensand; they project from the surrounding softer sands.

**Dry valley** A valley in permeable rock with no stream running through it, formed at a time when the water table was higher or the bed-rock was rendered impermeable by permafrost.

**Echinoderm** A group of marine animals with five-fold symmetry and a spiny calcite skeleton, including sea urchins (echinoids), starfish and sea lilies.

**Epifauna** Animals living on the sea floor either attached to a larger creature's shell or free-moving.

**Escarpment** The steep edge of a hill, found where resistant rocks are flat-lying or dipping gently into the hillside.

**Fault** A fracture in rocks along which there has been movement of one side in relation to the other, displacing the rock formations.

**Feldspar** Aluminium silicate mineral with sodium, potassium and calcium; originally a crystal in igneous rocks, it is commonly found as detrital grains in sediments.

**Ferruginous** Containing iron.

**Fissile** Splitting easily along a pre-existing weakness such as bedding planes.

**Flint** Microcrystalline quartz nodules found in the Chalk; the same as chert in other rocks.

**Fold** A bend in originally flat, layered rocks as a result of pressure during crustal movements of the Earth.

**Foraminifer** A single-celled animal with a 'shell' of variable composition, often silica or calcium carbonate.

**Fossil** The remains or trace of an animal or plant buried and preserved in the rocks.

**Freestone** A building stone of such uniform composition that it can be cut without fracturing.

**Gastropod** A group of molluscs, including snails, with helically-coiled shells of calcium carbonate.

**Glauconite/Glauconitic** A dark green mineral formed in marine sediments, essentially a hydrous silicate of iron and potassium.

**Ground-water** The water in porous rocks beneath the water table.

**Gypsum** Calcium sulphate, a mineral formed by evaporation of salt-water.

**Hard-ground** A hardened surface on the sea floor resulting from the contemporaneous removal of softer sediments by currents, leaving behind the better cemented nodules and areas of partially lithified rock.

**Hercynian** A mountain-building episode at the end of the Palaeozoic Era, affecting southern England and mainland Europe.

**Hollow way** Sunken road or track, deepened over the years by cart-wheels below the general ground level.

**Ice Age** A long period of colder climates and glaciation at lower latitudes, with much more extensive polar and mountain ice caps than today. The most recent was in the Pleistocene Period of geological time from 1,640,000 to 10,000 years ago.

**Igneous** Rock which solidified from molten magma (e.g. basalt lava or granite which crystallised at depth).

**Inlier** An outcrop of older rock surrounded by younger rocks.

**Interglacial** A period of relatively warm climate within an Ice Age, when glaciers retreated and sea levels rose.

**Ironstone** Sedimentary rock containing iron-rich nodules or layers.

**Jurassic** The period of time between 145 and 208 million years ago in the middle of the Mesozoic Era.

**Joint** A crack or fracture in the rock without any visible movement. They occur in sets as a result of stress during Earth movements.

**Lias** The lower part of the Jurassic rock sequence.

**Lignite** compressed fossil plant material in the process of changing from peat to coal.

**Limestone** Rock comprised mainly of calcium carbonate largely derived from the skeletons/shells of sea creatures.

**Limonite** Iron oxide which has become hydrated (combined with water) and a rusty brown colour.

**Lithification** The process of compaction and cementation which turns sediment into rock.

**Lithology** The overall composition, texture and make-up of a rock.

**Marl/Marlstone** Calcareous mudstone; a sedimentary rock of fine mud particles and calcium carbonate cement.

**Mesozoic** The era of geological time from 245 to 65 million years ago.

**Mineral** A naturally occurring inorganic chemical with a definite composition and structure.

**Nautilus** Cephalopod mollusc with coiled shell divided internally by smooth partitions - related to ammonites.

**Neolithic** The New Stone Age, between 7,000 and 4400 years ago.

**Nodule** Hard, rounded lumps within sediments, commonly cemented by calcium carbonate, but may be composed of other minerals such as pyrite, phosphates or silica.

**Ochrous** Describes sediments stained with hydrated iron oxides, red, yellow and brown in colour, resulting from the weathering of iron minerals in the rocks.

**Oolith/Oolitic/Oolite** Ooliths are concentrically laminated spherical particles built up around a nucleus of sand or shell coated with blue-green algae which causes the precipitation of layer upon layer of calcium carbonate. The rock formed by the build-up of ooliths is an oolite; commonly shell debris is mixed with the ooliths, forming an oolitic limestone. 'Oolith' is derived from Greek, literally 'egg-rock', as they resemble eggs.

**Ostracod** Group of small crustaceans with a bivalved calcareous carapace; useful for dating and correlating rocks.

**Outcrop** The area where a rock formation occurs at the surface of the ground, though it may be covered by soil and vegetation.

**Outlier** Younger rocks cut off from their main outcrop, so that they are surrounded by older rocks.

**Oxide** The chemical combination of an element (such as iron) with oxygen. Iron minerals are commonly found in rocks and iron oxides, commonly hydrated (with the addition of water) give them a yellow, orange or red colour.

**Palaeolithic** The Old Stone Age, 12,000 to 9,000 years ago, starting before the end of the last glaciation of the Ice Age.

**Palaeozoic** the era of geological time from 570 to 245 million years ago.

**Periglacial** Cold-climate tundra-type geographical conditions around the margins and beyond the limits of glaciers or ice caps.

**Permafrost** Permanently frozen sub-soil; found in Arctic climates.

**Pipe** A hollow or channel dissolved in the top surface of the Chalk by percolating rain-water, guided by fractures or weaknesses. They probably formed in the wetter periglacial conditions of the Ice Age; they are filled with Plateau or Valley Gravels, subsequent river deposits.

**Plesiosaur** Large extinct marine reptile with paddle-shaped limbs, living in Mesozoic time.

**Pliosaur** A type of plesiosaur with a large head and ferocious teeth.

**Pyrite** Iron pyrites or fool's gold is iron sulphide, a very common shiny, yellow mineral.

**Quartz** The mineral silica, silicon dioxide, is an extremely common and durable mineral, the main component of sand.

**Quaternary** The period of geological time from 1,640,000 years ago to the present day. It includes the Ice Age.

**Radiometric dating** The technique of determining the age of a rock from the relative proportions therein of radioactive elements and their decay products; the former break down at a known rate.

**Ragstone** A poorer quality building stone, more suitable for walls, due to thinner

more irregular bedding and a higher fossil content than freestones.

**Rift-valley** An elongated area which has dropped down between two parallel extensional faults in the Earth's crust; they form in regions of crustal tension.

**Rock-salt** Sodium chloride naturally occurring in rocks formed by the evaporation of salt-water; it has cubic crytals.

**Sandstone** Sedimentary rock made up of cemented sand grains, predominantly of quartz.

**Sarsens** Blocks of hard, silica-cemented sandstone found lying on the surface of the downlands of parts of Wiltshire; they were formed by localised cementation of sands along sub-surface drainage channels in the Tertiary period.

**Scaphopod** Mollusc with a tusk-shaped shell, open at both ends.

**Scarp** The same as an escarpment.

**Sedimentary** Describes rocks formed from the build-up of sediments and their features.

**Silcrete** A hard, silica-cemented, surface or near-surface layer, formed by the precipitation of silica within the soil or underlying sediments.

**Silica** Silicon dioxide; quartz is the most common form, but it can also form chert, flint, jasper, agate, opal and onyx. Silicification means replacement, for example of a fossil, with silica.

**Silt/Siltstone** A sediment with a grain-size intermediate between mud and sand.

**Solution** In this context is the dissolving of minerals or fossils from the sedimentary rock by the surrounding water in the pore-spaces (may be ground-water or sea-water).

**Strike** The horizontal direction the rocks follow at right angles to their dip.

**Syncline** Downfolded structure or trough.

**Tectonic** Describes structural disturbances and deformation of the crustal rocks resulting from Earth movements.

**Tertiary** The period of geological time, between 65 million and 1,640,000 years ago, following the Mesozoic Era.

**Tile-stone** Thinly bedded layers of rock suitable for roofing tiles.

**Topography**  The shape of the land surface; the physical features.

**Travertine**  Calcium carbonate deposits precipitating out of water which is saturated with calcium carbonate after passing through calcareous rocks; it is the result of evaporation and/or biochemical activity as the water flows over a surface (at a spring, waterfall or cave).

**Tundra**  Arctic regions with permanently frozen sub-soil and specialised vegetation.

**Unconformity**  A break in the rock sequence representing a period of erosion or lack of sedimentation. Earth movements may have occurred during this period, resulting in an angular discordance between the beds below and above the unconformity.

**Water table**  The water level at the top of an aquifer (water-bearing rock).

# Further Reading

*A Guide to the Industrial Archaeology of Wiltshire*, edited by M.C. Corfield. Published by Wiltshire County Council Library & Museum Service for the Wiltshire Archaeological & Natural History Society, 1978.

*British Caenozoic Fossils*, British Museum (Natural History), HMSO.

*British Mesozoic Fossils*, British Museum (Natural History), HMSO.

*British Regional Geology: The Hampshire Basin and adjoining areas*, British Geological Survey, HMSO.

*British Regional Geology: London and the Thames Valley*, British Geological Survey, HMSO.

*British Regional Geology: Bristol and Gloucester Region*, British Geological Survey, HMSO.

*Building with stone in Wessex over 4000 years*. Edited by T. Tatton Brown. The Hatcher Review Vol. V, No. 45. Available from Devizes Museum Tel. 01380-727369).

*The Geology of Wiltshire* by R.S. Barron, Moonraker Press, 1976.

*The Rocks of Brown's Folly* by R.B.J. Smith, published by the Bath Geological Society (Tel. 0117-932 2249).

British Geological Survey 1:250,000 maps: Bristol Channel (Sheet 51N 04W) and Chilterns (Sheet 51N 024).

British Geological Survey 1:50,000 / 1:63,360 maps: Sheets 251:Malmesbury, 252: Swindon, 253: Abingdon, 265: Bath, 266: Marlborough, 267:Hungerford, 281: Frome, 282: Devizes, 283: Andover, 297: Wincanton, 298: Salisbury, 299: Winchester, 313: Shaftesbury, 314: Ringwood, 315: Southampton. Detailed geological memoirs accompany many (but not all) of the geological maps. These are published by HMSO. They are available for reference at specialist libraries (e.g. the library in the Wills Memorial Building of Bristol University).

Ordnance Survey Landranger 1:50,000 maps: Sheets 172: Bristol & Bath, 173: Swindon & Devizes, 174: Newbury & Wantage, 183: Yeovil & Frome, 184: Salisbury and The Plain.

Ordnance Survey Explorer 1:25,000 maps: Sheets 168: Stroud, Tetbury & Malmesbury,169: Cirencester & Swindon, 155: Bristol & Bath, 156: Chippenham,157: Marlborough, 158: Newbury & Hungerford, 143: Warminster & Trowbridge, 130: Salisbury & Stonehenge, 131: Romsey & Andover, 118: Shaftesbury.

Ordnance Survey Outdoor Leisure 1:25,000 map: Sheet 22: New Forest.

# INDEX

Aldbourne 80, 166, 172
Alderbury 32, 58, 174-177
Algae 52, 135, 202
All Cannings 87
Alps 22, 29, 31-32, 97, 143, 175
Alvediston 199
Amesbury 174, 175
Ammonite 21, 23, 48, 49, 53, 55
 Jurassic 18, 35, 40, 42, 43, 45, 99, 101,
105, 111, 112, 129, 130, 133, 134, 136, 139,
140, 145, 157, 201
 Cretaceous 19, 158, 159, 190
Ampthill Clay 41, 129-130
Anticline/upfold 31-32, 143, 174, 165,
 172-173, 175,176,177, 195, 199, 201
Ark Farm 196, 198
Arn Hill 185, 186
Ashton Common 156
Ashton Keynes 34, 67, 80, 85,118,
 139-140
Atworth 75
Aqueduct 107, 109
Aquifer 90-92, 130, 163, 187, 197, 199
Avebury 60-61, 64, 70, 80, 118, 126, 132
Avoncliff
Avon valley (Bristol Avon) 13, 33,
 41-43, 67
Avon valley (Salisbury Avon)
Axes, Stone Age 68, 141

Badbury 87, 136
Badminton Park 97, 98
Bagshot 165, 166
Bagshot Beds 12-13, 24, 27, 59-60, 169,
 174, 176
Barbury Castle 118, 136
Barford St. Martin 80, 183, 195
Barker's Hill 197, 198
Bath 117
Bathford 108, 113
Bath Oolite 37, 113, 114

Bath Stone 71, 74, 104,110
Battlesbury Hill 185
Beacon Hill, Marlborough Downs 119,
 120, 124, 158
Beacon Hill, Wardour Vale 50, 192, 194,
 198
Bedwyn Brail 167
Bedwyn Brook 169
Beef 201, 202
Beggar's Knoll 145, 149
Belemnite 18-21, 35, 42, 45, 53, 55, 58,
 100, 101, 111, 130
Berwick St. John 31, 182, 199
Bishopstone 92, 199
Bison 141
Bivalve 21
 Cretaceous 19, 49, 50, 52, 53, 57, 58, 145,
 146, 158, 163, 190, 191, 194, 195
 Jurassic 18, 35, 37,39, 40, 42, 43-46, 98,
 101, 111, 112, 115, 130, 135, 136, 157,
 201-203
 Tertiary 20, 59, 140, 169, 178
Botley Down 142, 143, 164
Bourne, River 92, 174
Bournes 90, 199
Bowden Hill 43, 103, 104, 119
Bowden Park 101, 104
Bowerchalke 31, 182, 184, 199
Bowerchalke anticline 31, 174, 184, 199
Bowood House 89, 119, 121
Box 35, 71, 74, 75, 96, 116, 117, 187
Brachiopod 21
 Cretaceous 19, 48, 50, 53, 55, 57, 158,
 190
 Jurassic 18, 35, 37, 39, 40, 45, 98, 101,
 111, 112, 115
Bracklesham Beds 12-13, 24, 59-60, 80,
 84, 174, 176, 178, 180
Bradford Clay 38, 114,115
Bradford-on-Avon 34, 38, 72, 74, 75, 84,
 96, 97, 105-108, 111

Bratton 142, 144, 148-150, 152, 161
Bremhill 96, 101
Bricks 43, 49, 59, 76, 80, 84, 87, 136, 138, 158, 159, 167, 172, 178
Broad Chalke 91, 92, 182, 199
Broad Town 118, 127, 130
Bromham 87, 89, 155, 158
Brown's Folly 38, 96, 113-116
Bryozoan 37, 52, 98
Budbury 106
Building stones 71-83, 197, 199, 201
Burbage 142, 144
Burderop Wood 136
Burridge Heath 167, 171
Burrows 98, 115, 153, 154, 160, 171, 186, 191, 195, 197
By Brook valley 13, 34, 35, 96, 116, 117

Caen Hill 87, 158, 159
Calne 43, 48, 75, 84, 86, 118, 121, 122
Calne Freestone 43, 75
Casterley 87
Castle Copse 167
Castle Ditches 195, 201
Cement 83, 87, 106, 145, 147, 148
Chalk 12-13, 24, 27, 32-33, 47, 50-58, 80-85, 89, 90, 92, 106, 142, 143, 145, 147, 149, 152, 153, 159-160, 165, 166, 167-169, 182, 184, 187, 194, 202
    Lower 55-56, 91, 119-120, 124, 130, 136, 148-151, 155, 161-163, 185, 186, 189, 192, 195, 199
    Middle 55-58, 119, 125, 130, 136, 151, 162, 163, 173, 177, 186, 189, 192, 195
    Upper 55, 57, 58, 123, 130, 136, 150, 162, 164, 171, 175, 177, 185, 186, 189, 191
Chalk Rock 53, 55, 57, 80-81, 130, 145, 163-164, 183, 185-193, 195, 198
Charnage 82, 84, 182, 191
Cherhill Down 118, 125, 126
Chert 183, 190, 191, 196, 197, 199, 201, 203
Chilmark 46, 76-77, 182, 192, 202
Chilmark Stone 45, 77, 192, 199-201

Chilton Foliat 171
Chippenham 34, 42, 96, 97, 101
Chisbury 166, 167, 169, 170
Chisledon 118, 136
Chitterne 182
Church Springs 150-152
Clay-with-Flints 12-13, 24, 69-70, 89, 123, 125-127, 136, 165, 166
Cley hill 106, 186
Coal 112, 127, 144, 148
Coate Water 135-136
Cob walls 82, 83
Coccoliths 52
Cole, River 118, 138
Colerne 117
Combes 65, 90, 126
Combe Bottom 150, 151
Combe Down 113
Combe Down Oolite 37, 110, 114
Concrete poducts 84, 85, 121, 141
Concretion 121-122, 141, 157, 160, 190
Conifer 46, 202
Conkwell 74, 109
Continental rocks 15
Coral 18-20, 35, 37, 43, 45, 53, 60, 75, 98, 112, 115, 137, 155, 156, 191, 199
Coral Rag 43, 137
Corallian Beds 12-13, 24, 26, 41, 43-44, 75, 80, 87, 88, 101, 103-106, 121, 127, 129-130, 133, 136, 137, 142-144, 150, 155, 156-158, 185, 187
Coral Rag 43, 137
Cornbrash 12-13, 24, 34, 40, 75, 98-99, 101, 105, 111, 186
Corsham 39, 74, 75, 96, 103, 117
Corston 39
Cotswolds 13, 33-40, 67, 71, 75, 91, 96-99, 112, 148, 186
Cotswold Water Park 67, 84, 140
Cranborne Chase 13, 31, 183, 184, 198, 201
Cretaceous 10, 12, 24, 26, 135, 144, 157, 183, 204
Cretaceous-Tertiary boundary 27

Cricklade 84, 118
Crinoid see Sea lilies
Crockerton 87
Crocodile 141
Crookwood Farm 160
Crustacean 53, 60
Cycad 46, 202

Damp course 79, 80, 160, 195
Dauntsey 87, 96, 100
Dean Hill 13, 31-32, 177
Dean Hill anticline 174-177
Derry Hill 43, 101, 121
Devil's Den 131, 132
Devizes 44, 47, 49, 87, 96, 142, 144, 150, 158-159
Dewponds 84, 85
Dinton 46, 182, 184, 192, 194-196, 204
Dip slope 98, 195
Ditteridge 117
Doggers 43, 49, 50, 160
Donhead Clift 148
Donhead St. Andrew 197
Donhead St. Mary 184, 197
Downton 86, 181
Dry valley 65, 90, 120, 126, 132, 150, 191, 192
Dundas aqueduct 109, 110

Easterton/Easterton Sands 142, 144, 150, 153, 154, 159
Easton Grey 96, 98, 99
East Grimstead 176, 177
East Knoyle 191, 193
Ebbesbourne Wake 199
Ebble, River 91-92, 177, 182-184, 199
Echinoid see Sea urchins
Edington 144, 150
Etchilhampton Hill 144, 161, 162
Eras 23
Erlestoke 144, 150, 153
Erosion 15
Escarpment, Chalk 106, 119, 124-125, 130, 136, 143, 150, 153, 158, 161-163,

173, 183, 186, 195, 197, 201
  Corallian 137, 155-156
  Greensand 186, 195, 197, 198, 202

Farleigh Hungerford 38, 71, 96
Faulting, normal 31, 103
Faulting, reverse 32
Fifield Bavant 82, 199
Fir Hill, 184,195
Fish 18-20, 42, 45, 46, 53, 100, 141, 178, 262
Flint 53-55, 57, 67, 68, 80, 82, 141, 163, 167, 169, 171, 172, 175, 177, 178, 181, 185, 191
Fold 31-32, 143, 163, 165, 172-173, 192, 197, 199
Folly Wood 154, 161
Fonthill 76-77, 192
Foraminifera 20, 21, 52, 59
Forest Marble 12-13, 24, 34, 38-39, 75, 98-100, 105, 107-108, 111, 113-115, 186
Fossils, types and preservation  16, 21, 28
Fovant 202
Fovant Down 184, 184, 195
Freestone 36, 37, 43, 71, 107, 110, 115
Freshwater/non-marine environments 26, 135, 204
Frome 186
Fullers Earth 34-37, 109, 111, 114-117
Furze Knoll 123, 125
Fyfield Down 64, 80, 126, 130, 132

Gastard 3, 9, 75, 103
Gastropods/snails 18-21, 37, 43, 45, 46, 53, 98, 101, 112, 115, 135, 140, 158, 190
Gault Clay 12-13, 24, 26, 47-49, 87, 89, 91, 119, 123, 130, 136, 142, 144, 150, 153, 158-162, 173, 183-184, 187, 190, 192, 194, 196, 197
Giant's Grave 163
Glauconite 47, 49, 55, 59, 60, 89, 121, 173, 181, 190, 197, 198
Golden Ball Hill 162, 163

Gravel 84, 100, 140-141
Great Bedwyn 166, 167, 169, 172
Great Chalfield Manor 74
Great Oolite 12-13, 24, 26, 34, 36-38, 71, 74, 75, 91, 105, 110-111, 113, 117, 186
Great Somerford 67, 100
Great Western Railway 75, 88, 100, 107, 144
Greenhill Common 130
Ground-water 90-92, 122, 150
Gutch Common 184

Hackpen Hill 118, 127, 130, 132
Hampshire Basin 13, 32, 58-60, 175, 176, 178
Ham 142, 166, 172, 173
Ham, Vale of 13, 165, 167, 171-173
Harding Farm 169
Hard-ground 53, 153, 186, 191
Head 69, 145, 147
Heath 179
Heaven's Gate 186
Heddington 123
Heron Bridge 45
Heytesbury 65
Heywood Fault 13, 31, 142
Highworth 43, 137
Hilperton 105
Hindon 182, 191, 193, 194
Hollow way 153, 154, 160, 173, 191
Horningsham 187
Horsecombe Brook 112
Hurdcott Stone 80, 195
Hypersaline lagoons 135, 202

Ice Age 24, 28-29, 64-67, 69, 90, 97, 119-120, 126, 138, 140, 141, 145, 150, 161, 175-176, 192
Ichthyosaur 18
Idmiston 92, 174
Inferior Oolite 12-13, 24, 26, 34, 35-36, 107, 111-113, 115-117
Inlier 165, 199
Insects 46, 202

Ironstone 44, 47-48, 87-88, 122, 144-146, 155, 157, 169
Iron Age hillforts 106, 119, 126, 136, 148, 149, 162, 169-170, 187, 201
Iron sulphide 37-38, 51, 145, 162, 167

Jurassic 10-12, 24-26, 97, 111, 113, 115, 116, 132, 144, 182, 186, 204

Kellaways 41-42, 96, 101
Kellaways Beds 12-13, 24, 26, 41, 41-43, 91, 98, 100-104
Kellaways Rock 101-103
Kennet and Avon canal 72-75, 80, 84, 87, 107, 110, 158, 164, 165, 169, 172
Kennet valley 13, 67, 126, 166, 172
Kimmeridge Clay 12-13, 24, 26, 41, 44-45, 83, 86, 87, 121-123, 127, 130, 132-134, 136, 142, 144, 145, 147, 148, 155, 182-185, 187, 190, 194
Kingston Deverill 187
King's Play Hill 68, 119, 123-124
Kitchen Barrow 56, 162
Knap Hill 162, 163
Knockdown quarry 39

Lady Down 201
Landfill 39, 121
Landslips 12-13, 65-66, 111, 116, 184, 197
Langley Burrell 101
Latton 67, 68, 118, 140
Laycock 71, 74, 101, 103, 104
Laycock Abbey 117
Laycock Fault 96, 101, 103
Leigh Delamere 96, 100
Leigh Hill 163, 166, 169
Leigh Park Hotel 106
Lias 12-13, 24, 25, 34-35, 111-112
Lidbury 87
Liddington Castle 136
Lime 76, 78, 83, 130, 185, 188, 201, 202
Limpley Stoke 35, 73, 74, 84, 97, 107, 108, 111
Littlecote 166, 171

Little Knoll 185, 187

Lockeridge 61, 64, 80, 118, 126, 165

London Basin 13, 32, 58, 165, 166

London Clay 12-13, 24, 27, 59, 87, 166, 167, 169, 176, 174, 178

Longbridge Deverill 187

Longleat 74, 89, 106,182, 185-187

Long Hill 189, 190

Long Knoll 185, 187

Lower Calcareous Grit, 43

Lower Chicksgrove Manor 200

Lower Greensand 12-13, 24, 26, 47-8, 76, 78, 84, 86, 87, 89, 101, 103, 105, 119, 121-123, 142, 144, 150, 155, 157, 159, 184, 197, 198

Luccombe Springs 150, 152

Luckington 96, 97

Lydite Beds 134

Lyneham 43, 75, 96, 101, 118,

Maiden Bradley 182, 185, 187

Malmesbury 33, 34, 40, 71, 74, 75, 96-98, 99

Mammals 202

Mammoth 67-68, 140-141

Manperton Hill 185

Maps 95, 211

Market Lavington 79, 80, 87, 144, 150, 159

Marlborough 57, 60, 132, 166

Marlborough Downs 13, 61, 80, 85, 91, 118-132, 106, 143, 150, 158, 161, 165, 186

Martinsell Hill 142, 143, 162, 163

Maud Heath's Causeway 101, 102

Melbourn Rock 53, 55, 56, 80, 123, 145, 149-151, 153, 163, 189, 190

Melksham 34, 42, 43, 96, 97, 104, 105, 162

Melksham Spa 104-105

Mendips 31, 148, 186

Mere 76, 79, 183, 185, 187, 189, 190

Mere Fault 13, 31-32, 182, 184, 185, 187, 191, 193

Middle Hill 117

Middle Woodford 57, 174, 175

Midford Brook 35, 96, 111-112

Midford Sands 12-13, 24, 25, 35, 111-112, 116-117

Milk Hill 143, 161, 163

Milton Lilbourne 163

Monkton Farleigh Priory 74

Morgan's Hill 123, 125

Mother Anthony's Well 119

Mud springs 127-129

Murhill 36, 74, 109

Mushroom growing 107

Nadder, River 44, 46, 67, 182, 184, 185, 192, 195, 197, 198, 201, 202

Naish Hill 101

Nautilus 20, 59

Neolithic 162, 187

Newtown 169, 170, 172, 173

New Forest 58, 60, 96, 178-180, 198

Nower's Copse 198

Odstock 177

Ogbourne St. George 130

Old Sarum 80

Old Swindon 136

Oliver's Castle 106, 118-120, 158

Ooliths 16-17

Ostracod 18, 46, 52, 135, 202

Overton Down 62, 126, 132

Oxford Clay 12-13, 24, 26, 41-43, 87, 91, 97, 100, 101, 104-106, 121, 127, 129, 133, 136, 138-140, 150, 155, 158, 162, 186

Pepperbox Hill 176, 177

Pewsey 56, 144

Pewsey Hill 142, 143, 163,

Pewsey, Vale of 13, 31-32, 38, 44, 56, 89, 91, 106, 142-164

Phosphate 190

Picked Hill 161, 163

Piggledean 64, 80, 126

Pipe/solution hole 171-172, 175-176

Plants, fossil 122, 141

Plateau gravels 12-13, 66-67, 175-176, 178-179
Plate tectonics 21-23
Plesiosaur 50
Pliosaur 18, 44-45, 145, 147
Polissoir Stone 132
Pollen 141
Popple Bed 190
Portland Beds 12-13, 24, 26, 41, 45-46, 76, 132-136, 142, 155, 159-161, 182, 183, 192-194, 199, 200, 201, 203
Portland Stone 75
Potterne 80, 144, 155, 159, 160, 161, 163
Potterne Stone 50, 76, 160
Poulshot 144
Pound Bottom 80, 84, 174, 176, 178, 180
Pugged walls 83
Purbeck Beds 12-13, 24, 26, 41, 45-46, 75, 76, 132-135, 183, 197, 199, 201-204
Purton 43, 118, 133, 136-138
Pyrite 37-38, 51, 162, 195

Quaternary 10

Radioactive decay/dating 23, 29
Radiolaria 21
Ragstone 75, 76, 115, 190
Ramsbury 87
Reading Beds 12-13, 24, 27, 59, 166, 167, 169, 170, 174, 176, 178, 179
Redhorn Hill 142
Redlynch 58, 176, 178, 179
Red Down 137
Reindeer 141
Reptiles 42, 45, 46, 67, 100, 123, 140, 145, 181, 202
Ridge 192
Ridgeway 126, 132
Rivar 166, 171-173
River deposits 12-13, 24, 67-69, 171, 174
River terraces 98, 67, 140
Rochester Cathedral 76
Roddenbury Hill 186-187
Romans 144

Roots, fossil, 126, 181
Roundway Down
Rowde 119, 142, 144, 155, 159
Rudloe 117
Rybury 162

Salisbury 45, 76, 87, 175, 185, 200-202
Salisbury Plain 13, 60, 81, 91, 142, 151, 155, 159, 161, 163, 164, 167, 167, 172, 185, 187, 192, 198
Sandridge Park 43, 96, 104, 142
Sandy Lane 76, 78, 121
Sand & gravel 84, 100, 138-139
Sand extraction 121-122
Sarsen stones 58, 60-64, 70, 80, 81, 126, 131, 132, 165, 172
Savernake Forest 32, 58, 59, 70, 90, 143, 165-171,
Savernake tunnel 87, 142, 172
Scaphopod 19
Scarp see escarpment
Sea level changes 26
Sea lilies/crinoids 18, 19, 21, 37-39, 58, 115, 160, 167
Sea mat 37, 52, 98
Sea urchins 19, 21, 35, 40, 43, 46, 50, 52-55, 57, 58, 60, 105, 137, 158, 177, 190, 191
Sedimentary rocks 15-16
Seend 43, 47, 48, 87, 88, 96, 119, 142, 144, 150, 155, 157
Seend Cleeve 157
Sem, River 185, 197
Semington Brook 44, 155
Severn 25, 33, 65, 98
Shaftesbury 182, 183, 185
Shalbourne 172, 173
Shear Water 182, 187
Sherston 39, 96, 98
Shrewton 82
Silcrete 62-63
Silicification 62-63, 126, 132
Sink hole 168-169, 178, 198
Six Wells Bottom 190

Snails see Gastropods
Soils 88-90
Solutionpipe/hole 171-172, 175-176
Somerset & Dorset Railway 112
Somerset Coal Canal 14
South Wraxall 73
Sponge 18-19, 37, 50, 53-55, 171, 191, 199, 201, 203
Spring 104, 109, 115, 150-152, 163, 173, 190, 192, 199, 202, 204
Spring line 91, 111, 119, 123, 150, 160, 172, 186
Stanton St. Quintin 40, 99
Star agate 199
Staverton 105
Steeple Ashton 43, 142, 144, 145, 155, 156
Stert 142
Stert Brook 155, 159, 160, 163
Stokeford Weir 111-112
Stoke Hill mine 73, 107
Stonehenge 64-65, 70, 80, 81
Stone Age 65, 67-68, 123, 126, 131, 132
Stour, River 185, 187, 190
Stourhead 89, 182, 185, 187, 190
Structure 29-33
Stype Wood 166-169, 171
Summerham Brook 155, 157
Swindon 43-45, 47, 48, 60, 76, 80, 118, 132, 136
Syncline 31-32, 129-130, 175-176, 178

Tan Hill 142, 143 161
Tan Hill Way 161, 162
Teff, River 202
Teffont Evias 76, 78, 199, 201, 202
Teffont Magna 192, 202
Templar's Bath 132
Terracettes 68-69, 119, 123, 151
Terrace Hill 169
Tertiary 10, 12, 24, 27, 69, 126, 127, 164-171, 174-181, 188
Tetbury Avon 96, 99
Thames valley 13, 33, 41-43, 64, 65, 67, 84, 85, 91, 118, 130, 136, 138-141

The Terraces 192, 194
Tidcombe 143
Tile-stone 75, 76, 202
Tinhead 153
Tisbury 76, 182, 183, 192, 199, 201
Tisbury Stone 193
Tithe barn 107-108
Tollard Royal 198
Tottenham Park 166, 169
Totterdown 80
Town Gardens 132-135
Tramways/trolleyways 107, 109, 113
Trowbridge 34, 43, 162
Trowbridge Fault 96, 105
Tucking Mill 35, 96, 111-113, 199
Turleigh 109
Twinhoe Beds 37, 110, 114

Unconformity 26, 34, 47, 48, 58-59, 97, 112, 142, 157, 161, 167, 198, 204
Upavon 142
Upper Building Stones 45
Upper Calcareous Grit 43
Upper Chicksgrove 76, 199, 201, 203
Upper Greensand 12-13, 24, 26, 33, 47, 49-50, 66, 76, 89, 90-92, 106, 119-120, 136
  Vale of Pewsey/Ham: 142-144, 147, 150, 153, 154, 158, 159, 160, 161, 163, 164, 166, 167, 172, 173
  Vale of Wardour: 182-187, 189-192, 194-199, 201-202
Upper Lias  12-13, 24, 25, 34-35, 111-112
Upper Rags 37, 114
Upton 191
Urchfont 142, 144, 150, 153

Vale of Pewsey fault 31, 188
Valley gravel 67, 100, 126, 138-141, 171, 192
Vegetation (see also woodland & heath) 101
Vertebrates 21

Walkers Hill 161, 163
Walls 71, 75, 80, 83
Wanborough 80
Wansdyke 123
Wardour 185
Wardour Castle 13, 194, 196, 197
Wardour, Vale of 13, 31-32, 44-47, 50, 66, 76, 182-184, 187, 191-204,
Warminster 50, 83, 182, 185, 186
Warminster Fault 182
Warminster, Vale of 13, 31-33
Watercress 90, 92, 199
Water supplies 90-92
Water table 90, 187, 190, 192, 199, 204
Wattle & daub 83
Weathering 15
Westbury 35, 43, 44, 45, 83, 86-88, 142-151, 161, 186
Westwood 74, 75, 107
West Ashton 43, 144, 155
West Grimstead 178
West Harnham 177
West Kennet 80
West Knoyle 184, 185
West Wiltshire Downs 13
West Woods 70, 90, 127, 165
William Smith 14, 35, 111

Wilton, Vale of Pewsey 87, 165-167, 173
Wilton, near Salisbury 84, 174, 175
Wilts & Berks canal 127, 136
Winchester Cathedral 74
Wincombe Park 197
Windsor Castle 107
Winsley 107, 109, 111
Win Green 182, 198
Wealden Beds 12-13, 24, 26, 41,46, 204, 135, 184
Wexcombe Down 143
White horses 125-126, 130, 148, 149, 158, 163
White Sheet Down/Hill 182, 187, 189, 195, 197, 201
Wood, fossil 42, 46, 60, 123, 140, 181, 204
Woodborough Hill 161, 163
Woods 89, 106, 121, 127, 161, 165, 178, 183, 186, 187, 191, 192, 195, 197
Wootton Bassett 43, 75, 118, 127-129
Worms 18-20, 35, 45, 46, 50, 59, 112, 153
Wroughton 118, 136
Wylye valley 67, 182, 186, 187

Zeals 185
Zeals Knoll 190
Zone fossil 23

## More books on Wiltshire from Ex Libris Press:

**EXPLORING HISTORIC WILTSHIRE**
**Volume 2: South**
by Ken Watts
Featuring six of the finest landscapes of rural south Wiltshire.

*176 pages; Illustrated*
*ISBN 0 948578 92 0*
**Price £7.95**

**THE DAY RETURNS**:
*Excursions in Wiltshire's History*
by John Chandler
This is the perfect dipping into book for all lovers of Wiltshire.

*256 pages; Illustrated*
*ISBN 0 948578 95 5*
**Price £9.95**

**THE PROSPECT OF WILTSHIRE**
Words by John Chandler; Pictures by Jim Lowe
The first and only full-colour book dedicated to the beauties of this special county.

*112 pages; full colour maps and photographs throughout; ISBN 0 948578 74 2;* **Price £14.95**